The Face Pullers

The Face Pullers
Photographing Native Canadians 1871-1939

Brock V. Silversides

FIFTH
HOUSE
PUBLISHERS

Front cover photograph, "Black Plume–Sixapo–Blood Indian," by Frederick Steele, reproduced courtesy Saskatchewan Archives Board R-B 1344
Back cover photograph, "Three Suns, wife of Dick Bad Boy," by Harry Pollard, reproduced courtesy Provincial Archives of Alberta P.149
Cover design by NEXT Communications Inc.

The publisher gratefully acknowledges the support received from The Canada Council, Communications Canada, and the Saskatchewan Arts Board.

Printed and bound in Canada by D.W. Friesen and Sons

9 8 7 6 5

CANADIAN CATALOGUING IN PUBLICATION DATA
Silversides, Brock V., 1957–

The face pullers
ISBN 1-895618-32-0 (bound)
ISBN 1-895618-42-8 (pbk.)

1. Indians of North America - Canada - History -
Pictorial works. 2. Indians of North America -
Canada - History. 3. Photographers - Canada - History.
I. Title.

E78.C2S54 1994 971'.00497'00222 C93-098209-6

FIFTH HOUSE LTD.

Contents

To the memory of Franklin H. Silversides
1920–1993

Acknowledgments

A sincere thank you to Tim Novak, photo archivist with the Saskatchewan Archives Board,
to Bruce Ibsen, director of the City of Edmonton Archives, and to the staff
of the Glenbow Archives and the Saskatoon Public Library's Local History Department.
Thanks also to Marlena Wyman, my fellow audio-visual archivist at
the Provincial Archives of Alberta for pointing out the "pointing Indians" of Harry Pollard,
and to Karen Rathgeber Mitra for data input.
Finally, I wish to acknowledge the tremendous assistance of Laurel Wolanski
in preparing the images for the book, and editor Nora Russell
for ensuring that the text was both readable and accurate.

Introduction

This book is a visual introduction to the world of the prairie Indian, a quick glimpse at a world gone by and a comment or two on how and why it was captured by photographers. It is not intended to be a definitive study, but rather a selection of some of the most interesting images of First Nations people taken during the several decades following the introduction of photography into the old North-West.

Since the beginning of European colonization, there has always been a market for "Indian pictures," and although their popularity waxed and waned according to the relevance of the Indian to white society at a given time, they have never entirely lost their desirability or saleability.

Historically, Indians have represented many different things to many different people. For some they were bloodthirsty, unstable, vengeful, heathen beasts, while for others they were Rousseau's "Noble Savage," dignified and honorable beings who lived an unspoiled, unsullied life closely attuned to nature. For still others they were a pitiful, ignorant, and degraded race engineering their own extinction by living alcoholic and immoral lives. Finally, for some, the Indian was a sterling example of a person without a culture—a child, a "tabula rasa," who could only walk the path to civilization by adhering to the framework of a white Eurocentric set of religious, political, and moral rules.

None of these archetypes was or is accurate or even realistic, but all unfortunately can be depicted in a painting or photograph. While it is generally accepted that paintings can be fictitious and are not necessarily trustworthy, it is a common misconception that photographs do not lie. Common sense, however, shows that such is not the case. Photographs can be fixed, fabricated, or deliberately arranged to mislead, and viewers can misinterpret them or load them with meanings that were never involved in the original picture-taking session.

Simply put, photographs can be as biased as the creator wants them to be, and can also be read in any way the viewer chooses. Like statistics, they can be made to support or discredit almost any point of view.

This book is divided into four chapters, each of which reflects one approach to photographing Indians. Although the chapters are arranged in chronological order, it is difficult to attach specific time periods to each one, as photographers documented certain districts and bands before others. Thus they all overlap to some degree and the work of certain photographers may fall into several chapters, as their careers progressed and their approaches changed.

Any selection of images is, by its very nature, limited in number and therefore biased in certain unavoidable ways. This particular group is limited first by a geographical area—the central and southern portions of Saskatchewan and Alberta, both of which were integral parts of the North-West Territories prior to 1905. It is mainly in the West that the four distinct phases of photographing First Nations people examined in this book can be so clearly observed. The selection is also restricted by an arbitrary time period—from 1871, when the first photographs of aboriginal people were taken in the North-West Territories, to 1939, the beginning of World War II.

Other criteria include the aesthetic appeal of the images and their technical quality. As well, there has been an attempt (not always successful) to seek a balance between male and female subjects, young and old, famous and obscure, candid and posed, and between professional and amateur work. In addition, as many Indian nations as possible have been

represented. Some groups, however, for a variety of reasons, had fewer photographs taken of them, and the images of others, in a number of cases, have not survived.

While a few of these images are quite well known, most, surprisingly, have never seen the light of day. Western Canadian archives, libraries, and museums house thousands of photographs of Indians, while numerous private collectors possess equally valuable images in similar numbers. If more of these images were accessible to and consulted by both academics and the general public, the history of the myth-making and the reality behind the white race's often misguided notions about Native people would surely become more evident.

Photography arrived on the Canadian Prairies in 1858. That year the Canadian government funded the Assiniboine and Saskatchewan Exploring Expedition, which included a young photographer by the name of Humphrey Lloyd Hime (1833–1903). During his stay at Red River (the future Winnipeg), Hime was attracted to the Indian and Métis residents, and his images became the first in a long line of highly popular (and all-Canadian) tourist souvenirs.

Charles Horetzky (1840–1900) produced the first photographs of Native people taken in that part of the North-West Territories from which the provinces of Alberta and Saskatchewan were later carved. Horetzky was a member of the 1872 Canadian Pacific Railway Survey Party, which was examining the country between Red River and the Yellowhead Pass. He documented people and scenes from Fort Carleton to Vermilion, and over to Edmonton, Jasper, and Rocky Mountain House.

In 1872, after years of quarreling and indecision over territorial rights, the United States and British governments (the British representing Canadian interests) set up a joint boundary commission to survey the border along the 49th parallel from Lake of the Woods to the southern tip of the Rocky Mountains. The British half of the team was made up of members of the Royal Engineers, a branch of the British Army that had established photography as a subject of instruction at its training school.

The border commission, which took two years to complete its task, included four photographers but, unfortunately, three of the four remain unknown. Their work was, according to the written mandate, "to be confined to points of scientific interest or such as may be usefully illustrative of the progress of the commission." Under such terms of reference, it is understandable that much of their work is dull, but surprisingly, they also focused on the more attractive plains scenery and on the Indians.

A more comprehensive and regular system of surveying north of the 49th parallel was introduced by the Canadian government through a department known as the Geological Survey of Canada (GSC). It had been established in 1842, with a mandate to investigate the country's natural resources. In fulfilling their duties such as mapping, recording, and publishing reports, the members of this agency also recognized the value of photography.

Notable amongst the GSC were Thomas C. Weston (1832–1910), Robert Bell (1841–1917), Joseph B. Tyrrell (1858–1957), Donaldson Dowling (1858–1925), and of most significance to Indian iconography, George W. Dawson (1849–1901). The one known photographer of the British North American Boundary Commission of 1872–1874, Dawson was appointed to the GSC two years later. A geologist by training, he was also a noted authority in ethnology, and made an in-depth study of the Haida Indians of the Queen Charlotte Islands. In 1881 and 1883 he was assigned to survey the resources of the Bow, Belly, and St. Mary's rivers. At the same time he concentrated his photographic interests on the Blackfoot and Cree respectively, producing a series of remarkable views (a term applied at the time to any image taken outside a studio). Dawson would later become the director of the GSC and have a city in the Yukon named after him.

The first resident photographer in the North-West Territories was George Anderton (1848–1913), an Englishman who had enlisted in the North-West Mounted Police and was stationed at Fort Walsh in the Cypress Hills from 1876 to 1897. Anderton established his credentials by photographing Chief Sitting Bull when he moved across the Canadian border after the Little Big Horn battle in 1876. Throughout his term in the force, and for a couple of decades afterwards in Medicine Hat and Fort Macleod,

Anderton documented the various bands of Indians moving into and out of the area that eventually became southern Saskatchewan and Alberta.

With the completion of the Canadian Pacific Railway across the Prairies from Winnipeg to Calgary in 1883, numerous itinerant photographers from outside the region started to ride the rails, offering their portraiture skills to the few townspeople along the way, and their view and landscape talents to the railway itself. A few of the more significant itinerants included Adam B. Thom (active 1884-1900) from Winnipeg and Regina (sometimes in partnership with Fred Bingham); Otto B. Buell (1844-1910), an American based in Montreal (famous for his coverage of Regina in 1885, including the shot of Louis Riel in the courtroom); J.D. Doherty (active 1876-1886) from Winnipeg and Portage la Prairie (sometimes in partnership with Joseph McIntyre); William McFarlane Notman (1857-1913), son of the famous Montreal photographer; and finally, one of the more prolific and well-traveled itinerants, Frederick Steele (1860–1930).

Raised in Toronto, where he apprenticed at the Notman & Fraser studio, Steele moved west to Winnipeg in 1886, setting up a studio with partner William E. Wing. The business later evolved into Steele & Co. A tireless traveler, Steele made regular tours across the Prairies; working journeys were made in 1889, '90, '91, '94, '95, '97, '98, '99, and 1903. By 1901 he had set up branch studios in Macleod, Medicine Hat, Pincher Creek, Cardston, Fernie, and Calgary. During these years he built up a collection of mountain scenes and images of North-West Mounted Police, miners, and especially Indians, many of which are held by the Saskatchewan Archives Board. In 1918 Steele relocated permanently to Saskatoon.

After 1886, when the CPR reached Vancouver, some itinerants started branching out from the West Coast inward—people such as Richard Trueman (1856-1911) and his sometime partner Norman Caple, and the Bailey brothers, William (1865-1936) and Charles (1869-1896). While these practitioners took some stunningly picturesque images of Native people, they did not get to know their subjects and there is a feeling that their images are posed tableaux.

With the gradual increase in prairie population in the 1890s came the establishment of numerous permanent urban studios. Rarely could a professional photographer make a comfortable living from city work alone. He thus had to continue devoting a considerable portion of each year to travel. The more significant studio/itinerants represented in this book include W. Hanson Boorne (1859-1945) and Ernest G. May of Calgary; Alex J. Ross (active 1885-1891 and responsible for the famous photograph of the "last spike") of Calgary; William J. James (1870-1944) and Theodore Charmbury (1879-1945) of Prince Albert; Charles W. Mathers (1868-1950) and Ernest Brown (1877-1951) of Edmonton; Harry Pollard of Calgary; Ralph Dill (1876-1948) of Saskatoon; Nathaniel Porter (1872-1953) of Moose Jaw; Edgar Rossie (1875-1942) of Regina; and one of the rare females, Geraldine Moodie (1854-1945) of Battleford, Maple Creek, and Medicine Hat. Due to the fact that these photographers lived in the area where they were working, they made repeated visits to the Indian bands during their itinerant circuits and in some cases got to know their subjects very well. This undoubtedly fostered a greater feeling of contact, possibly even trust or warmth on the part of the First Nations people, and definitely the emergence of individual character in the photographs.

One must always keep in mind that the chief incentive for taking photographs of Native people was money. The availability of Indian scenes in a photographer's advertisements usually guaranteed a steady flow of curiosity, if not business. George Anderton regularly promoted four types of work in his newspaper advertisements: "Rocky Mountain views, Indian groups, ranche views, and Horseback Pictures."

In 1897 Charles Mathers of Edmonton offered a Christmas souvenir album to his customers, which appears to have sold in large numbers. The editor of the *Bulletin* gave a lengthy description of the variety and beauty of the images, making special mention of his Indian views.

> C.W. MATHERS has just received his souvenir album of the Edmonton district, consisting of sixteen pages of photo-gravures, reproduced from photographs taken by Mr. Mathers of

scenes in and around the town. There are in all twenty one views, showing Edmonton in the distance, gold dredges and grizzleys at work on the river here, pack horses starting for the Klondike, the first lady to leave for the gold fields via Edmonton, supplies at the Landing and boats leaving for the far north, Edmonton in '97 and as it was 30 years ago according to an old painting, Indian teepes [*sic*] and ponies, Alexander's band of braves in "tea dance" attire, the original red river cart, Indians in fancy dress and agricultural and many other scenes. Altogether, the booklet which is gotten up in neat and first class style, is a most artistic and interesting souvenir.[1]

In terms of quantity of "Indian photographs," it was the amateurs who won hands down. They were a diverse group, from tourists, to "weekend Kodakers" going for a drive in the country, to the farm instructors and priests teaching on the reserves themselves.

Most obvious were the tourists, who wanted to capture a bit of the summer camp atmosphere of the Canadian West and take it back home. One British traveler, Douglas Sladen, wrote in his 1894 book *On the Cars and Off* that the First Nations people quickly learned how to deal with them.

The Canadian Pacific Railway ought to have a commission on detective cameras, Kodaks, hawkeyes, etc. for the average passenger would as soon think of going without antibilious medicines as without a camera. Whenever you stop at a station, all the steps getting down are packed with people taking pot shots with Kodaks. American children learn kodaking long before they learn how to behave themselves. As the train moves out there is always a scramble between the people who have got out and do not want to be left behind, and the people who are kodaking up to the last minute. Crossing the prairie, every operator imagines he is going to kodak an Indian; but the wily Indian sits in the shade, where instantaneous photography availeth not, and if he observes himself being "time exposed", covers himself with a blanket.[2]

Three notable Oblate priests—Louis Cochin (1856-1927), Joseph Edouard Tessier (1873-1952), and Jean Lessard (1911-1966)—extensively documented their travels and their time spent in Native communities. Cochin ministered to the Cree Nation in the Battleford district from 1882 until 1900 (especially the Poundmaker, Sweetgrass, Thunderchild, and Moosomin bands). He also spent time at Prince Albert, Jack Fish, and Île-à-la-Crosse, and in 1908 founded a mission at Meadow Lake. The town of Cochin, Saskatchewan, is named after him. Two albums of his photographs have been

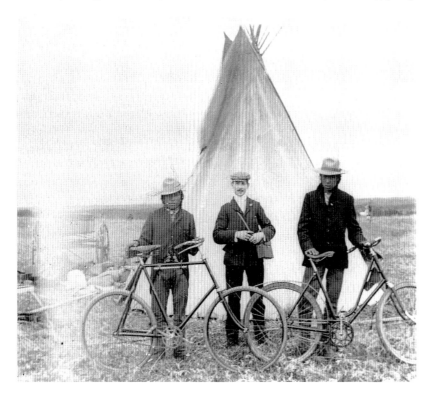

Prince Albert photographer Theodore Charmbury visits Indian friends at a nearby reserve ca. 1905.
SASKATOON PUBLIC LIBRARY, LOCAL HISTORY DEPARTMENT PH.90 82-2

preserved in the Saskatoon Branch of the Saskatchewan Archives Board.

Joseph Edouard Tessier started his duties in Ottawa in 1901. He moved to western Canada at the beginning of World War I and appears to have been constantly on the go. His many postings included Strathcona (1914-16), Macleod (1916), Duck Lake (1916-18), St. Paul (1918-26), Cut Knife (1926), Cold Lake and Athabasca Landing (1926-27), Cut Knife again (1927), and Delmas (1928). For two years he worked at the newspaper *Le Patriote* in Prince Albert, and then returned to his religious duties at Pincher Creek (1930-34), Edmonton and St. Albert (1934-35), Maidstone, Paynton, and Marshall (1935-38), and finally Meadow Lake (1938).

Jean Lessard was more academically inclined than Tessier or Cochin, immersing himself early in his career in the Indian culture and language. He spent five years at Cluny (1936-40) and another eight at Cochrane (1940-47). An assiduous student of First Nations history and society, he was later appointed professor of anthropology at College St. Jean in Edmonton and at the University of Ottawa; he also taught the Cree language at the Blue Quills Indian School at St. Paul, Alberta. Many of Lessard's and Tessier's prints and negatives are in the Oblates of Marie Immaculate (OMI) Archives at the Provincial Archives of Alberta.

As far as is known, there was no attempt to do a comprehensive photographic documentation of the prairie Indians in Canada, as had been done in the United States. There, the Rodman Wannamaker Expeditions from 1908 to 1913, for example, resulted in the book *The Vanishing Race*. And Edward S. Curtis of Seattle was also determined to preserve a record of the Native peoples before they disappeared. His work, carried out between 1900 and 1930, culminated in a series of books under the collective title *The North American Indian*. Although the majority of his subjects were American, Curtis did photograph several British Columbia bands as well as the Piegan and Blackfoot in Alberta in 1927.

As far as can be determined, there were no professional Indian photographers active in western Canada who could have produced an alternative vision of the Native peoples in the late nineteenth and early twentieth century. There were undoubtedly a number of amateur Native photographers active after the turn of the century. Their work would be of immense significance, helping to balance an obviously one-sided view of their people. If any collections still exist, it is hoped that they will eventually find their way into archives and become available to the public.

Even with their suspect motives and cultural delusions of grandeur, one cannot help but admire the variety and quality of images produced by these prairie photographers. During this period, the act of photographing demanded a great deal of skill, while the equipment and materials were quite primitive. It certainly had nothing in common with the present-day activity of point, shoot, and move on.

Professionals, without exception, used view cameras—large wooden boxes with bellows and primitive lenses—which needed to be supported by a tripod. This meant that the photographer had to spend several minutes setting up and composing a shot. Amateur cameras were smaller and could be hand-held, but they did not give the operator as much control, nor was the resulting image large enough to be useful for anything but the family album.

There were no built-in exposure meters to tell the photographer how long to leave the shutter open. Professionals developed a finely tuned awareness through daily experience of how much light was falling on their subjects. Amateurs, however, consulted charts of rough calculations (some had two settings: sunny or cloudy) and as a result, the quality of the images varied drastically.

Up to the 1890s, all photographs were taken on glass plate negatives (usually five by seven or eight by ten inches), and even though plastic (cellulose nitrate) film was available from then on, most professionals continued to use glass up to the mid-1920s. The enormous weight of a set of glass plates obviously determined how far afield photographers could roam, and what type of transport they had to use.

On the Prairies, plastic roll film in numerous gauges and formats was used in amateur hand-held cameras from about 1895 onward. Both the plates and the plastic film were less sensitive than today's films

and thus candid or action shots were the exception rather than the norm. And although color film (in the form of autochromes) was invented as far back as 1903, color was neither readily available nor regularly used until well into the 1950s.

While many professional photographers in the early years sold mounted eight-by-ten-inch prints, numerous others, by the 1890s, were turning their images into postcards, which were cheap to produce and tended to bring in a steady revenue. If they were intended for a local or regional clientele, they would be printed on real photographic paper, cut to the dimensions of a postcard. If they were intended for a wider national or international audience, however, they would be reproduced in larger quantities by a photomechanical printing process such as chromo-lithography, photogravure, or halftone.

By the time the photographers became a significant presence on the Prairies, the various Indian nations had more or less ended their nomadic existence and settled onto reserves jointly chosen by them and the Canadian government following the signings during the 1870s of numbered treaties 4, 6, and 7, which covered central and southern Alberta and Saskatchewan.*

It has been a generally accepted truism that Native people did not like having their pictures taken. However, it is inaccurate to say that all Indians were hostile to the process of photography. Some indeed were hostile, but just as many were either frightened, curious, or indifferent, and many more both enjoyed looking at photographs and sitting for portraits. In other words, Native people reacted to this new technology much as any diverse group of people would. And with a unique perspective on the mysterious equipment and its final product, they labelled the camera "the face puller."

One reason for their lack of co-operation was undoubtedly a misunderstanding about the camera itself, which, even to a well-educated modern person, is mystifying. For instance, in May 1858 Humphrey L. Hime reported the first prairie Indian response to the

camera when he tried to photograph a group of Ojibways at Fort Frances.

When an attempt was made to take a photograph of the interior of one of the lodges, several squaws, who were seated with their children around the fires, instantly rose, and, driving the children before them, hastened off to the neighbouring forest, and no argument or presents could induce them to remain. They said that "the white wanted to take their pictures and send them far away to the great chief of the white men, who would make evil medicine over them, and when the pictures were sent back the Indians who were drawn would all perish. They knew this was the way the white man wanted to get rid of the Indians and take their land."[3]

In 1884 Thomas C. Weston of the Geological Survey of Canada photographed a band of Cree Indians near Maple Creek, Saskatchewan. One of the group "only consented to have his picture taken after being allowed to hold a rifle so he could shoot the picture maker if he was hurt in any way."[4]

It was obviously not trust-inducing to point unknown objects at others. A group of Blood Indians visiting Fort Macleod in the autumn of 1884 generated this note in the *Gazette*:

It is rather strange to note the aversion which the average Indian has to be photographed. This feeling extends to the fair sex, as well as the warriors. Mr. Stavely Hill took a number last week, and experienced some difficulty in getting just what he wanted. The street between the GAZETTE office and I.G. Baker & Co's store was filled with traveaux of every conceivable shape and design . . .

He got several good views of the traveaux, and then wanted a photograph of one with a squaw mounted. A bribe was offered one to get up, but the moment she saw the muzzle of the face puller in her direction, she looked indignant and got out of range . . .

Several made a break to get on, but the moment they saw preparations for business, they

* For detailed information about the reserves and their locations, please see Supplementary Information, p. 12.

retreated. At last however, one of them, in blissful ignorance that was to be made immortal by Mr. Hill's camera, mounted her crow bait in full range. One moment . . . and tick! that ancient Blood lady . . . made an impression that would last forever.[5]

Another example can be gleaned from a brief article on Calgary lensman Harry Pollard.

The big 8 by 10 camera would be set up on its tripod, the photographer would disappear under the black cloth, and the picture would be taken—often the Indian would be unwilling and all were somewhat superstitious of the hidden eye . . .

Often a brave simply refused to have anything to do with "the white man's mystery box". But generally the photographer was successful because the chief had ordered it, and because the chief generally was near at hand to see his orders were obeyed.[6]

William Hanson Boorne of the Calgary firm Boorne & May also experienced this reluctance many times. He discussed it with his Native acquaintances.

Boorne often found the Indians opposed to having their pictures taken. On occasions they threatened and abused him, but more often fled to hide their faces.

The Indian "bashfulness" puzzled Boorne, but he eventually discovered the cause of their strange attitude and wrote: "I discovered that the real reason for the objections of the Indians to being photographed arose from the fact that they could not understand it. They could not see how the 'Spirit Picture' could possibly be taken of them without taking something from them. The camera MUST rob them of some part of themselves and therefore must certainly shorten their lives."[7]

This quotation elucidates a second theory—that the Indians felt as if a part of them (spirit) was being taken away, thus weakening them, when a photograph was produced.

Native people may indeed have felt as if a part of them was being taken when a photographer departed. In many cases there were no primitive spiritual apprehensions, but rather commercial misgivings. The photographer had taken something he could resell, but the Indian was usually given nothing or a mere token bribe in return. Irritation, anger, and a feeling of being cheated were bound to follow.

The Cree chief Big Bear did not have a problem with having his picture taken. He realized, however, that he could earn money from his own image. The *Saskatchewan Herald* reported on his interaction with an itinerant photographer in August of 1883.

Big Bear is becoming civilized, and already poses as a speculator. When Mr. Rolland, the artist who accompanied Prof. Kenaston on his recent exploratory trip through this country, was taking some views of the town, Big B. was among the onlookers. Being asked to stand for his photograph, he drew his blanket around him with what dignity he could and informed the artist that he, B.B. was a great man, whose name was known everywhere, and the desire for his photograph was so wide-spread that its sale would bring a fortune to the man who could secure it, and that therefore it must be paid for. However, not to stand in the way of enterprise, he would consent to having it taken if he were given a chest of tea, a side of bacon, a corresponding modicum of sugar, tobacco, and other things the possession of which contributes to an Indian's idea of happiness. His name may become immortalized, his features never at Mr. Rolland's hands. The price fixed was too high.[8]

Another documented case of First Nations hostility to photographers is found in the papers of W. Hanson Boorne. He encountered serious resistance when he attempted to capture the sun dance ceremony in July 1887 on the Blood Reserve near Macleod. In his notes on the ceremony he wrote:

There was intense opposition amongst the Indians when I attempted to take photographs of the "Sundance" and "Brave Making". They believed

that a picture made of them, took away a part of themselves, and must shorten their lives, and it was especially difficult at a high sacred ceremony like the "Brave Making".

He was let into the Medicine Lodge only with the insistence of the Blood head chief Red Crow.

I saw the whole ceremony, and fourteen young bucks "tortured", of whom five failed to stand it, and were roughly torn down by the Head Medicine Man in charge of the proceedings, and "sent back to the squaws". There was violent opposition to my being there, by the younger bucks, and nearly all of the squaws, who made a horrible noise, shouting and yelling, but Red Crow kept them in hand according to promise.

Boorne evidently did not take the hint that he was an uninvited and unwelcome guest. He continues, explaining how a tragedy occurred:

One or two of the most excitable Indians fired their rifles over my head to try and scare me out of the Lodge. A bullet from one of them struck a boy of about nine years of age who had climbed up, with other Indian children, on the outside branches of the lodge to see what the noise was about. It passed through his breast just under the heart, and he died the same evening.

Boorne then gives a fascinating step-by-step description of the brave-making ceremony he subsequently witnessed and documented:

An old Indian, presumably the boy's father, then got up and addressing the assembled crowd, "counted" the boy's "coups". In these peaceful days, these do not usually include actual scalps as they formerly did, but he managed to make a great harangue. He said that this young brave had a lion heart. He had stolen many horses, arrows and other things, (probably mostly imaginary), and intended to get a great many more before he had done.

After this had gone on for some time, and the Indians being greatly interested I managed to get a photograph, not an easy thing as the light in the lodge was not at all good, without attracting much attention. Then the boy lay down on his back at the foot of the Medicine Pole in the centre, and the Chief Medicine Man took a knife, and pinching up a portion of the muscle on each breast, cut a small gash on each side of his fingers on both breasts, and ran a wooden sliver through each side leaving them sticking in the flesh like a butcher's skewer through a piece of meat. He then turned the boy over and performed the same operation in the muscles of his back, under each shoulder blade.

This done, the boy jumped to his feet, (I got another photograph), and with the reed whistle in his mouth, a heavy "medicine drum" was hung by pieces of raw hide to the slivers in his back, and the pieces of wood in his breasts were fastened to the ends of a raw-hide lariat which was passed up and over the fork of the Medicine Pole. (I secured another photograph of this). He then went up to the Medicine Pole, threw his arms around it, and put his lips to a notch cut out in the side for the purpose, removing the little whistle for a moment to do so. He was supposed to derive comfort and strength from the notch in the Medicine Pole, to enable him to carry on the ordeal.

He then made a few spectacular tugs at the lariat, by leaning back and throwing his whole weight on the flesh of his chest, to show that he was "game", (I got another photograph), and then commenced to dance around the pole, leaning heavily on the rope so as to extend the muscles of his chest and tear them right out, which in a few minutes he did. After this he made a quick and strong jerk on the drum fastened to his back, and tore it out, throwing it from him.

He has, throughout this ordeal, made no sound whatever, except through the little reed whistle, and this he blew violently all the time. I was informed that this served a double purpose, viz, the violent blowing of the whistle relieved his feelings under the great pain of the ordeal, and also that it kept all evil spirits away from him

during the great ceremony of his life. He then fell back on to the ground, and was blessed by the Medicine Man in charge, and jumped up a full fledged "Brave".[9]

A third theory, more to the point, is that Indians as subjects reacted to photography depending on the personality, approach, and purpose of the photographer himself. There were many reasons for photographing First Nations people. Among these was a genuine interest and concern to document the culture. But apart from obtaining material for the anthropological record, this could also be approached from other angles, such as sheer curiosity or for commercial exploitation of the inherent culture shock. All the photographs in this book were taken by white people whose cultural baggage—especially the conviction that the white race was superior morally, intellectually, and spiritually—could not help but create tension between sitter and taker.

It would also be quite natural for the Indians to feel hostile if they thought their images were being used for entertainment or cheap laughs, as they often were. No group of people enjoys being subject to ridicule or pictured as dirty, stupid, primitive, or disgusting.

Unfortunately most photographers did not consider Native people worthy of the respect they would accord their white subjects. One sign of this is the sad fact that great numbers of First Nations portraits were never identified as to name or location, a portrait of a Native person being considered "representative" of a people, rather than an image of an individual.

In addition, Native people were often used as props or backgrounds, in much the same way as photographs of hunters have animal heads and rifles off to the side. An interesting account from the *Moose Jaw News* of May 1884 shows how one group of Indians simply refused to co-operate.

Photographing the Aborigines

A photographer who has recently come to town set out the other day, accompanied by a few Moose Jawites, for the Sioux encampment near town, with the view of obtaining a set of photographs of the braves and their surroundings. The design of the operator seems to have been artistically conceived. His object in taking along a few of our best-looking citizens was no doubt to have their pictures interspersed amongst those of the dusky occupants of the tepees, whose personal beauty is not usually their strongest point, by way of using the laws of contrast to enhance the value of the picture. But "the best laid schemes, etc." On approaching the tepees, it quickly became evident that their painted occupants had been forewarned. The party no sooner came in sight than a body of the Indians herded their horses and drove them off to some distance, evidently resolved that their four-footed friends should not be degraded to the low use of filling in a picture to gratify the impertinent curiosity of the pale-faces. Those of the natives who did not join in the stampede instantly concealed themselves in their tents, covering their heads with blankets, skins, or whatever came to hand. The spot which but a moment before had been swarming with human figures now reminded the more poetical of the visitors of passages in Goldsmith's "Deserted Village". Occasionally one of the artful dodgers, a little bolder than the rest, would thrust his head outside the canvas and, if the coast seemed clear, would make a rush for the next tent, taking care, however, that no part of his features became visible.

One of the visiting party, who spoke a little Indian, finally prevailed upon one of the Indians to look through the instrument but the wary red-skin took great care to keep his head covered and himself well in the rear of the stand.

Meanwhile the artist and his companions had been anxiously expecting Mr. Graham, of Wood Mountain, who was to join them and whose arrival was at length hailed with great satisfaction. Mr. Graham speaks the Indian like a native and it was naturally supposed that he could persuade the braves to listen to reason and thus break the awkward dead-lock. Mr. G. went from tent to tent, reasoning, expostulating and explaining, but all to no purpose. The warriors, some of whom had, perhaps, faced the muzzles

of Custer's rifles, could not be brought to face the artist's harmless little tube. Mr. Graham says that the chief cause of their obstinacy was some superstition. Connected with this was a dread lest their pictures should fall into the hands of their enemies and in some way bring them into trouble. We shrewdly suspect that liberal distribution of silver would have proved wonderfully reassuring. In the course of the negotiations one young brave, bolder or more excitable than his comrades, sallied forth, armed with a heavy club, and rushed towards the camera with the evident intention of settling the question by demolishing the object of dread. He was followed by the old warrior who, with some difficulty, compelled him to return.

The patience of the visiting party being at length exhausted, they decided to have at least their own pictures taken with the picturesque tepees for a background, trusting, no doubt, to the discernment of an intelligent public to prevent possible mistakes in interpretation.

The thing seemed a little like the play of Hamlet with Hamlet left out, but that couldn't be helped. The process was closely watched from a distance by their red brothers, who, as soon as they saw the operation was over, commenced to dance and jeer evidently delighted with their success in baffling the design of the artist.

The party now moved homewards. In an instant the prairie was alive with jubilant Indians. They evidently thought the chief danger past. Still they kept sharply on the alert for, upon the instrument being again pointed towards them, they all vanished as if by magic, some fleeing to cover, others throwing themselves upon the ground and covering their heads with their blankets till

"It seemed that Mother Earth
Had swallowed up her war-like birth"

and the disappointed picture makers had nothing left for it but to make the best of their way to the town, a little crestfallen at the frustration of their artistic plans.[10]

The photographers who took pictures of Native people approached their task in a variety of ways. Some itinerant photographers followed only the well-traveled paths of the Canadian Pacific and Canadian National railways and their branch lines. Frederick Steele of Steele & Co., for example, produced a large body of high-quality First Nations images throughout the 1890s. He limited himself, however, to those Native communities adjacent to the CPR and its two branch lines—the Qu'Appelle, Long Lake, and Saskatchewan (Q.L.L.&S.) in Saskatchewan, and the Calgary and Edmonton (C.&E.) in Alberta.

Other photographers, more adventurous and wide ranging, struck out from the rail line on wagons, stagecoaches, or even riverboats. They ended up spending more time with the Indian people and brought back images of the more isolated reserves north of the railway.

This approach raised its own problems. Generally speaking, Native people did not go to photographers' studios to get their portraits taken. The photographers more often came after them, in their territory, in their environment. By its very nature this is an invasive act, and it is amazing in retrospect that more photographers were not summarily ejected from the Native communities.

None of the professional photographers lived on the reserves, nor did they spend much time with their subjects. They were tourists. It was left, therefore, to the amateurs (priests, farming instructors, nearby settlers, etc.) to fully record the everyday events and lives of the Indian peoples.

Some photographers eschewed all nuance of subtlety or sensitivity, barging their way into encampments or onto reserves. Unannounced and uninvited, they made no attempt to seek permission, feeling they they were entitled to take their pictures, and refusing to take no for an answer. In response to resistance, they might as a last resort offer a bribe, which offended their potential subjects immensely.

Fortunately, there were other photographers who took a more gradual approach, seeking first to establish friendly relations, then a degree of trust, prior to taking photographs. Harry Pollard of Calgary was one such example. According to one article:

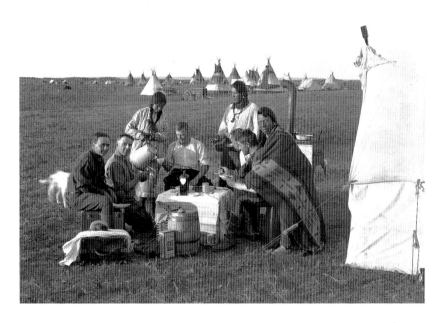

Calgary photographer Harry Pollard, left, shares a meal with his Indian hosts on the Blackfoot Reserve ca. 1912. PROVINCIAL ARCHIVES OF ALBERTA P.60

Photographing Indians isn't a job for a timid soul either and more than once this pioneer photographer felt the sting of an Indian's stick. But painstakingly he did win the confidence of the chiefs. Accompanied by a driver from the local livery stable, Harry Pollard would load up a democrat with provisions of tea, sugar, flour and tobacco and drive out for a pow wow on one of the reserves in the southern part of the province. There, given permission to set up his tent, he would patiently set about making the Indians understand his genuine interest in them and their tribal customs.[11]

Still, the legacy of white photographers appropriating images of Native people persists. As contemporary Native photographer Richard Hill writes in his essay "Photography's Next Era" from the catalogue *The Silver Drum*:

Once the camera was a symbol of the outside world, trying to invade the Native nations, to capture our souls. Anthropologists and other tourists would sneak photographs of our people. Indians were the most popular subjects of turn of the century films and stereo view cards. Tour buses of vacationing whites would visit the quaint Indian villages and capture snapshots of "real live Indians." Taking a picture became an act of oppression that many Native people came to resent. People on the reserve are still leery of the caucasian with a camera.

The results of the photographic transgression has [sic] lasted for years. Scholars republish the stiffnecked photos of Indians, unsmiling and unattached. The tourists return every summer even though they may now find signs that say "NO PHOTOS ALLOWED". The public, however, believes the images of Indians that they saw. . . . The Indian reaction to photography was very negative. Indians are constantly being asked to pose for the outsiders' cameras, to look "mean" or "stoic." If you fold your arms across your chest, you will be an instant hit for their instamatics.[12]

In summary, the Indian image continued to excite the imagination of white Canadian society throughout the period 1871-1939. In response, white professional photographers over the decades shaped their portrayal of the Native person according to their public's whims—first it was the dirty, backward aboriginal in need of guidance, then the idealized, but soon-to-be-

extinct "noble savage," followed by the Christianized, civilized "white" Indian, and finally, a romantic rendering of the "legendary" Indian.

White amateur photographers also produced images with their own peculiarities. Tourists snapped shallow, superficial pictures as they passed by the reserves, as if the Prairies were a giant Jurassic Park with exotic red-skinned animals to look at. If they lived with or near the Indians, however, they often portrayed a more unposed and sympathetic view of their subjects and their activities.

All these portrayals capture some aspect of the Native experience, but even taken together, what they present is far from the total picture. And while it is unlikely that sifting through these images will provide a cumulative, accurate view of the early First Nations people, these photographs are nevertheless a crucial part of the historic record and should be valued and preserved as such.

Supplementary Information
Reserves in Alberta and Saskatchewan

The Cree Nation hunted and traveled extensively throughout Saskatchewan and were scattered widely when they finally accepted their reserves. Three contiguous reserves—Piapot, Muscowpetung, and Pasqua—were located in the eastcentral portion of the province in the Qu'Appelle Valley, an area that also included the Cowessess, Ochapowace, Sakimay, and Kahkewistahaw settlements near Crooked and Round lakes. To the south was White Bear, adjacent to present-day Moose Mountain Provincial Park.

The Touchwood Hills were home to the Gordon, Muskowekwan, Poor Man, and Day Star reserves, while to the north of them were Fishing Lake (near Wadena) and Nut Lake (near Rose Valley). There were also four adjacent blocks—Little Black Bear, Star Blanket, Okanese, and Peepeekisis (north of Balcarres)—collectively known as the File Hills.

A host of Cree communities orbited Prince Albert: One Arrow (near Batoche) and Beardy/Okemasis (near Duck Lake) to the south; Mistawasis (near Shellbrook), Atakakup or Star Blanket (north of Shell Lake), Big River, Witchekan Lake, and Muskeg Lake (near Marcelin) to the west; Muskoday (John Smith), James Smith and Cumberland (near Fort à la Corne), and Kinistino (south of Tisdale) to the east; and Sturgeon Lake, Little Red River (near present-day Prince Albert National Park), and Bittern and Montreal lakes (east of the park) to the north. Far to the northeast were the Carrot River, Red Earth, and Shoal Lake reserves.

The Battleford district also contained several important reserves: to the west lay the Sweetgrass Reserve, and further west were the adjacent Poundmaker, Little Pine, and Lucky Man settlements (south of Paynton). To the north were the Moosomin (by the town of Cochin) and Saulteux reserves, while further north were Thunderchild and Chitek Lake.

The Seekaskootch and Makaoo reserves, with Onion Lake as their urban center, lay north of Lloydminster on the Alberta/Saskatchewan border, with Ministikwan, Makwa Lake, and Meadow Lake further north of the same area. Finally, to the east near the Manitoba border, were the Cote, Keeseekoose, and Key bands (north of Kamsack).

The Cree also inhabited numerous and far-flung settlements in Alberta. Four bands took up residence in the central part of the province around the town of Hobbema on the C.&E. Railway: the Ermineskin, the Louis Bull (originally part of Ermineskin), the Montana, and the Samson. One offshoot, the Pigeon Lake Band, put down roots on the shore of Pigeon Lake thirty kilometers (eighteen miles) to the west.

The Alexander Band bordered on Sandy Lake, about forty kilometers (twenty-four miles) northwest of Edmonton, while the Enoch Band settled on a reserve on the western outskirts of the city. Further north, five bands clustered around the southern shore of Lesser Slave Lake at Sucker Creek, the Drift Pile, Swan, and Assineau rivers, and Sawridge.

Northeast of Edmonton the Cree took up residence on four major reserves: Saddle Lake (which amalgamated the Saddle Lake, Blue Quills, and Wahsetanaw bands in the early 1900s) twenty-five kilometers (fifteen miles) west of St. Paul; Whitefish Lake (a k a Goodfish Lake as the community touches both lakes); Beaver Lake, thirteen kilometers (eight miles) south of Lac La Biche; and Heart Lake, forty kilometers (twenty-four miles) northwest of Lac La Biche.

Finally, near the Alberta-Saskatchewan border, were the two Frog Lake reserves—Unipoukious and Puskiokiwenin— and the Kehiwin Reserve on Sinking Lake (south of Bonnyville). The three Cold Lake reserves clustered around Grand Centre were also home to a number of Chipewyan and Montagnais peoples.

The Siksika (Blackfoot) settled along the Bow River approximately fifty kilometers (thirty miles) east of Calgary. The Canadian Pacific Railway ran the length of the reserve with two stations, one at Gleichen, the other at Cluny.

The other two nations within the Blackfoot Confederacy were also located in southern Alberta. The Kainai (Blood) chose a reserve between the Belly and St. Mary's rivers, near which the town of Cardston would later be built. The North Piegans (as opposed to the South Piegans, who lived across the border in Montana) located on the Old Man River between Fort Macleod and Pincher Creek, while the Sarsi (a k a Sarcee and now known as Tsuu T'Ina) chose their reserve on the southwest edge of Calgary, south of the Elbow River.

The Stoney Nation (composed of the Chiniki, Bearspaw, and Wesley bands) settled on three reserves west of Cochrane near Morley; one on Abraham Lake due west of Rocky Mountain House; and one sixty kilometers (thirty-six miles) south of Calgary at Eden Valley.

Three Stoney offshoots—the Alexis, Paul, and Sharphead bands—settled on the shores of Lac St. Anne, Lake Wabamun, and the Battle River respectively. In Saskatchewan, another Stoney band, the Assiniboine, settled ten kilometers (six miles) south of Sintaluta. Finally, the Mosquito, Grizzly Bear's Head, and Lean Man bands occupied adjoining reserves south of Battleford in the Eagle Hills.

A smattering of Sioux bands originally from the United States also settled throughout the Prairies. The White Cap Band settled at the Moose Woods Reserve on the South Saskatchewan River forty kilometers (twenty-four miles) south of Saskatoon. The Wahpeton were granted a reserve about twelve kilometers (seven miles) northwest of Prince Albert, and the Wood Mountain Band, although strongly tied to Moose Jaw, was given a reserve near the town of Wood Mountain. Finally, Standing Buffalo, a Sisseton chief, took a reserve around the area where Jumping Creek enters the Qu'Appelle Valley ten kilometers (six miles) north of Fort Qu'Appelle.

Notes

1. *Edmonton Bulletin*, 20 December 1897.
2. Quoted in D. Francis, *The Imaginary Indian: The Image of the Indian in Canadian Culture* (Vancouver: Arsenal Pulp Press, 1992), 42-43.
3. R. Huyda, *Camera in the Interior 1858: H.L. Hime, Photographer* (Toronto: Coach House Press, 1975), 11.
4. Quoted in E. Hall, *Early Canada: A Collection of Historical Photographs by Officers of the Geological Survey of Canada* (Ottawa: Canada Dept. of Energy Mines & Resources, 1967), 21.
5. *Fort Macleod Gazette*, 17 October 1884.
6. G. Brawn, "Historic Photo Collection: Calgary Basement Holds Treasure," *Herald Magazine*, 8 July 1967.
7. "Boorne and May 1886-1889," *Farm and Ranch Review*, December 1960, 16.
8. *Saskatchewan Herald*, 4 August 1883.
9. W.H. Boorne, "Notes on the Canadian Indian 'Sundance' Ceremony and the 'Brave Making,'" manuscript, McCord Museum, 1887.
10. *Moose Jaw News*, 23 May 1884.
11. *A.T.A. Magazine*, undated article, found in Harry Pollard's scrapbook, Provincial Archives of Alberta, 64.33/1.
12. R. Hill, "Photography's Next Era," *The Silver Drum: Five Native Photographers* (Hamilton: Native Indian/Inuit Photographer's Association, 1986), 21.

Suggested Readings

Banta, M., and C. Hinsley. *From Site to Sight: Anthropology, Photography, and the Power of Imagery.* Cambridge: Peabody Museum Press, 1986.

Blackadar, R.G., ed. *On the Frontier: Photographs by the Geological Survey of Canada.* Ottawa: Supply & Services Canada, 1982.

Blackman, M. "Copying People: Northwest Coast Native Response to Early Photography." *BC Studies* 52 (Winter 1981-82).

Boorne, W.H. "Notes on the Canadian Indian 'Sundance' Ceremony and the 'Brave Making.'" Manuscript, McCord Museum, 1887.

"Boorne & May 1886-1889." *Farm and Ranch Review.* Part I, October 1960; Part II, December 1960.

Brawn, G. "Historic Photo Collection: Calgary Basement Holds Treasure." *Herald Magazine,* 8 July 1967.

Cavell, E. *Journeys to the Far West.* Toronto: James Lorimer & Co., 1979.

Dempsey, H. *Indian Tribes of Alberta.* Calgary: Glenbow-Alberta Institute, 1978.

——. "Nineteenth Century Photographers on the Canadian Prairies." Manuscript, Glenbow-Alberta Institute, 1978.

Dickason, O. *Canada's First Nations: A History of Founding Peoples from Earliest Times.* Toronto: McClelland and Stewart, 1992.

Fleming, P., and J. Luskey. *The North American Indians in Early Photographs.* New York: Barnes and Noble, 1992.

Francis, D. *The Imaginary Indian: The Image of the Indian in Canadian Culture.* Vancouver: Arsenal Pulp Press, 1992.

Goetzmann, W. *The First Americans: Photographs from the Library of Congress.* Washington: Starwood Publishing Inc., 1991.

Hathaway, N. *Native American Portraits 1862-1918.* San Francisco: Chronicle Books, 1990.

Holmgren, E. "Ernest Brown, Photographer." *Alberta History* (Autumn 1980).

Huyda, R. *Camera in the Interior 1858: H.L. Hime, Photographer.* Toronto: Coach House Press, 1975.

Lippard, L., ed. *Partial Recall: Photographs of Native North Americans.* New York: The New Press, 1992.

McNeil, G. "Old West Photographs Are Man's Memorial." Regina *Leader-Post,* 13 May 1960.

Medland, W. "Harry Pollard, Photographer." *Alberta History* (Spring 1981).

Middleton, S.H. *Indian Chiefs Ancient and Modern.* Lethbridge: Council of Blood Indians, 1952.

Miller, J.R. *Skyscrapers Hide the Heavens: A History of Indian-White Relations.* Toronto: University of Toronto Press, 1989.

Monaghan, D. *Oliver Buell (1844-1910) Photographer.* Montreal: Concordia Art Gallery, 1984.

Pritzker, B. *Edward S. Curtis.* London: Bison Books, 1993.

Seifried, C. *Guide to Canadian Photographic Archives.* Ottawa: Public Archives of Canada, 1984.

Silver Drum: Five Native Photographers. Hamilton: Native Indian/Inuit Photographer's Association, 1986.

Silversides, B. *C.W. Mathers' Vision.* Edmonton: Alberta Culture & Multiculturalism, 1989.

——. "The 'Face Puller'—George Anderton: A Victorian Photographer on the Northwest Frontier." *Beaver* 71 no.5 (Oct./Nov. 1991).

——. "Geraldine Moodie: Through a Woman's Eyes." *Epic* 1 no.1 (March 1991).

——. "A Life of William James." In *William James: Selected Photographs 1900-1936.* Saskatoon: Mendel Art Gallery, 1986.

——. "Ralph Dill: Saskatoon's First Photographer." *Saskatchewan History* 36 no.3 (Autumn 1983).

Snow, J. *These Mountains Are Our Sacred Places: The Story of the Stoney People.* Toronto: Samuel Stevens, 1977.

First Contact

The initial period of contact between First Nations people on the Prairies and white photographers appears to have been the only true documentary period. Although photographers were biased about what they were recording, it was too new and unpredictable an experience for them to skew it in the direction they might have liked.

Photographers, and white society in general, were genuinely curious about the Native lifestyle and appearance. They wanted to explore and record their dress, hairstyles, homes, methods of travel, and their modes of worship.

The ambience was also different from later periods in that the relationship between the photographer and the subject was either equal or weighted in favor of the Native people. The Indians themselves chose whether or not they wanted to be photographed.

Somewhat isolated from society and the police, the photographer could not afford to be heavy-handed, condescending, or unfriendly. The photographs that survive, then, are more indicative of the true nature of First Nations people than later images would show.

The items of greatest interest to photographers (and their customers) were the tepees, the travois, the apparel, and the ceremonies.

The events most often photographed were the sun dance, the tea dance, the delivery of the annuity payments, and any gathering that could be passed off as a "powwow."

Note on the Captions

Locations in the captions are identified by contemporary designations, although Alberta and Saskatchewan were officially part of the old North-West Territories until 1905.

Certain words in the original captions for these photographs may be offensive to some readers. They are nevertheless a reflection of attitudes and the language of the time and have thus been retained in the interests of historical accuracy. Although these words are no longer acceptable in common usage, both the author and the publisher felt it was important to preserve the integrity of the original documents.

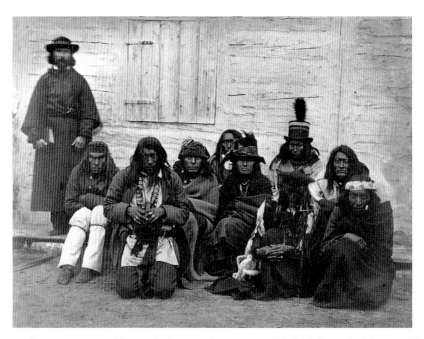

A group portrait of Piegan Indians with missionary, Rocky Mountain House, AB

1871

CHARLES HORETZKY

NATIONAL ARCHIVES OF CANADA C7376

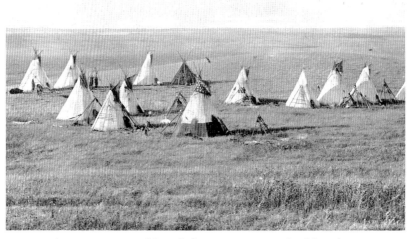

An encampment of Cree Indians near present-day Vermilion, AB

1871

CHARLES HORETZKY

NATIONAL ARCHIVES OF CANADA C5181

These appear to be the first photographs of Native people taken in the old North-West Territories.

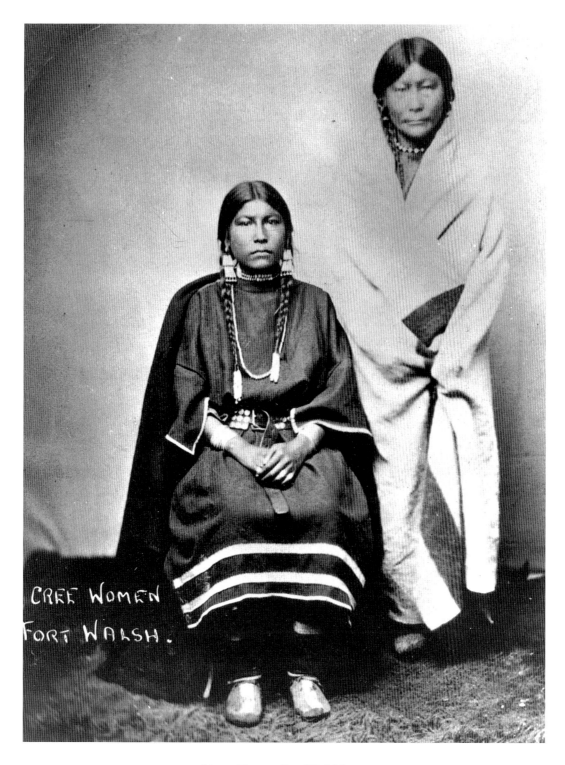

"Cree Women, Fort Walsh"
SOUTHERN SASKATCHEWAN / 1878-79
GEORGE ANDERTON
PROVINCIAL ARCHIVES OF ALBERTA A.18806

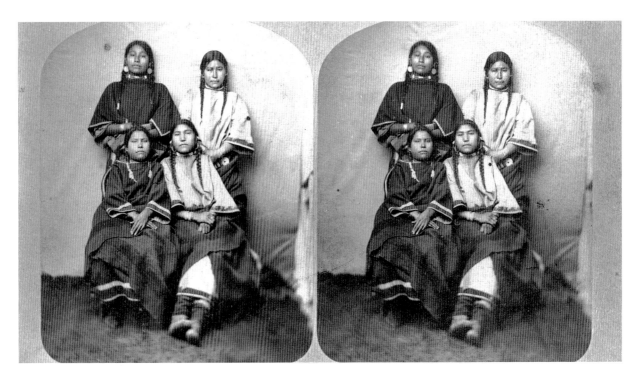

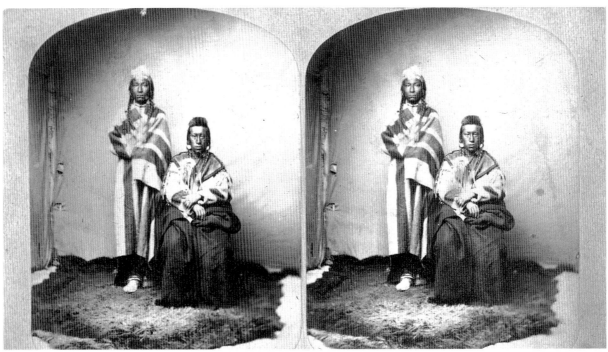

These two portraits of Sioux boys and girls were taken by George Anderton at Fort Walsh, Saskatchewan, in the Cypress Hills in 1878-79. They are stereographs—two separate images taken by a two-lensed camera, the lenses being 6 1/2 cm (2 1/2 in) apart, the distance between the pupils of the human eye. Mounted side by side and viewed through a stereoscope, the viewer's brain merged the two into one three-dimensional image.

(Top) SASKATCHEWAN ARCHIVES BOARD R–A 5046; (bottom) SASKATCHEWAN ARCHIVES BOARD R–A 5047

~ 18 ~

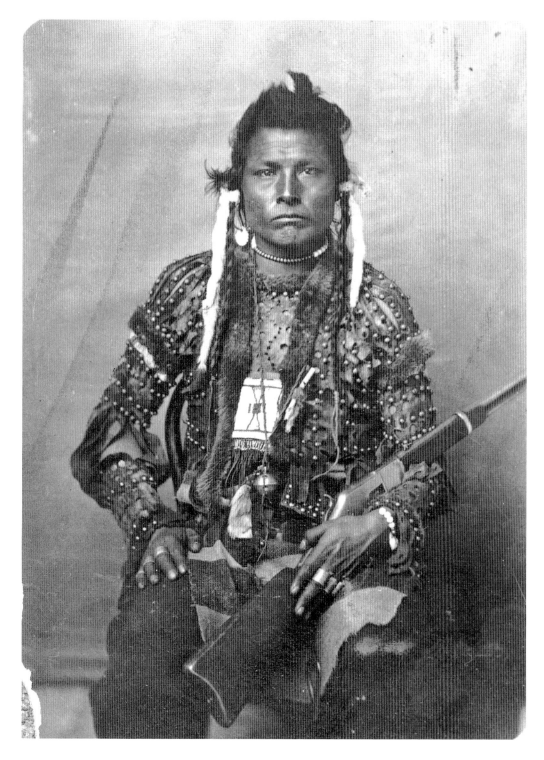

"Bear Shield–Kyi-otan" (a k a Pig Shirt)–Blackfoot
FORT WALSH, SK / 1877–78
GEORGE ANDERTON
SASKATCHEWAN ARCHIVES BOARD R-A 5044

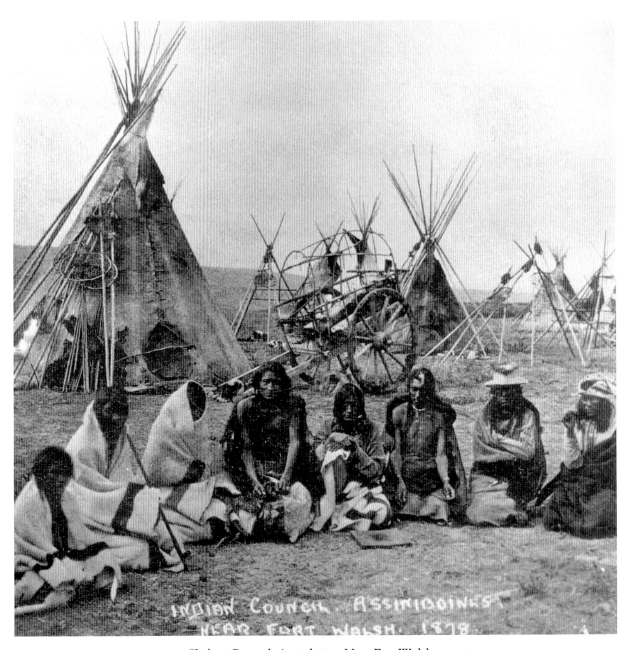

"Indian Council. Assiniboines Near Fort Walsh. 1878"
SOUTHERN SASKATCHEWAN
GEORGE ANDERTON
RCMP MUSEUM (GLENBOW ARCHIVES NEG. NA-936-34)

Group of Blackfoot Indians
FORT WHOOP-UP, NEAR LETHBRIDGE, AB / 1881
GEORGE W. DAWSON (GEOLOGICAL SURVEY OF CANADA)
PROVINCIAL ARCHIVES OF ALBERTA A.17475

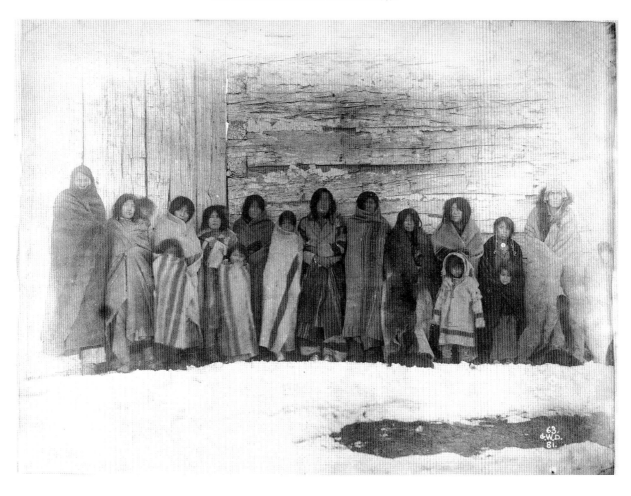

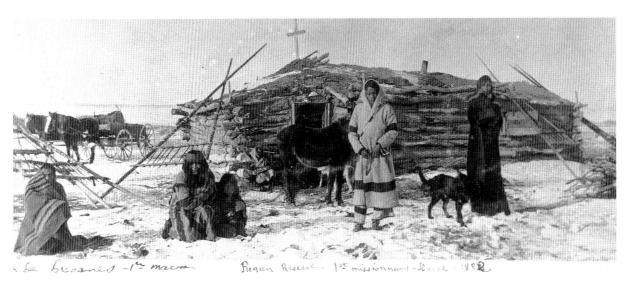

"Piegan Reserve. 1st Missionary House. 1882"–set up by the Oblate Order
SOUTHERN ALBERTA
PHOTOGRAPHER UNKNOWN
PROVINCIAL ARCHIVES OF ALBERTA OB.177

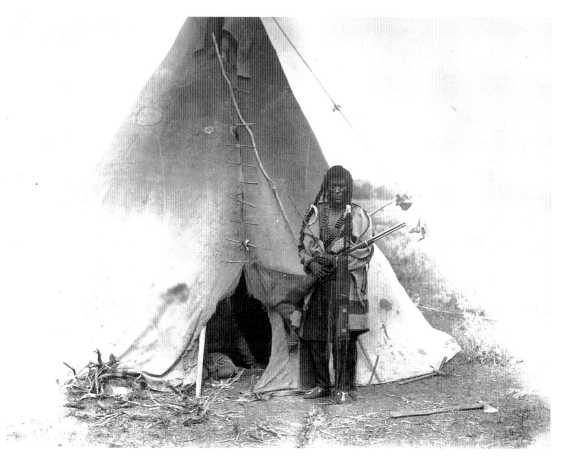

Blackfoot Indian
SOUTHERN ALBERTA / 1881
GEORGE W. DAWSON (GEOLOGICAL SURVEY OF CANADA)
PROVINCIAL ARCHIVES OF ALBERTA A.17478

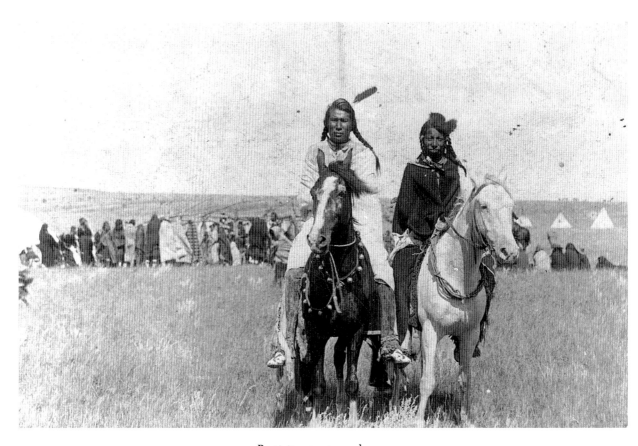

Participants at sun dance
NEAR FORT MACLEOD, AB / CA. 1886
GEORGE ANDERTON
PROVINCIAL ARCHIVES OF ALBERTA A.18696

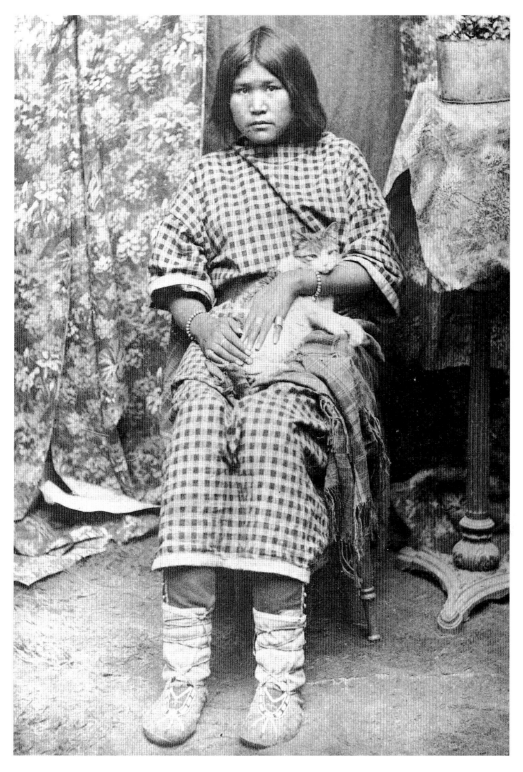

A young child with a cat is an attractive image in any society and any era.
This Blackfoot girl was photographed by George Anderton in Fort Macleod, Alberta, ca. 1884.

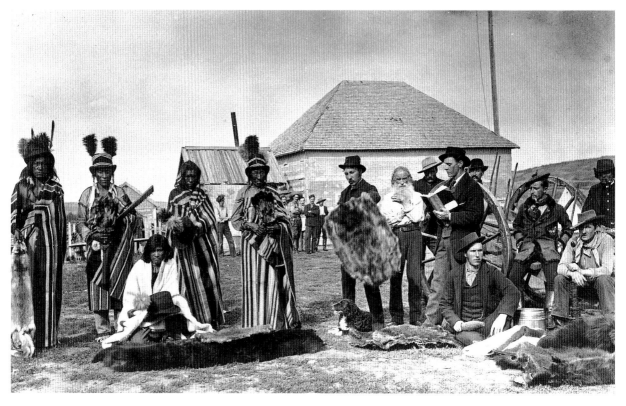

"Big Bear Trading at Fort Pitt, N.W.T."
The image includes (*left to right*) Four Sky Thunder, Sky Bird, Matoose (*seated*), Napasis, Big Bear,
Angus McKay (*holding fur*), Otto Dufresne, Louis Goulet, Stanley Simpson, Mr. Rowley (*seated*),
Alex McDonald (*behind wheel*), Capt. R.B. Sletch, Mr. Edmund (*seated*), and Henry Dufrain.

WESTCENTRAL SASKATCHEWAN / 1884

OTTO B. BUELL

NATIONAL ARCHIVES OF CANADA PA118768

"Indians on the Trail"
NEAR MEDICINE HAT, AB / 1883-84
GEORGE ANDERTON
PROVINCIAL ARCHIVES OF ALBERTA A.18849

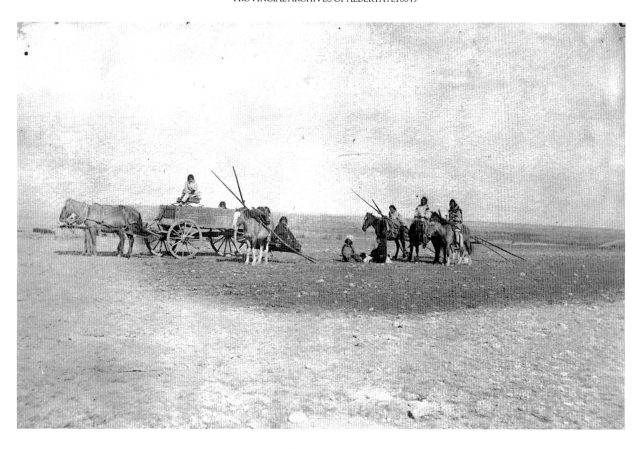

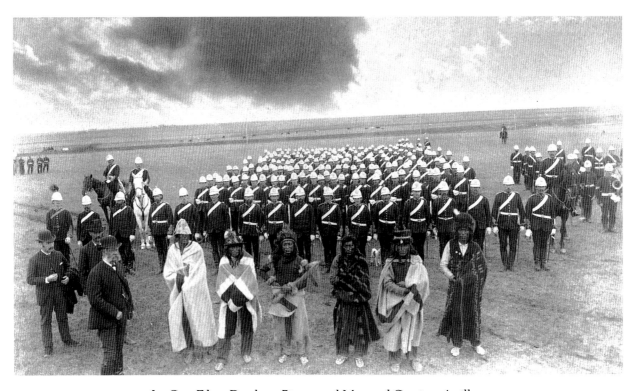

Lt. Gov. Edgar Dewdney, Piapot, and Montreal Garrison Artillery

REGINA, SK / MAY 1885

OTTO B. BUELL

NATIONAL ARCHIVES OF CANADA PA118775

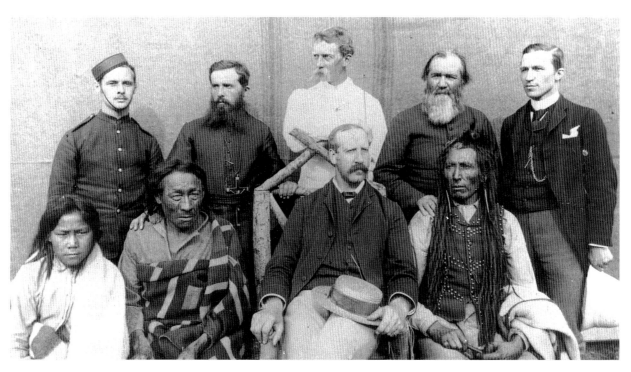

*A group of North-West Rebellion participants from both sides, including
(back row, from left) Constable Black, Louis Cochin, Inspector R.B. Deane, Alexis André, and
Beverly Robertson; (front row) Horse Child, Big Bear, Alexander Stewart, and Poundmaker*

REGINA, SK / MAY 1885

OTTO B. BUELL

NATIONAL ARCHIVES OF CANADA C1872

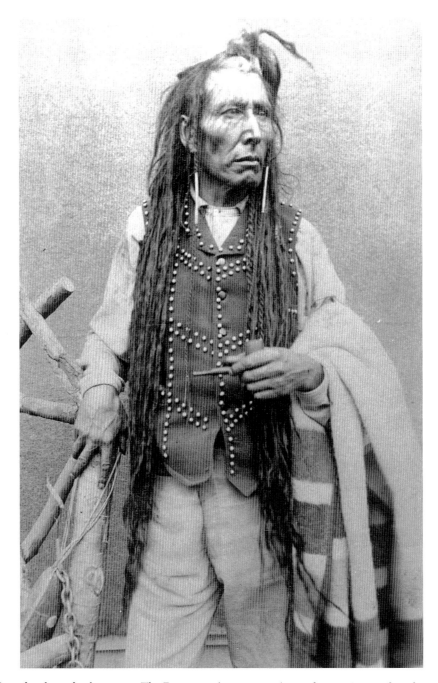

Poundmaker, also known as The Drummer (ca. 1842-86), was born a Stoney, but through his mother's family became associated with a Cree band near Battleford, Saskatchewan. Originally opposed to Treaty No 6 in 1876, he later signed, but his disgruntlement with government inaction on Indian needs was made evident when his band ransacked Battleford in 1885. Poundmaker was eventually tried for treason and sentenced to prison. He died in 1886 while visiting his adoptive father, Crowfoot, on the Blackfoot Reserve.

OTTO B. BUELL

REGINA, SK / 1885

CANADIAN PACIFIC LIMITED 8615

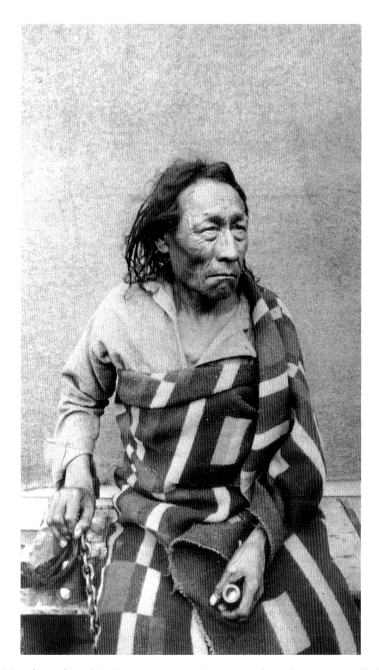

*Mistahimaskwa (Big Bear, ca. 1825-88) was an independent, strong-willed
Plains Cree chief. Determined that his people should be able to live where they wanted
to live, as in the past, he refused to sign Treaty No 6 because he thought
the conditions of the agreement left the fate of the Native people in the hands of
the government. Many of his band, including his eldest son Imasis, took part in the
1885 Frog Lake Massacre. Tried for treason in 1885, Big Bear was found guilty
and given a three-year sentence. He died in 1888. This photograph was taken during his trial,
outside the NWMP barracks in Regina, Saskatchewan.*

OTTO B. BUELL

NATIONAL ARCHIVES OF CANADA C-1873

Indian cemetery (Cree)
FORT QU'APPELLE, SK / MAY 1885
OTTO B. BUELL
NATIONAL ARCHIVES OF CANADA PA118766

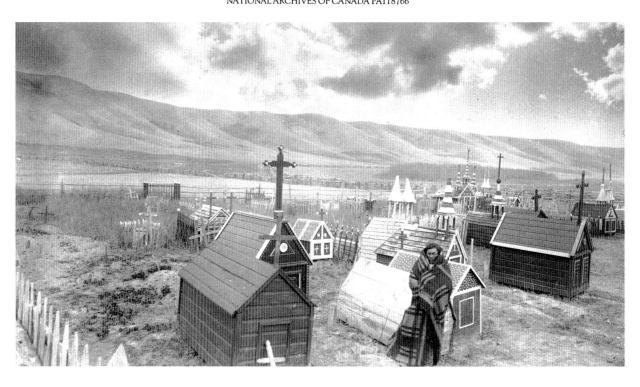

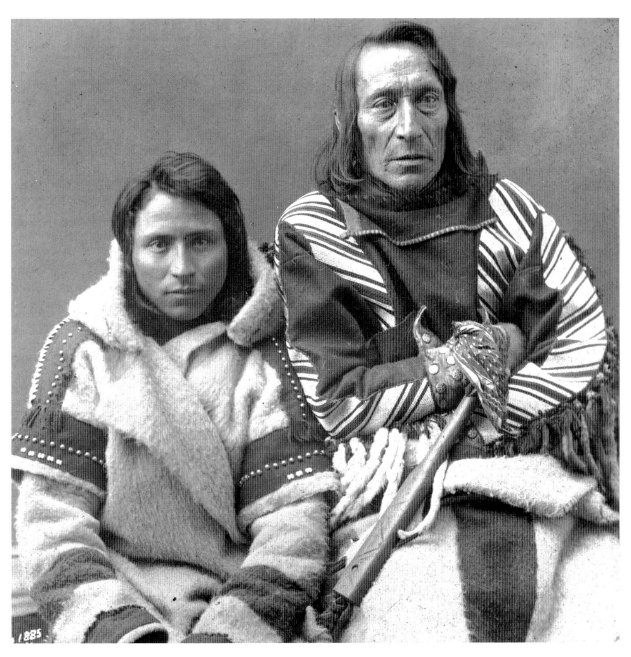

Chief Bobtail and son (Cree)
LOCATION UNKNOWN / 1885
OTTO B. BUELL
NATIONAL ARCHIVES OF CANADA PA66537

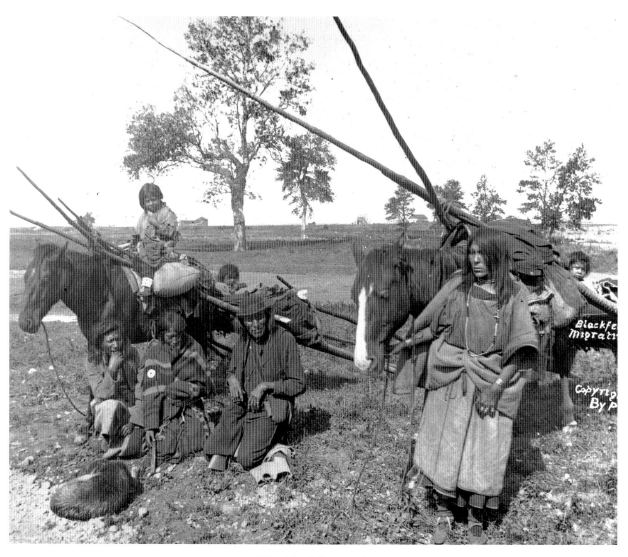

"Blackfeet Migrating"
BLACKFOOT CROSSING ON THE BOW RIVER, SOUTHERN ALBERTA / CA. 1885
OTTO B. BUELL
NATIONAL ARCHIVES OF CANADA PA66536

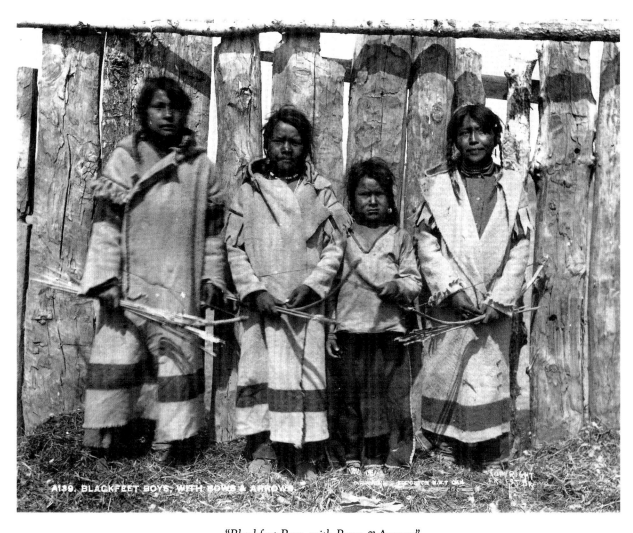

"Blackfeet Boys, with Bows & Arrows"
NORTH CAMP, BLACKFOOT RESERVE, SOUTHERN ALBERTA / 1887–88
BOORNE & MAY
PROVINCIAL ARCHIVES OF ALBERTA B.34

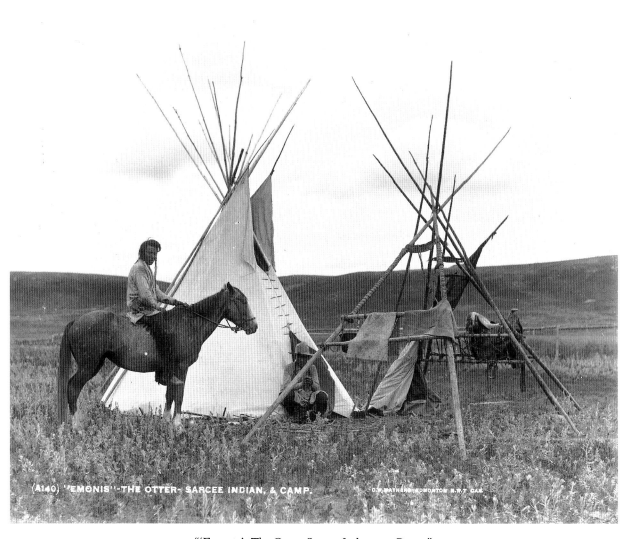

"'Emonis'–The Otter–Sarcee Indian, & Camp"
NEAR CALGARY, AB / 1887-88
BOORNE & MAY
PROVINCIAL ARCHIVES OF ALBERTA B.33

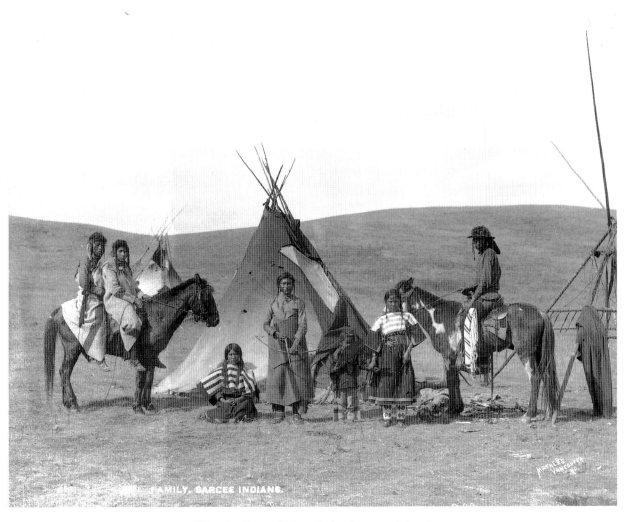

"Family. Sarcee Indians"–Astokumi and family
The Sarcee are now known by their old name—the name they always used themselves—Tsuu T'Ina. It means
The Beaver People, which acknowledges their connection to the Beaver Clan of the northern Dene.

NEAR CALGARY, AB / 1887-88

BOORNE & MAY

PROVINCIAL ARCHIVES OF ALBERTA B.49

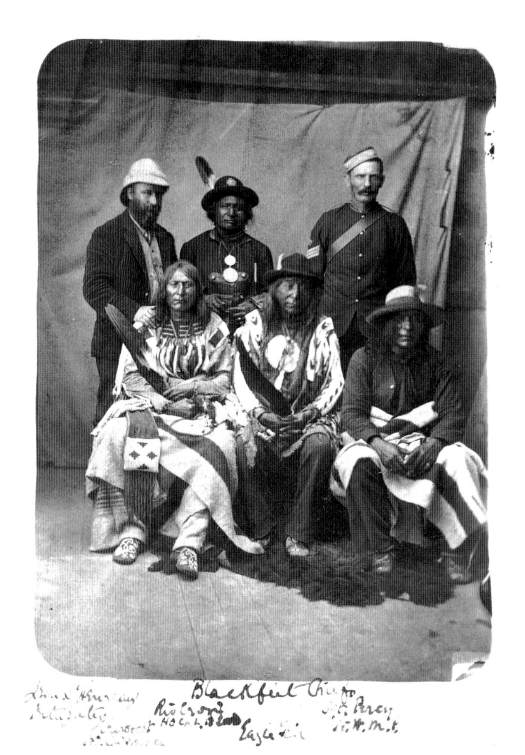

*(Back row, from left) Jean L'Heureux, Red Crow, and Sgt. Percy;
(front row) Crowfoot, Eagle Tail, and Three Bulls–enroute to Ottawa*

CALGARY, AB / SEPTEMBER 1886

GEORGE ANDERTON

PROVINCIAL ARCHIVES OF ALBERTA A.16120

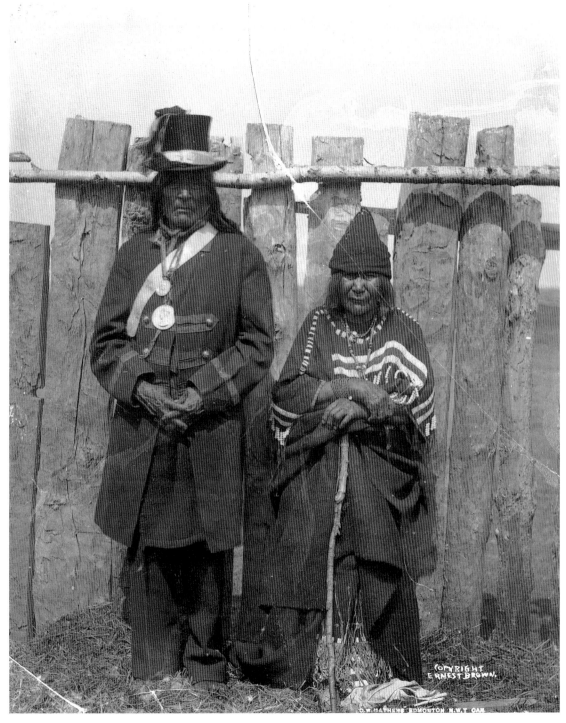

"'Old Sun,' Blackfeet Chief, & Squaw."
Old Sun, who shared power with Crowfoot, was a lesser known head chief and patriarch of the Blackfoot.
NORTH CAMP, BLACKFOOT RESERVE, SOUTHERN ALBERTA / 1887-88
BOORNE & MAY
PROVINCIAL ARCHIVES OF ALBERTA B.1035

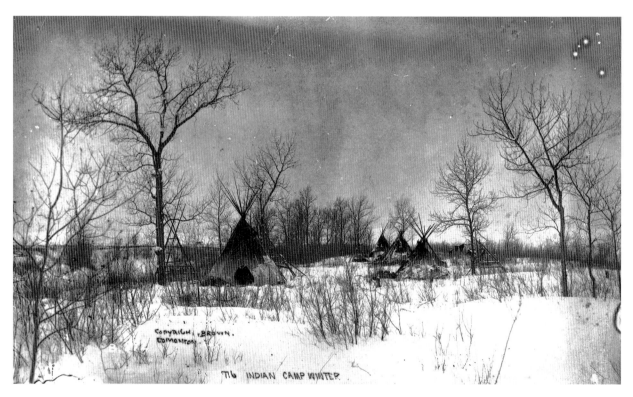

"Indian Camp, Winter"
ON THE ELBOW RIVER NEAR CALGARY, AB / 1887–88
BOORNE & MAY
PROVINCIAL ARCHIVES OF ALBERTA B.872

"Indian Pow Wow" (Assiniboine)
MOOSOMIN, SK / 17 JUNE 1889
FREDERICK STEELE
PROVINCIAL ARCHIVES OF BRITISH COLUMBIA B-199

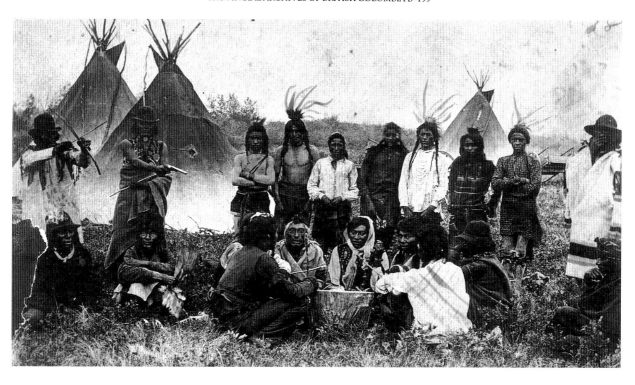

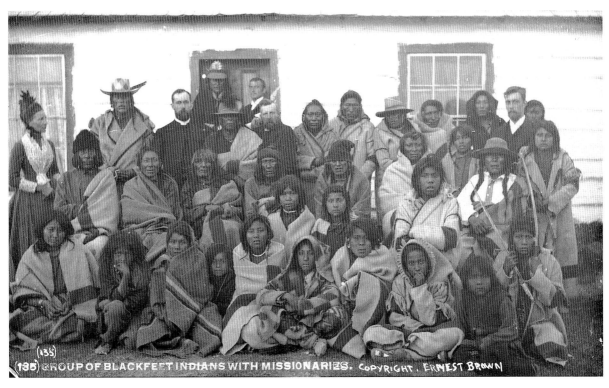

"Group of Blackfeet Indians With Missionaries"

BLACKFOOT RESERVE, SOUTHERN ALBERTA / 1887-88

BOORNE & MAY

PROVINCIAL ARCHIVES OF ALBERTA B.846

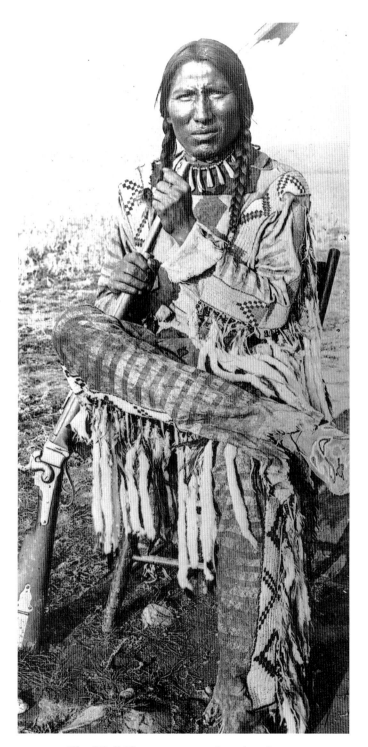

Chief Bull Plume in a somewhat absurd pose,
legs crossed on a chair on the open prairie
PIEGAN RESERVE, NEAR FORT MACLEOD, AB / 1880S
PHOTOGRAPHER UNKNOWN
PROVINCIAL ARCHIVES OF ALBERTA OB.8885

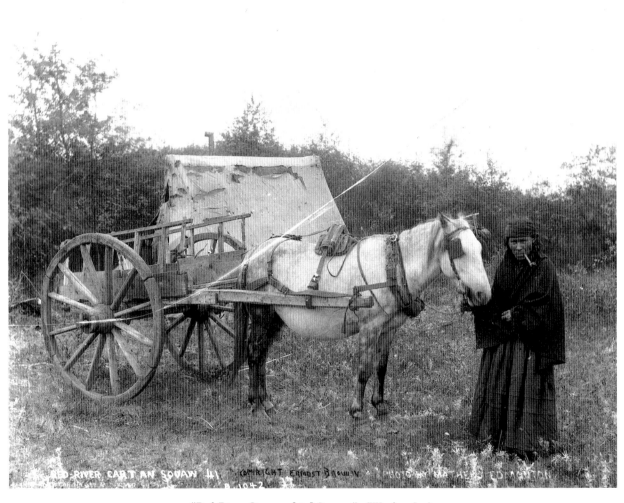

"Red River Cart an [sic] Squaw"–(Washee Joe)
NEAR EDMONTON, AB / 1895-98
CHARLES W. MATHERS
PROVINCIAL ARCHIVES OF ALBERTA B.1042

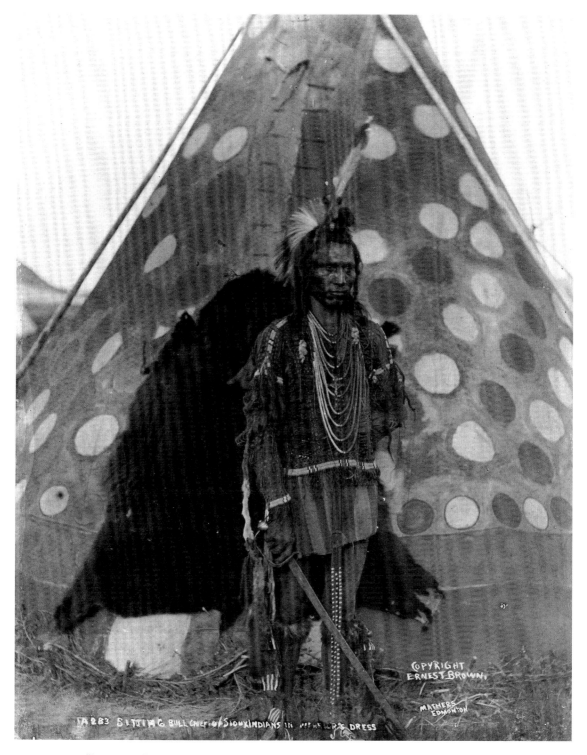

"Sitting Bull, Chief of Sioux Indians in Warrior's Dress"–(actually Sleeping Bull)

NEAR EDMONTON, AB / 1895-98

CHARLES W. MATHERS

PROVINCIAL ARCHIVES OF ALBERTA B.1040

"Ceremony of Erecting Sundance Lodge"
PIEGAN RESERVE, BROCKET, AB / CA. 1910
HARRY POLLARD
PROVINCIAL ARCHIVES OF ALBERTA P.49

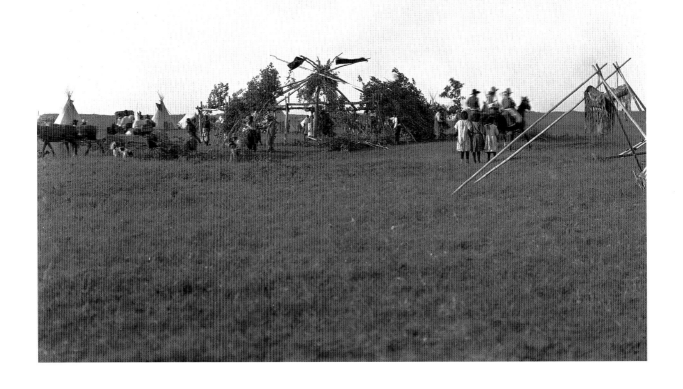

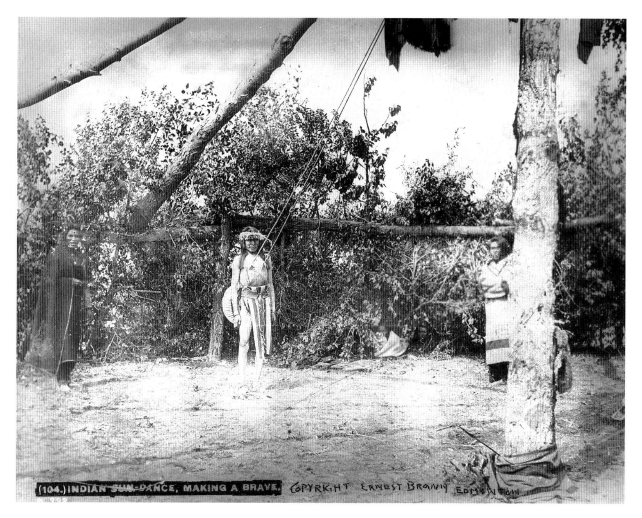

"Indian Sun-Dance, Making a Brave"
The sun dance (actually a corruption of the true Indian term *Okon*) was an annual gathering
of a band during which individual members could either be initiated into or renew their adherence
to the spiritual mysteries. There were a number of ceremonies conducted over several days,
all within a medicine lodge. The most dramatic ceremony was the brave-making,
wherein a young male underwent the initiation of pain (the ripping of skin on his chest)
in order to demonstrate his bravery and hence be admitted into the select group of warriors.
In 1880 the Canadian government declared the entire sun dance illegal, but in defiance of the law,
First Nations people continued to gather for the ceremonies, and do so to the present day,
although it is no longer illegal.

BLOOD RESERVE NEAR FORT MACLEOD, AB / 31 JULY 1886

BOORNE & MAY

PROVINCIAL ARCHIVES OF ALBERTA B.998

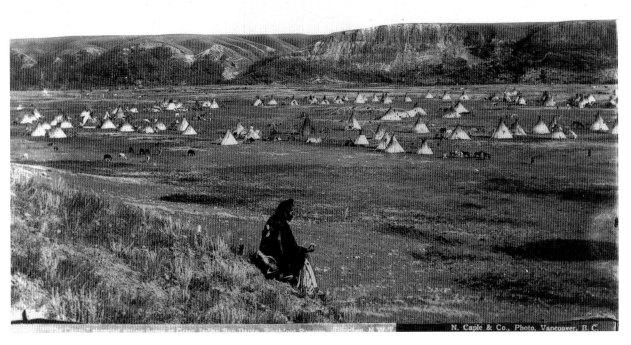

"'The Camp,' showing sitting figure at Great Indian Sun Dance, Blackfoot Reserve, Gleichen, N.W.T."
SOUTHERN ALBERTA / 1890s
NORMAN CAPLE
CITY OF VANCOUVER ARCHIVES IN.P.83, N.132

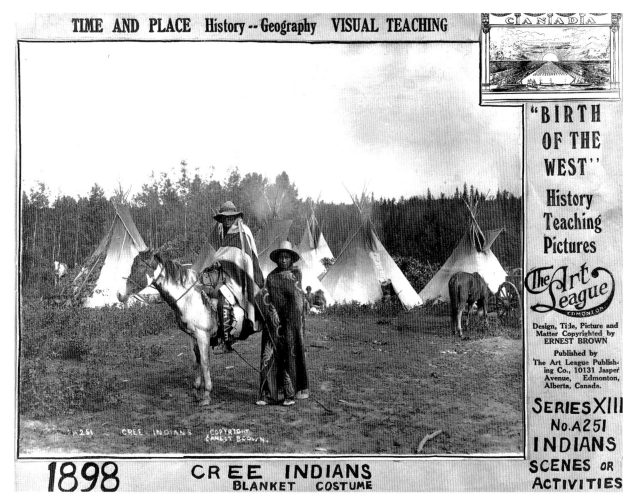

TIME AND PLACE History -- Geography VISUAL TEACHING

CANADA

"BIRTH OF THE WEST"

History Teaching Pictures

The Art League
EDMONTON

Design, Title, Picture and Matter Copyrighted by
ERNEST BROWN

Published by
The Art League Publishing Co., 10131 Jasper Avenue, Edmonton, Alberta, Canada.

Series XIII
No. A251
INDIANS
SCENES OR ACTIVITIES

A251 CREE INDIANS COPYRIGHT ERNEST BROWN.

1898 CREE INDIANS
BLANKET COSTUME

"Cree Indians, Blanket Costume"
LOCATION UNKNOWN
ORIGINAL IMAGE, 1890S, BY CHARLES MATHERS
MOCKUP, 1920S, BY ERNEST BROWN FOR "BIRTH OF THE WEST" TEACHING SERIES
PROVINCIAL ARCHIVES OF ALBERTA B.10594

"Cree Grass Dance, Beardy's Warriors, (of Duck Lake Fight, Northwest Rebellion)"
CENTRAL SASKATCHEWAN / 1891-92
FREDERICK STEELE
SASKATCHEWAN ARCHIVES BOARD R-B 980

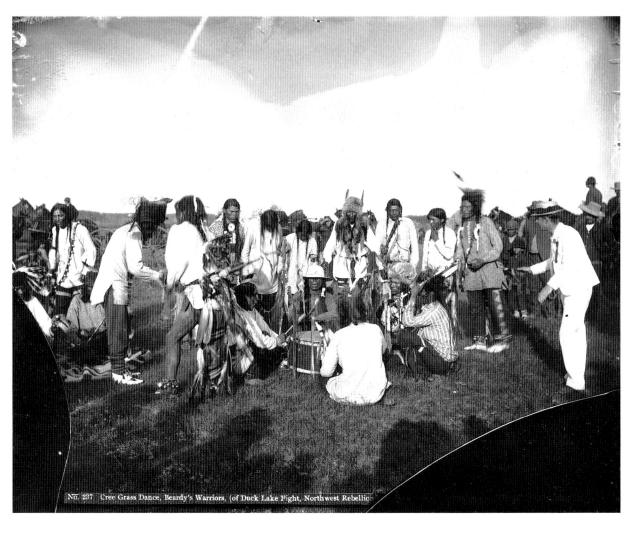

No. 237 Cree Grass Dance, Beardy's Warriors, (of Duck Lake Fight, Northwest Rebellion)

"Indian Tom-Tom Drummers at a Tea Dance"
NEAR EDMONTON, AB / 1896-99
CHARLES W. MATHERS
PROVINCIAL ARCHIVES OF ALBERTA B.977

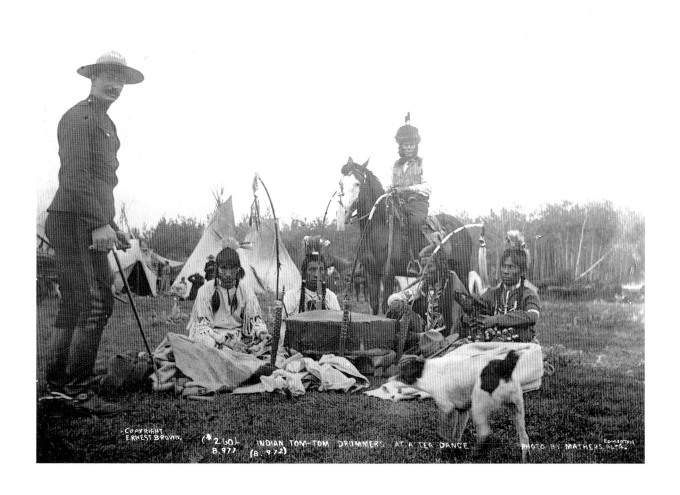

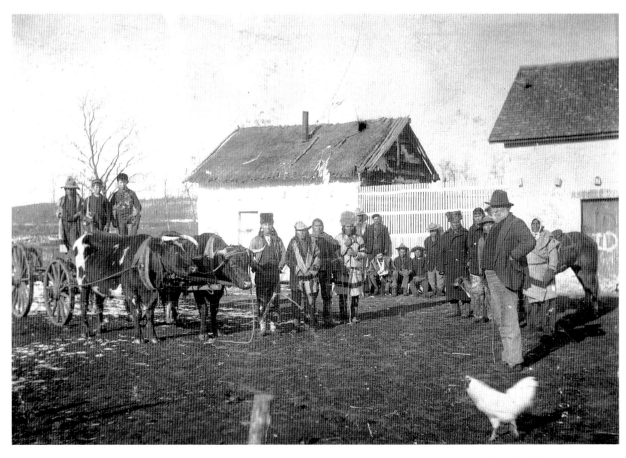

Indians with team of oxen visiting white settlers in the Battleford district, westcentral Saskatchewan
1890s
PHOTOGRAPHER UNKNOWN
SASKATCHEWAN ARCHIVES BOARD R–B 2839 P.27

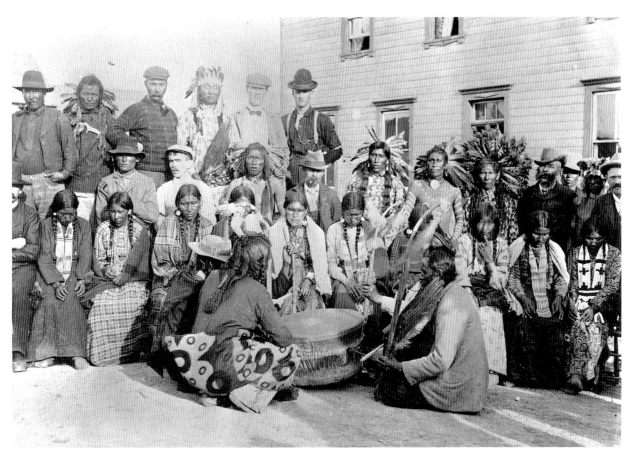

Indian gathering in Broadview, SK
1890s
DUFFIN & CO.
SASKATCHEWAN ARCHIVES BOARD R-A 18923

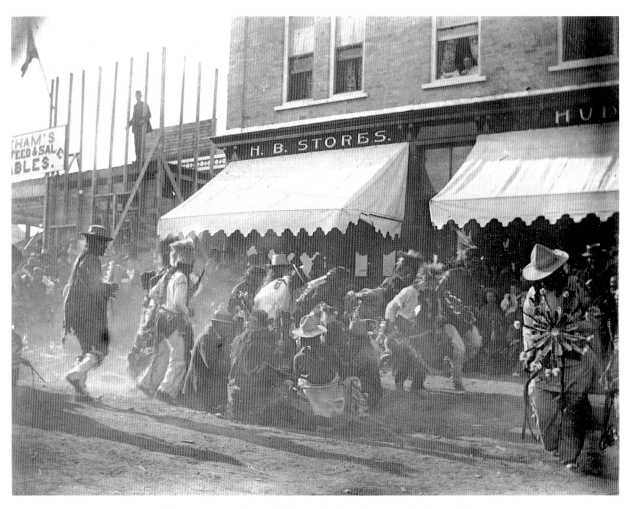

Indian dance in front of Hudson's Bay Co. store, Yorkton, SK
CA. 1900
PHOTOGRAPHER UNKNOWN
SASKATCHEWAN ARCHIVES BOARD R-A 4351

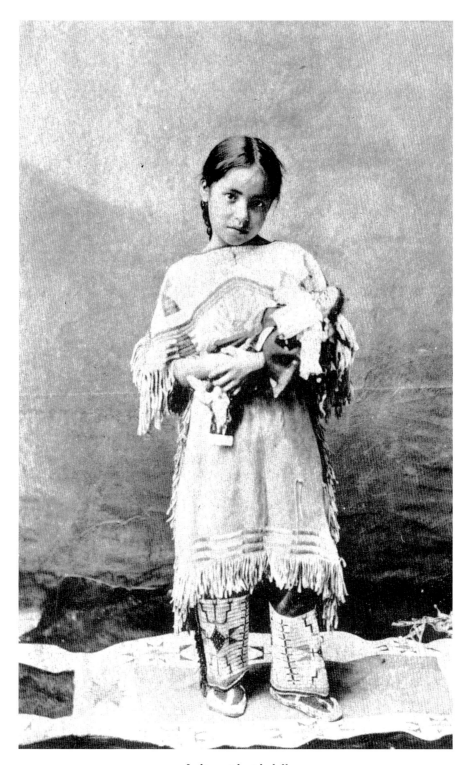

Indian girl with doll
LOCATION UNKNOWN / CA. 1900
PHOTOGRAPHER UNKNOWN
SASKATCHEWAN ARCHIVES BOARD R-A 22212

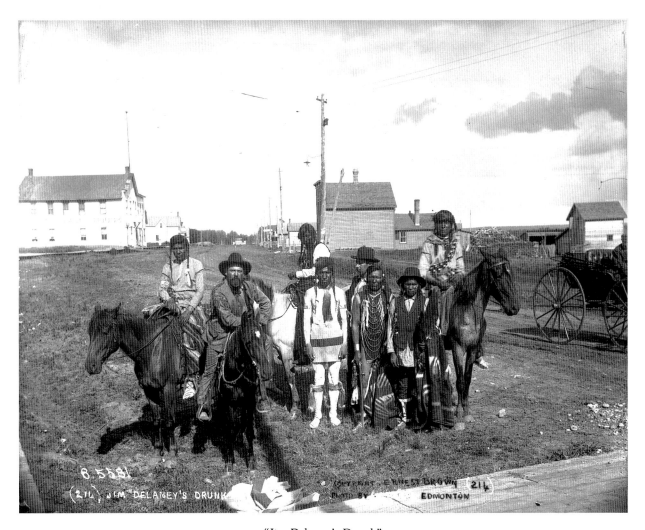

"Jim Delaney's Drunk"
Jim Delaney was a trader who regularly plied the Edson Trail. In recognition of the assistance
he received from his Indian guides on one particularly profitable trip, Delaney held
a thank-you barbeque for them, roasting an entire cow on Jasper Avenue.
Mathers's title is deliberately ironic as not a drop of alcohol was consumed that day.

EDMONTON, AB / 1902

CHARLES W. MATHERS

PROVINCIAL ARCHIVES OF ALBERTA B.5581

A Dying Race

In the final two decades of the nineteenth century, a theory developed amongst white society that the Indians were a dying race. This was most likely due to the prevalence of the idea of social Darwinism combined with the observed inability of the First Nations people to adapt to the technologically superior society moving into their territory.

With the influx of white settlers into western Canada, and the decline of the Indian population in reaction to disease, alcohol, and government mistreatment and neglect, the Native presence was definitely becoming less significant. Yet the Indian race was never really in danger of extinction. Census figures show that although numbers declined between 1880 and 1918, they started to increase by the beginning of the 1920s and have climbed steadily ever since.

White Canadians were quick to realize that the Native people were no longer a threat to them, and consequently felt safe in admiring many aspects of their existence. Thus developed the urge to capture a record of the "famous" Indian leaders for posterity, and "representative" Indians for anthropological purposes.

Professional photographers brought the notables into their studios and made character studies. These occasionally saw wide distribution, especially if the subject was involved in the treaty signings of 1876 and 1877, or was a participant in the North-West Rebellion of 1885.

For anthropologists, the photograph was considered a powerful scientific document. It was seen as significantly more accurate than written descriptions or artists' conceptions, and could communicate, they felt, in an objective manner a discovery or theory about a culture or religion. Yet, in many cases, an anthropologist's photograph could establish as ostensible fact what actually was not fact. As Melissa Banta and Curtis M. Nisley wrote in *From Site to Sight*: "Armed with a camera, anthropologists can prove, scan, magnify, reduce, isolate, contrast, debase or idealize their subjects. Through photography, they can create, disseminate, and forever seal in time their own interpretations of mankind." (p. 23)

The immediate post-Rebellion period saw the beginnings of western Canadian tourism, with the Canadian Pacific Railway in the vanguard. In order to attract visitors, the CPR bombarded potential customers with interesting images of those parts of the country it passed through that were unique or out of the ordinary. Numerous photographers and painters were given free passes on the railway in return for striking depictions of the flat plains, the mountains, the lakes, the waterfalls, even the trestle bridges and hotels. Equally unique, and of interest to eastern Canadians, Americans, and Europeans, were the images of Native people included in the CPR's promotional pamphlets and posters.

Of course, not everyone interested in Indian photographs could travel to the Prairies to see the exotic, soon-to-be-extinct race. To answer the demand, photographers started to market their images of Native people in the form of portfolios, postcards, and magazine illustrations. And so began the widespread commercialization of First Nations people.

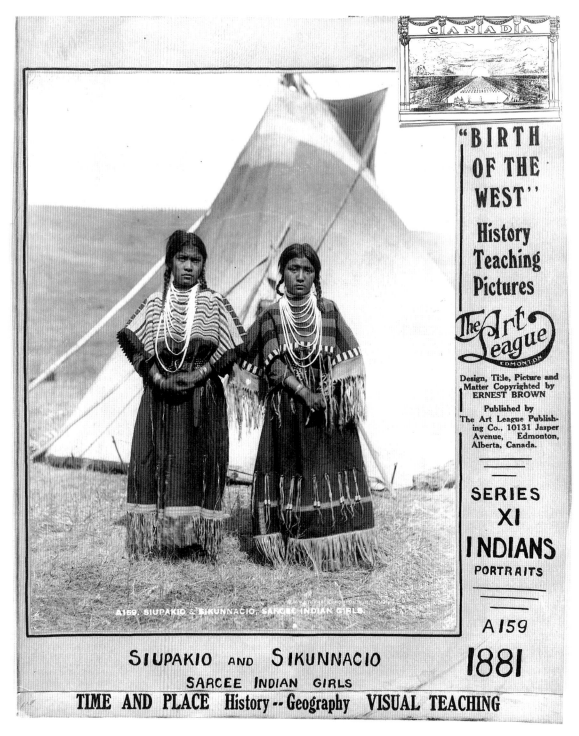

CANADA

"BIRTH OF THE WEST" History Teaching Pictures

The Art League
EDMONTON

Design, Title, Picture and Matter Copyrighted by ERNEST BROWN

Published by The Art League Publishing Co., 10131 Jasper Avenue, Edmonton, Alberta, Canada.

SERIES XI INDIANS PORTRAITS

A159

1881

A159. SIUPAKIO & SIKUNNACIO, SARCEE INDIAN GIRLS.

SIUPAKIO AND SIKUNNACIO
SARCEE INDIAN GIRLS
TIME AND PLACE History -- Geography VISUAL TEACHING

"Siupakio & Sikunnacio, Sarcee Indian Girls"
NEAR CALGARY, AB
ORIGINAL IMAGE, 1887-88, BY BOORNE & MAY
MOCKUP, 1920S, BY ERNEST BROWN FOR "BIRTH OF THE WEST" TEACHING SERIES
PROVINCIAL ARCHIVES OF ALBERTA B.10595

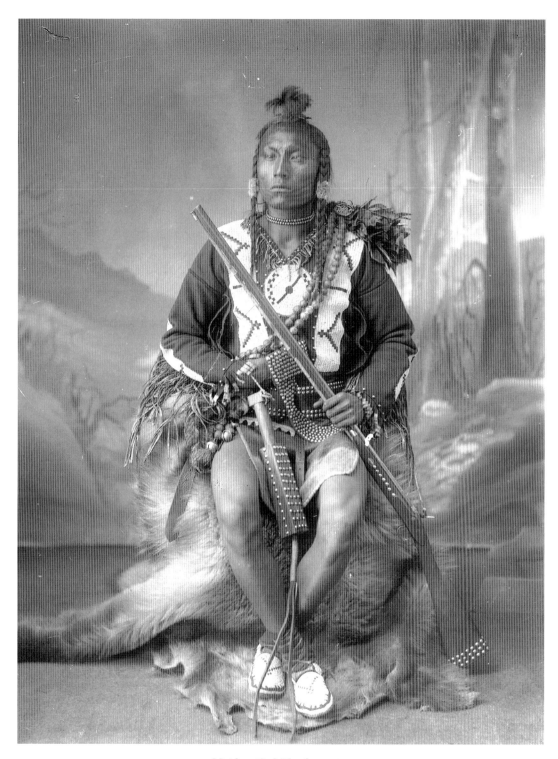

Unidentified Blood warrior
CALGARY, AB / CA. 1885
ALEX J. ROSS
PROVINCIAL ARCHIVES OF ALBERTA P.85

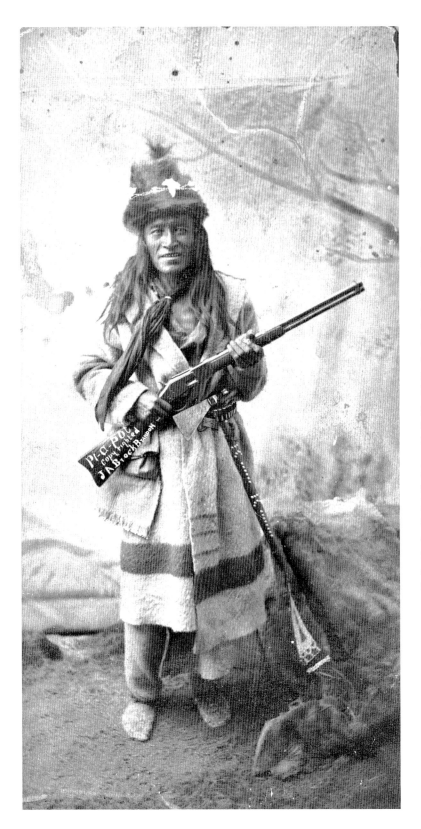

An almost candid portrait of Cree
chief Piapot (or Pie-a-pot) captured by
J.A. Brock in Regina, Saskatchewan,
ca. 1886. Based in Brandon, Brock was
touring Saskatchewan compiling a se-
ries of views and portraits connected
with the North-West Rebellion. Piapot
was notable for not participating in the
uprising, although he developed a trou-
blesome reputation for his reluctance to
pick out a reserve and settle down. He
also had a sarcastic tongue; in 1895 he
included these comments in a speech:
"In order to become sole masters of our
land they relegated us to small reserva-
tions as big as my hand and made us
long promises, as long as my arm. But
the next year the promises were shorter,
and get shorter every year until now
they are about the length of my finger,
and they keep only half of that."
SASKATCHEWAN ARCHIVES BOARD R-B 1444

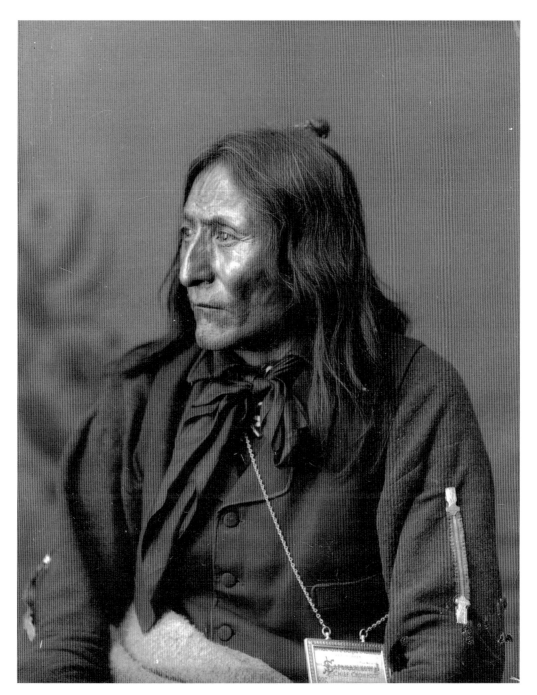

*A fine portrait of Isapo-Muxika (Crowfoot) taken by Calgary photographer Alex J. Ross in 1886.
Isapo-Muxika was born a Blood Indian ca. 1830 and earned his reputation as a warrior, taking
part in nineteen tribal battles over the course of which he was wounded six times.
Rising to the Blackfoot chieftainship in 1870, he immediately initiated a peace strategy,
patching relations with the Cree—the Blackfoot's traditional enemies—establishing good relations
with Father Lacombe and the Catholic Church, and welcoming the North-West Mounted Police
to the Blackfoot territory. Isapo-Muxika died in 1890.*

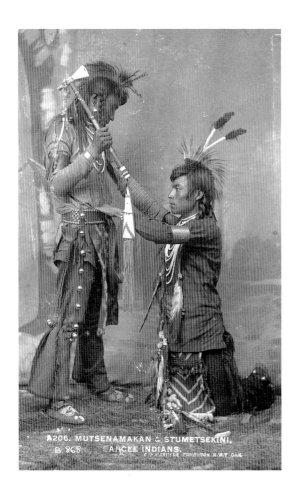

This staged portrait of Sarcee braves Mutsenamakan and Stumetsekini was taken by Ernest May of the Calgary firm Boorne & May in either 1887 or 1888.
PROVINCIAL ARCHIVES OF ALBERTA B.868

Blackfoot woman and papoose
CALGARY, AB / CA. 1885
ALEX J. ROSS
PROVINCIAL ARCHIVES OF ALBERTA
A.20694

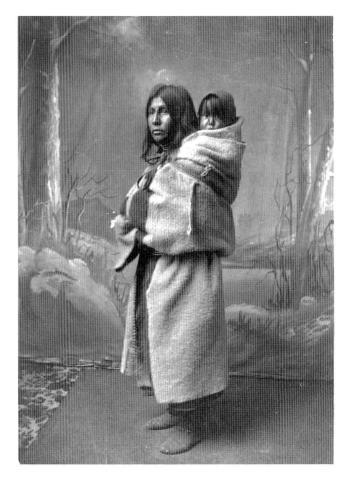

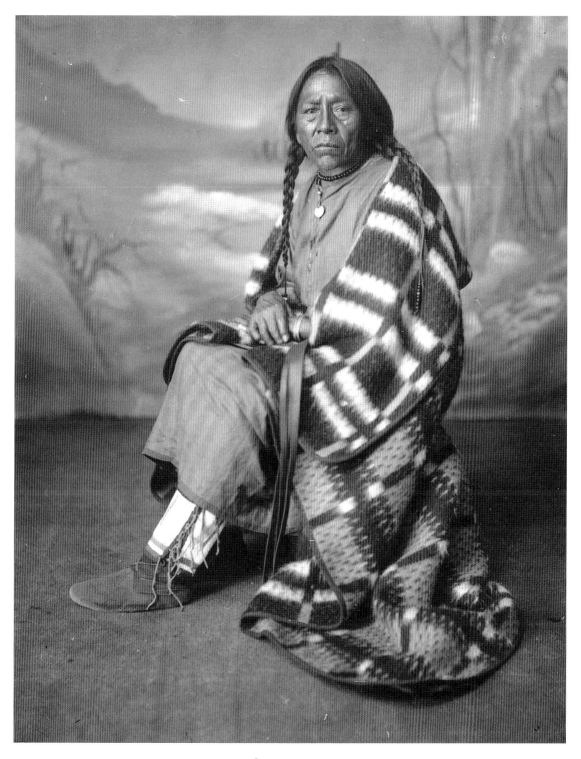

Sarcee woman
CALGARY, AB / 1885-86
ALEX J. ROSS
PROVINCIAL ARCHIVES OF ALBERTA P.86

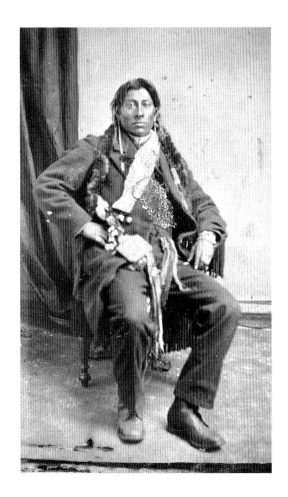

The photographs on these facing pages are from a series of unidentified portraits of prairie Indians by J.H. Doherty, an itinerant photographer who traveled throughout western Canada from about 1875 to 1885.

LOCATION UNKNOWN

SASKATCHEWAN ARCHIVES BOARD R-A 9500/left, 5; below, 3; facing page, 1

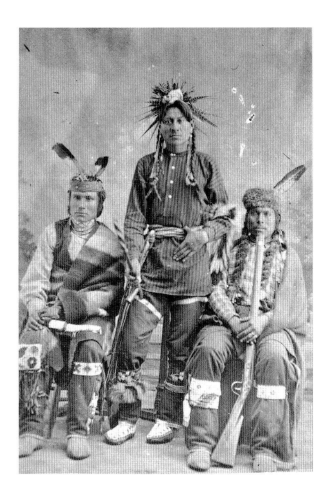

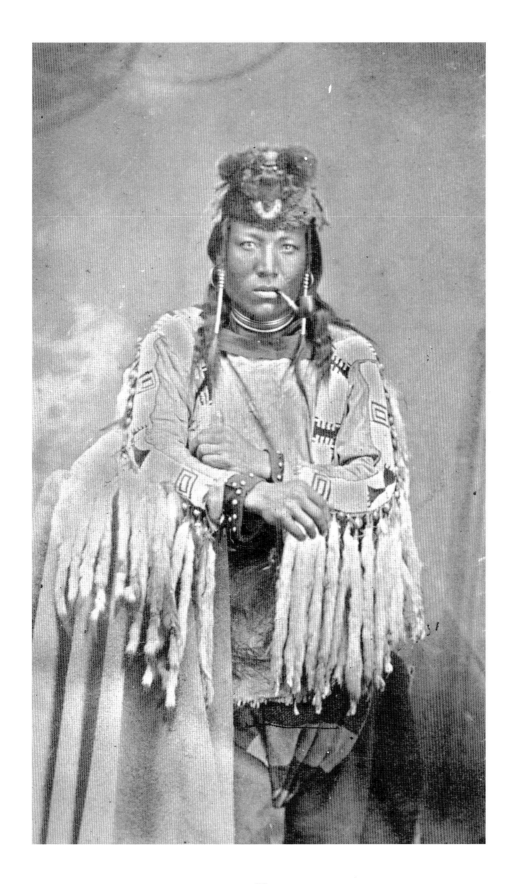

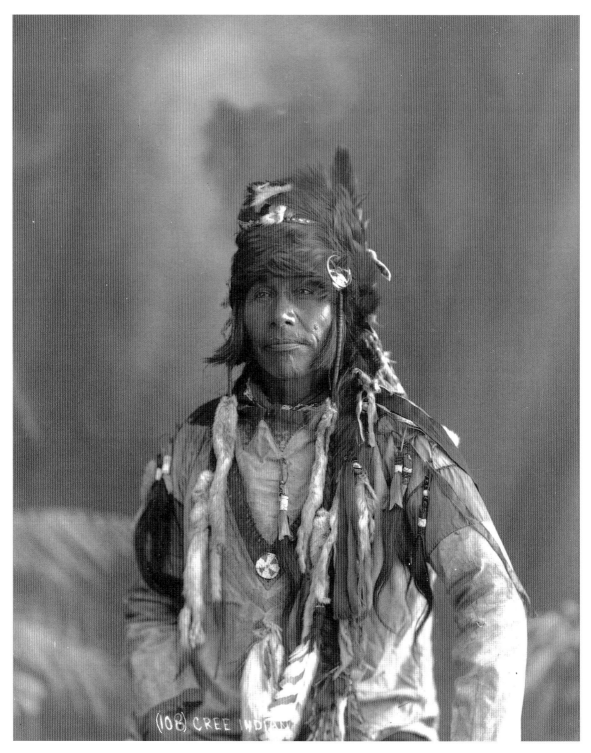

"Cree Indian"
EDMONTON, AB / 1890s
CHARLES W. MATHERS
PROVINCIAL ARCHIVES OF ALBERTA B.9

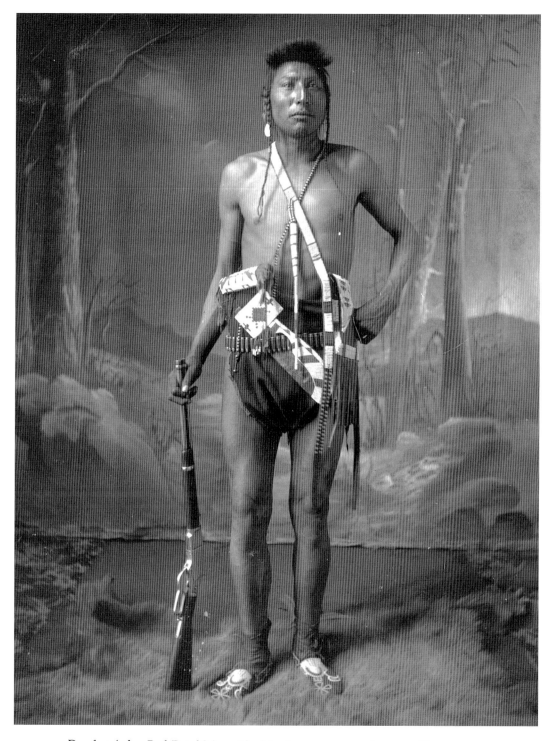

Deerfoot (a k a Bad Dried Meat–Blackfoot) was a renowned runner. The important north-south artery cutting through Calgary is called the Deerfoot Trail in his honor.

CALGARY, AB / 1885

ALEX J. ROSS

PROVINCIAL ARCHIVES OF ALBERTA P.133

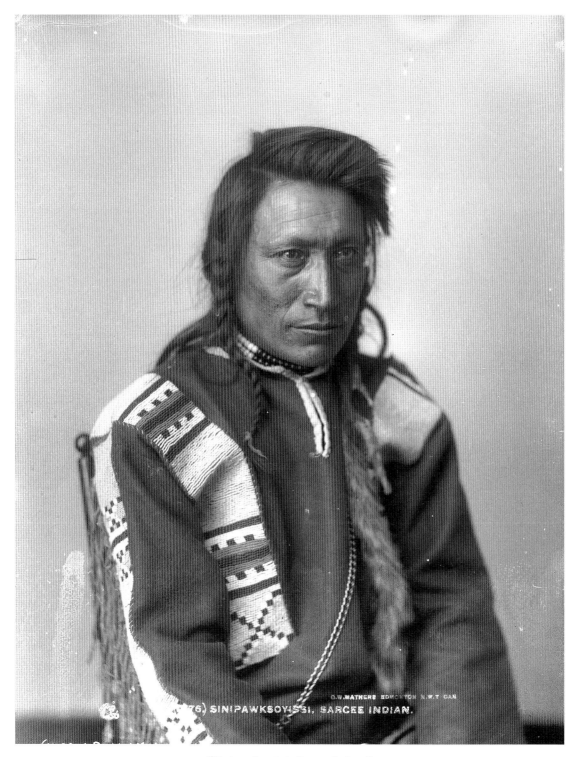

"Sinipawksoyissi, Sarcee Indian"
CALGARY, AB / 1887–88
BOORNE & MAY
PROVINCIAL ARCHIVES OF ALBERTA B.735

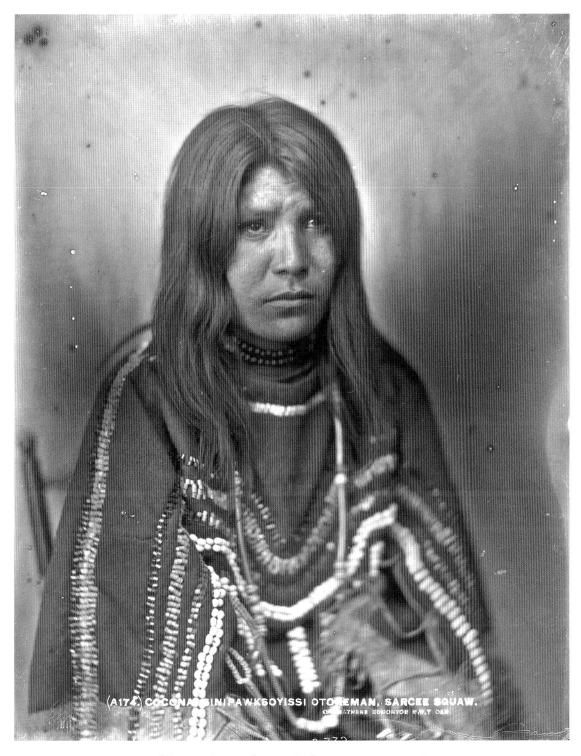

"Cocona, Sinipawksoyissi Otokeman, Sarcee Squaw"

CALGARY, AB / 1887–88

BOORNE & MAY

PROVINCIAL ARCHIVES OF ALBERTA B.732

"The Roaming Hunter Tribes, Warlike and Fierce"
NEAR EDMONTON, AB / 1890s
CHARLES W. MATHERS
PROVINCIAL ARCHIVES OF ALBERTA B.767

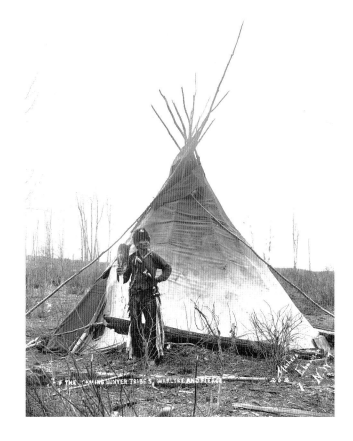

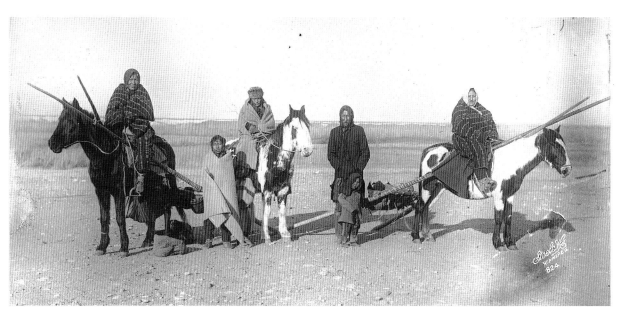

"Blood Indian Squaws, Papooses, Ponies and Travois, Macleod, Alberta"
1891
FREDERICK STEELE
SASKATCHEWAN ARCHIVES BOARD R-B 1346

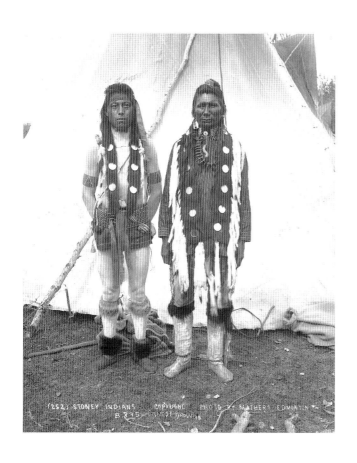

"Stoney Indians"
ALEXANDER OR PAUL RESERVES, CENTRAL ALBERTA / 1890S
CHARLES W. MATHERS
PROVINCIAL ARCHIVES OF ALBERTA B.895

"Two Cree Indians"
CALGARY, AB / 1887-88
BOORNE & MAY
PROVINCIAL ARCHIVES OF ALBERTA
B.843

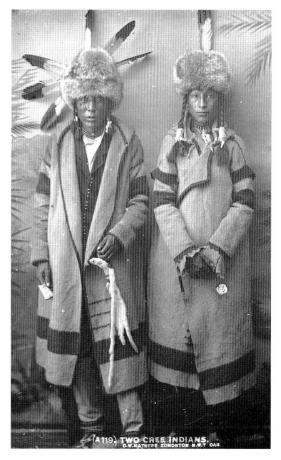

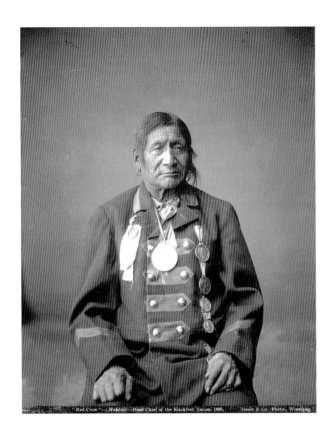

"Red Crow–(Makesto [sic])–Head Chief of the Blackfeet Nation, 1895"
Makeisto (ca. 1830-1900) was actually head chief of the Blood nation. Like his friend Crowfoot, he was a noted warrior in his younger years, and became chief in 1870. Also like Crowfoot, he was a signatory to Treaty No 7 in 1877, and while an advocate of friendly relations with white settlers, he was equally adamant that the Blood retain their customs and religion.
SOUTHERN ALBERTA
FREDERICK STEELE
SASKATCHEWAN ARCHIVES BOARD R-B 2274

"Piegan Indian Warrior–Acustie"
SOUTHERN ALBERTA / 1890S
FREDERICK STEELE
SASKATCHEWAN ARCHIVES BOARD R-B 2272

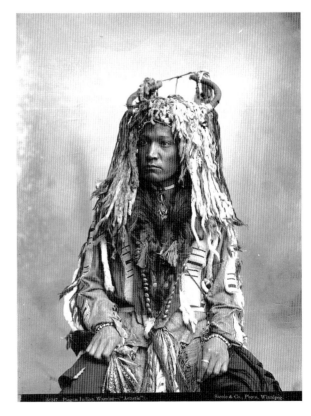

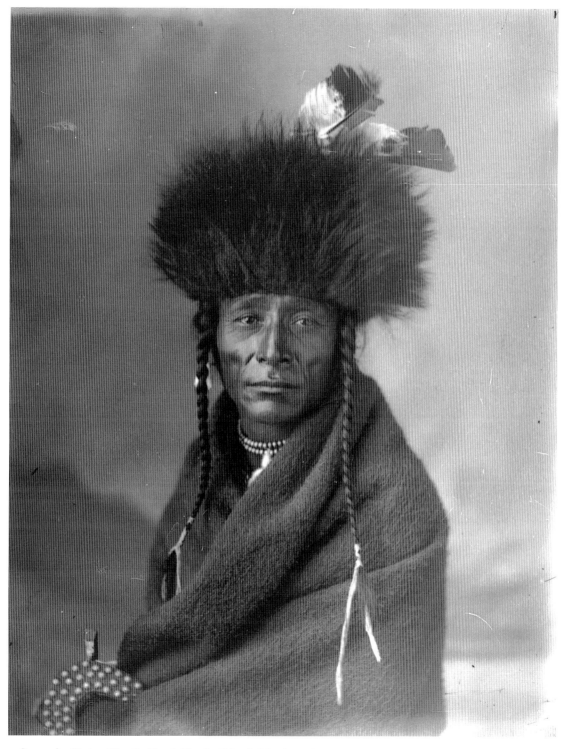

Sotanah–(Rainy Chief)–Head Chief of North Bloods and one of the signatories to Treaty No 7 in 1877
CALGARY, AB / 1885-86
ALEX J. ROSS
PROVINCIAL ARCHIVES OF ALBERTA P.93

"Crow Eagle–(Maesto Petah)–Chief
of North Piegan Indians, 1895"
SOUTHERN ALBERTA
FREDERICK STEELE
SASKATCHEWAN ARCHIVES BOARD R–B 2278

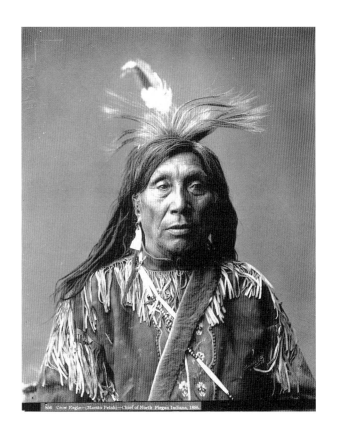

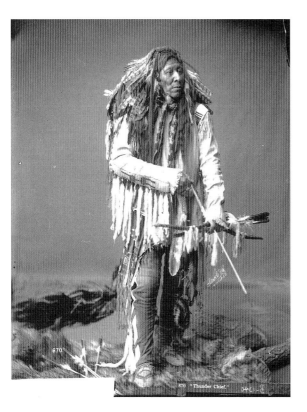

"Thunder Chief" (a k a Day Chief)
LOCATION UNKNOWN / 1895
FREDERICK STEELE
SASKATCHEWAN ARCHIVES BOARD R–B 1340

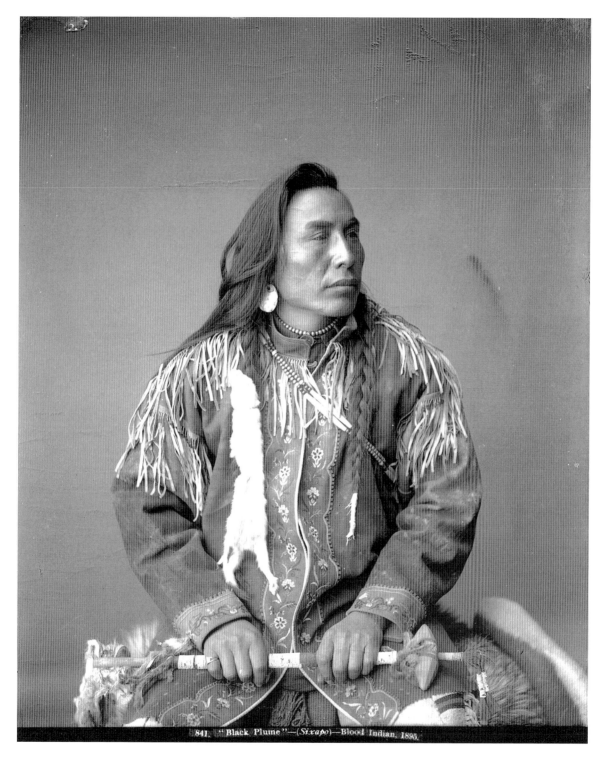

841. "Black Plume"—(*Sixapo*)—Blood Indian. 1895.

"Black Plume–Sixapo–Blood Indian"
SOUTHERN ALBERTA / 1895
FREDERICK STEELE
SASKATCHEWAN ARCHIVES BOARD R-B 1344

THE OLD ORIGINAL "RED RIVER" CART. THE NOBLE RED MAN IN FULL DRESS.

"The Old Original 'Red River' Cart" and "The Noble Red Man in Full Dress"—photogravure
reproduction from A Souvenir from the Edmonton District *(Edmonton: C.W. Mathers, 1897)*
CHARLES W. MATHERS
PROVINCIAL ARCHIVES OF ALBERTA 65.124/212

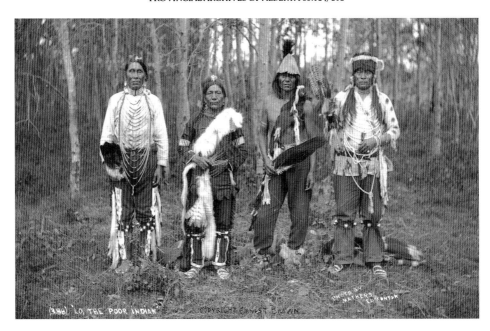

"Lo, The Poor Indian"–from a romantic poem by English poet Alexander Pope (1688–1744)
The full stanza reads "Lo, the poor Indian, whose untutor'd mind,
sees Gods in clouds or hears Him in the Wind."
NEAR EDMONTON, AB / 1890S
CHARLES W. MATHERS
PROVINCIAL ARCHIVES OF ALBERTA B.775

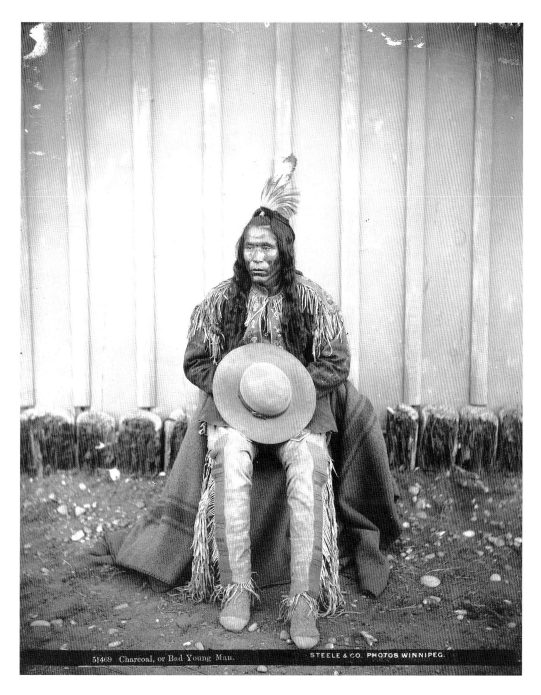

51469 Charcoal, or Bad Young Man.

STEELE & CO. PHOTOS WINNIPEG.

Sikokskitsis ("Charcoal, or Bad Young Man")–Blood
Charcoal (1856-97) first gained his violent reputation when he murdered his wife's lover.
Shortly afterwards he wounded a white farm instructor and a sergeant of the North-West Mounted Police,
which set off a concentrated manhunt. He was eventually captured, tried, and executed in March of 1897.
This may well be his final photograph, taken while he was in jail. The incongruous hat is hiding his handcuffs.

FORT MACLEOD, AB / CA. 1897

FREDERICK STEELE

SASKATCHEWAN ARCHIVES BOARD R-B 1350

Chief Abis-tos-quos
EDMONTON, AB / 1897
CHARLES W. MATHERS
CITY OF EDMONTON ARCHIVES EB-10-38

*"'Pointed Cap,' Cree Indian, with his fifth squaw, 1898.
Reputed age 105 years."*
In his book *A Trip to the Rockies*, Lord Southesk
mentions meeting Pointed Cap at Qu'Appelle,
alluding to him as "that old grumbler."
FILE HILLS RESERVE, SOUTHERN SASKATCHEWAN
PHOTOGRAPHER UNKNOWN
CITY OF VANCOUVER ARCHIVES IN.P.21, N-120

'Pointed Cap', Cree Indian, with his fifth squaw, 1898. Reputed age 105 years. Photo taken File Hills
Sask. about 1898. Lord Southesk, in his book, "A Trip to the Rockies" mentions meet-
ing him at Qu'Appelle, and alludes to him as "that old grumbler". This photo was reproduced in "Scarl
and Gold" some years prior to 1925. Royal North West Mounted Police". Photo presented by George
Guernsey, Esq. Police Magistrate, Penticton, B.C. In. N. P. 21. City Archives, J.S.M.

Three Cree women
PRINCE ALBERT, SK / CA. 1900
WILLIAM J. JAMES
SASKATCHEWAN ARCHIVES BOARD R-B 1627

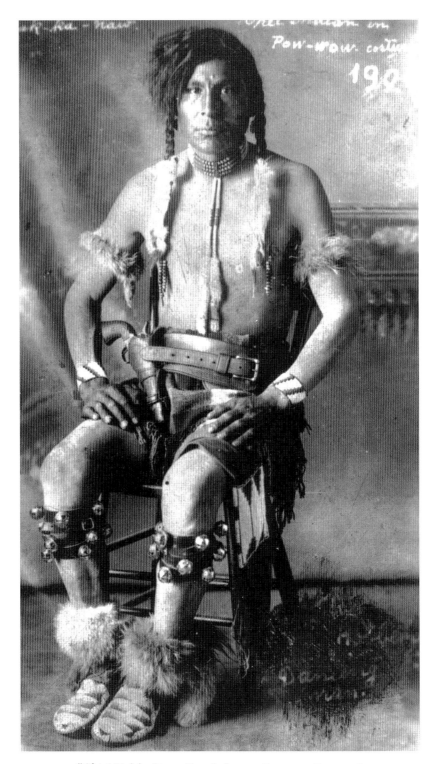

"Chief Nak-ka-Naw: Cree Indian in Pow-wow Costume"

CREE RESERVE, HOBBEMA, AB / 1900

PHOTOGRAPHER UNKNOWN

PROVINCIAL ARCHIVES OF ALBERTA OB.11129

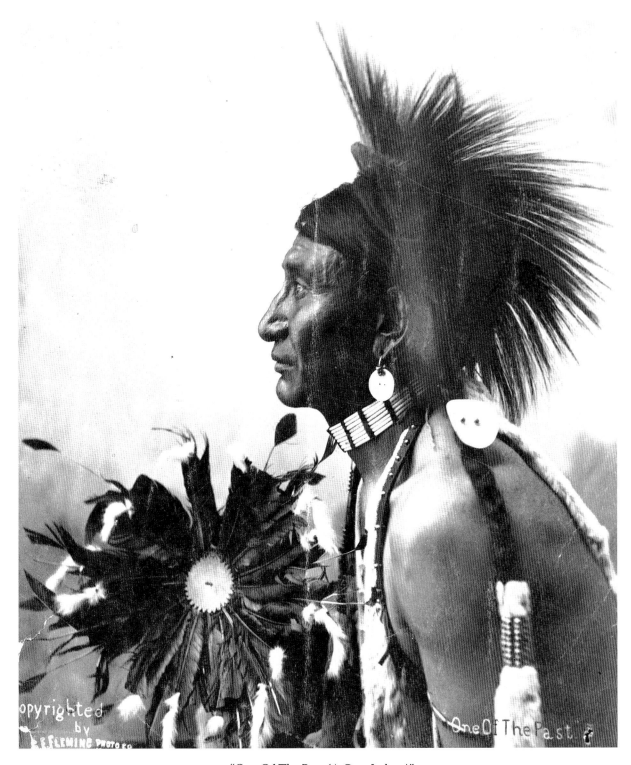

"One Of The Past (A Cree Indian)"
MAPLE CREEK, SK / CA. 1900
GEORGE E. FLEMING
SASKATCHEWAN ARCHIVES BOARD R–B 9206

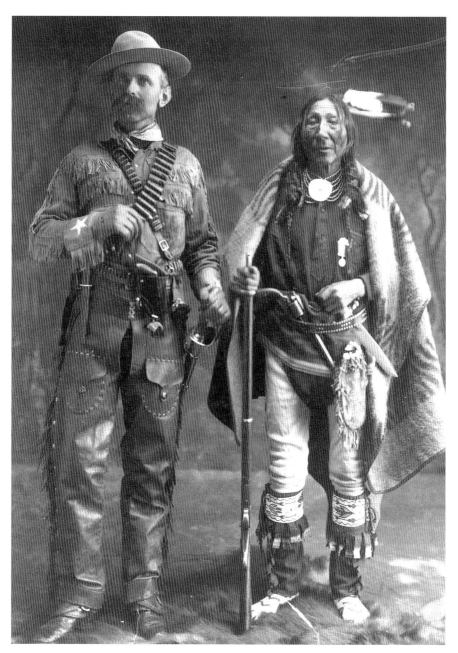

"Gentleman Joe" Mackay and Chief Mistawasis (a k a Big Child)
Mackay was responsible for the first death in the North-West Rebellion, shooting
Gabriel Dumont's brother. Cree chief Mistawasis wisely chose not to get involved on either side.
Mistawasis was a polygamist who embraced the Presbyterian faith. He was also an enthusiastic
singer of hymns, as documented by Rev. John Hines in his book *Red Indians of the Plains:*
"He had a tremendous voice which got beyond his control several times in each verse, and personally
I found it difficult to keep to the tune if he happened to be singing anywhere near me." (p. 164)

PRINCE ALBERT, SK / CA. 1895

WILLIAM J. JAMES

SASKATCHEWAN ARCHIVES BOARD R–B 3642

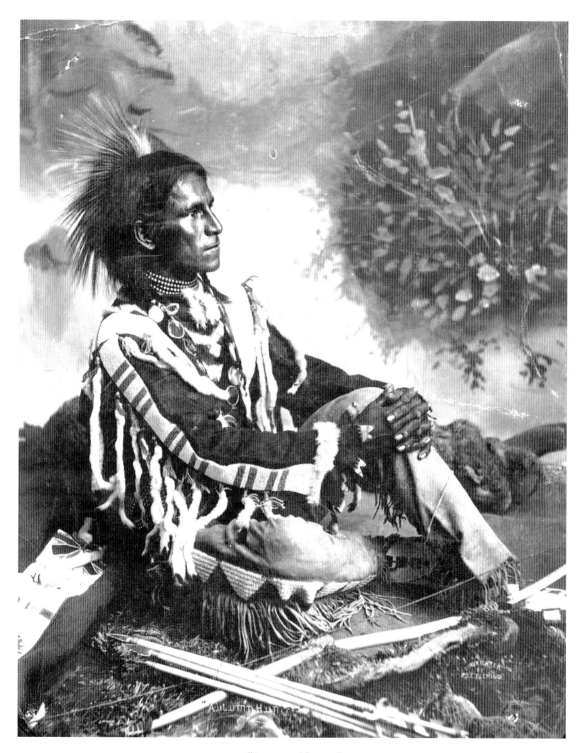

"Autumn Hunter"
MAPLE CREEK, SK / CA. 1900
GEORGE E. FLEMING
SASKATCHEWAN ARCHIVES BOARD R–B 9207

Little information is available about this disturbing image. It was taken by Ralph Dill, Saskatoon's first photographer, about 1905. It appears as if the townspeople were enjoying some sort of joke at the expense of the downtrodden soul on the ground. It is a prime example of one attitude held by the white population–that the Native people were debased individuals unable to take care of themselves.
WESTERN DEVELOPMENT MUSEUM (SASKATOON) 7-4-27

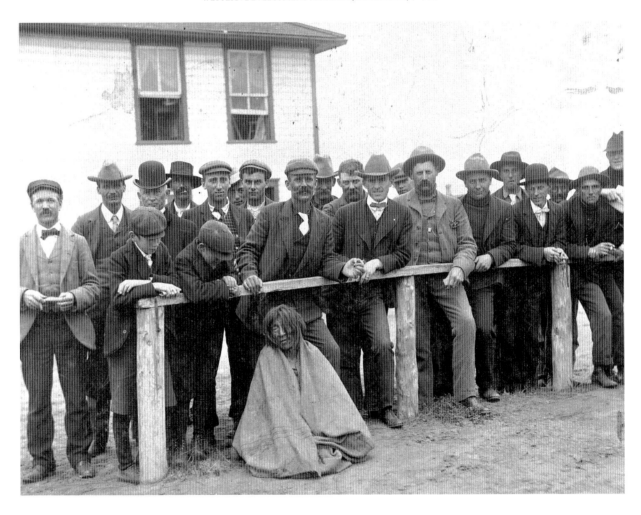

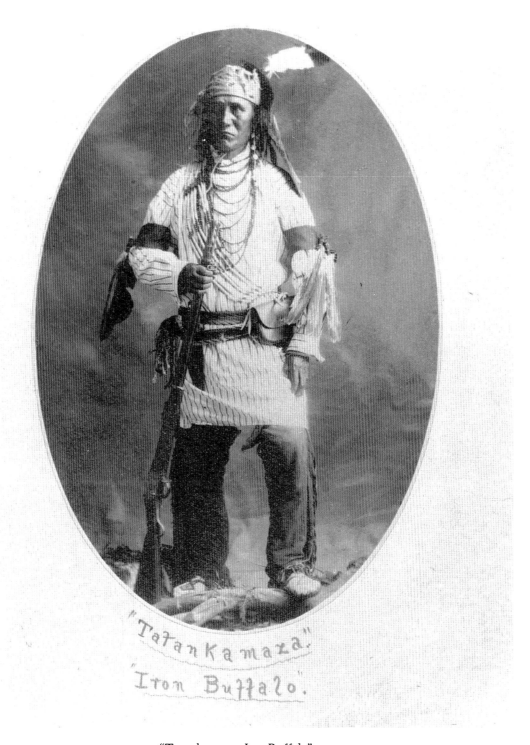

"Tatankamaza–Iron Buffalo"
A member of the Wahpeton Sioux Band poses for a portrait
in Theodore Charmbury's studio in Prince Albert ca. 1905.
SASKATOON PUBLIC LIBRARY, LOCAL HISTORY DEPARTMENT PH. 90-82-1

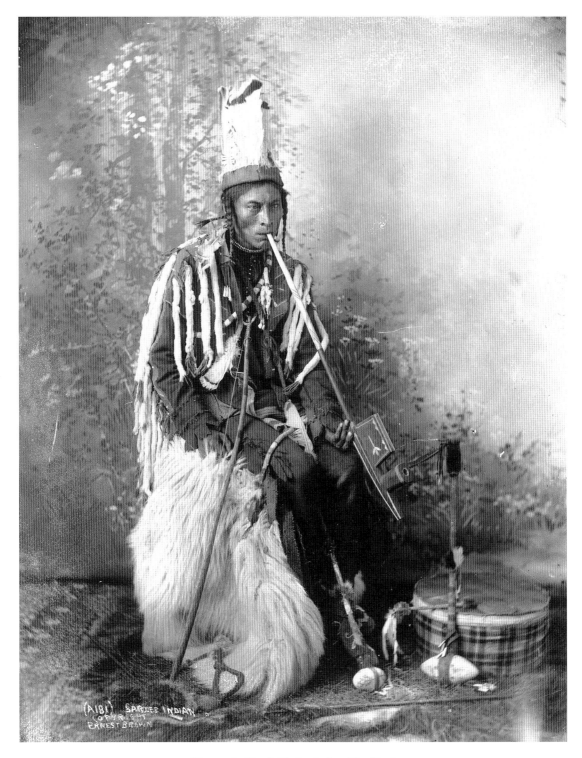

"Sarcee Indian"–Emita (a k a The Dog)

EDMONTON, AB / 1905-10

ERNEST BROWN

PROVINCIAL ARCHIVES OF ALBERTA B.740

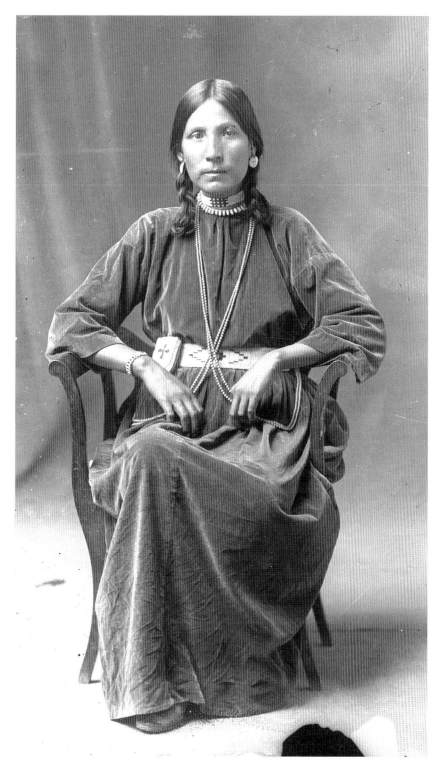

Grace and dignity characterize this studio portrait of an unidentified Blood Indian woman.
It was taken by John F. Atterton, who worked in Cardston, Alberta, in the 1920s.

GLENBOW ARCHIVES NC-7-852

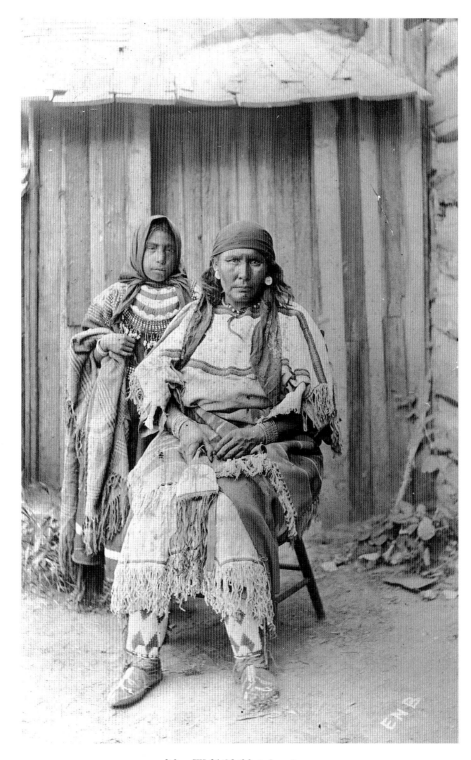

Mrs. Wolf Child & daughter
BLOOD RESERVE, CARDSTON, AB / 1906
PHOTOGRAPHER UNKNOWN
PROVINCIAL ARCHIVES OF ALBERTA A.5643

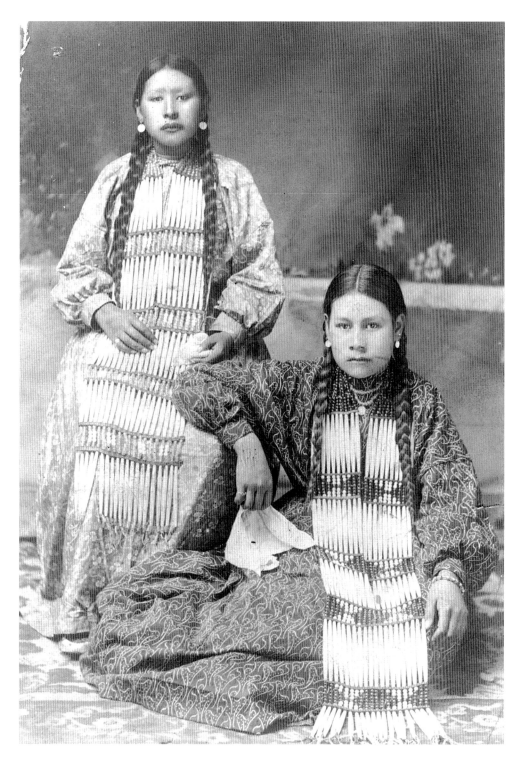

Two unidentified Indian women
LOCATION UNKNOWN / 1905
PHOTOGRAPHER UNKNOWN
PROVINCIAL ARCHIVES OF ALBERTA A.3249

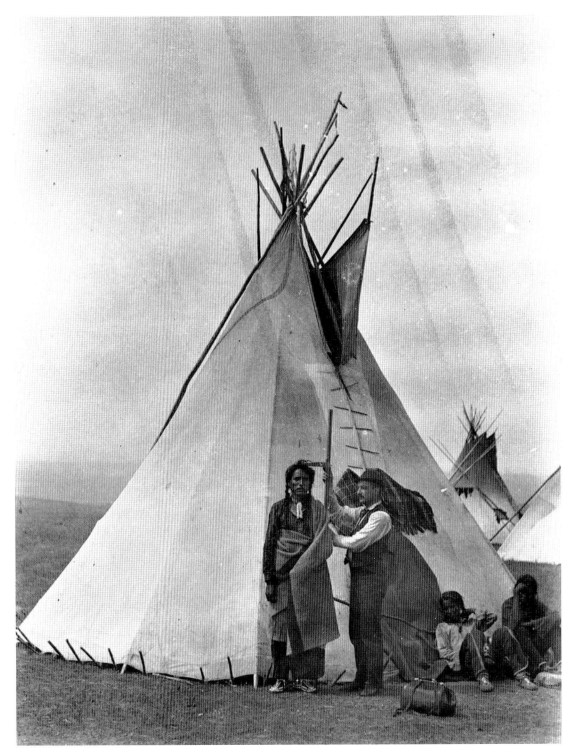

Ethnologist measuring and photographing Indian
MACLEOD DISTRICT, SOUTHERN ALBERTA / 1910s
PHOTOGRAPHER UNKNOWN
MACLEOD HISTORICAL ASSOCIATION FMP.80.104 (PROVINCIAL ARCHIVES OF ALBERTA NEG. A.20746)

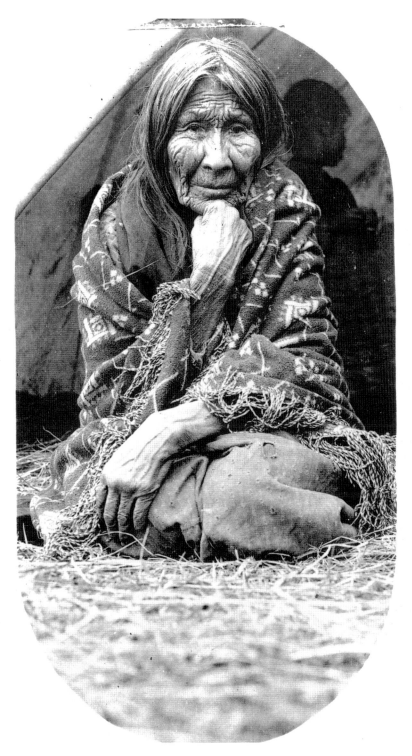

Unidentified elderly woman
LOCATION UNKNOWN / 1910S
PHOTOGRAPHER UNKNOWN
B. SILVERSIDES COLLECTION

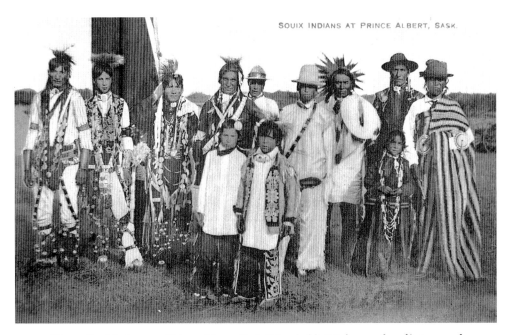

SOUIX INDIANS AT PRINCE ALBERT, SASK.

"Souix [sic] Indians at Prince Albert, Sask." (probably Wahpeton band)–postcard
CA. 1909
PHOTOGRAPHER UNKNOWN
SASKATCHEWAN ARCHIVES BOARD R-A 9911

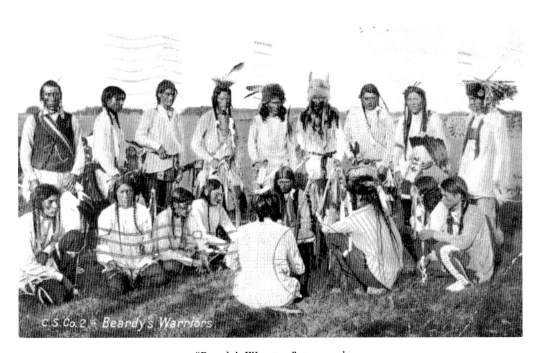

C.S.Co.2 – Beardy's Warriors

"Beardy's Warriors"–postcard
NEAR DUCK LAKE, SK / CA. 1910
PHOTOGRAPHER UNKNOWN
SASKATCHEWAN ARCHIVES BOARD R-A 19014

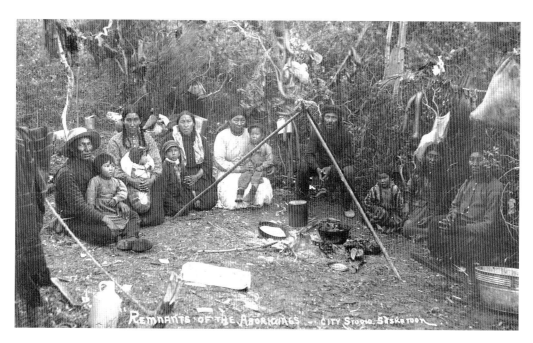

"Remnants of the Aborigines"–postcard
NEAR SASKATOON, SK / CA. 1908
CITY STUDIO
B. SILVERSIDES COLLECTION

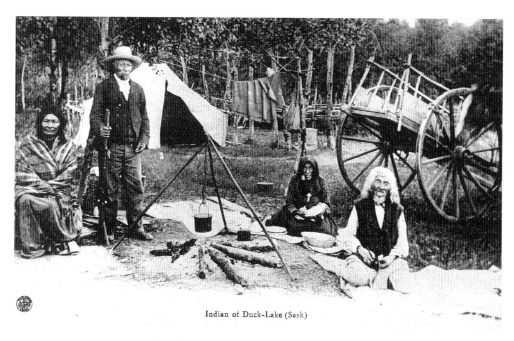

Indian of Duck-Lake (Sask)

"Indian of Duck-Lake (Sask.)"–postcard
CA. 1905
PHOTOGRAPHER UNKNOWN
PROVINCIAL ARCHIVES OF ALBERTA OB.7313

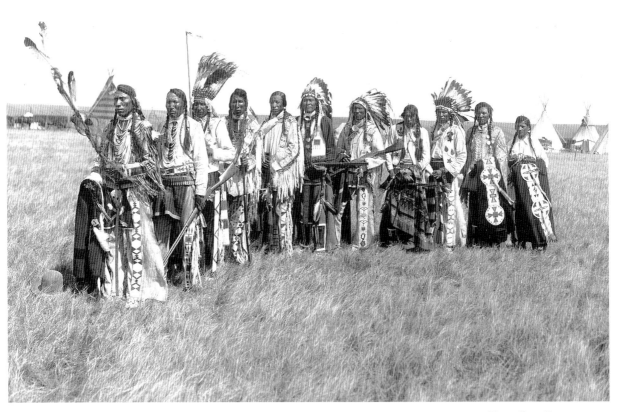

Chicken Dance Society (Blackfoot), including Heavy Shield, Pretty Young Man, Crow Shoe, One Gun, Spider Ball, Black Face, Manny Shot No. 2, Phillip Back Fat, and Frank Sugar (two remain unidentified)

BLACKFOOT RESERVE, SOUTHERN ALBERTA / 1913

HARRY POLLARD

PROVINCIAL ARCHIVES OF ALBERTA P.139

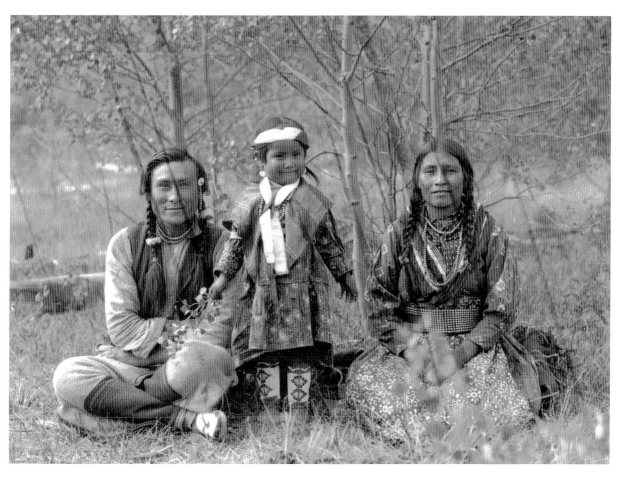

Sampson and Leah Beaver and daughter Francis
STONEY RESERVE, KOOTENAY PLAINS, AB / 1907
MARY SCHAFFER
WHYTE MUSEUM OF THE CANADIAN ROCKIES V 469/2271

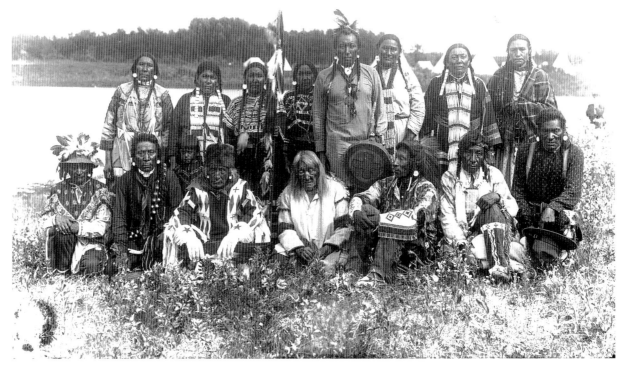

"Old Generation, File Hills Indian Agency"
The image includes (*back row, from left*) Mrs. Keewaydin, Mrs. Jack Fisher, Mrs. Miss-ta-tik,
Mrs. Buffalo Bow, Day Walker, Mrs. Yellow Belly, Mrs. Pimotatt, and Mrs. Playful Child (Tuckanow);
(*front row*) Chief Hawke, Crooked Nose, Chief Star Blanket, Pointed Cap (Cheepoostatin),
Buffalo Bow, Miss-ta-tik, and Kuinness (Cree).

FILE HILLS RESERVE, SOUTHERN SASKATCHEWAN / 1914

PHOTOGRAPHER UNKNOWN

SASKATCHEWAN ARCHIVES BOARD R–B 1854

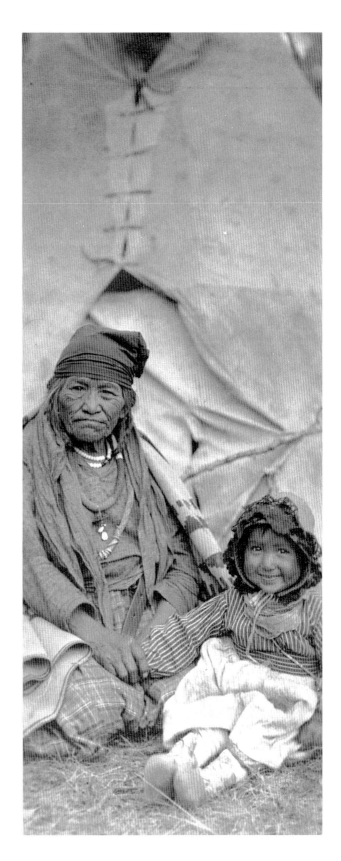

Grandmother and granddaughter (Stoney)
BANKHEAD, AB / 1919
PHOTOGRAPHER UNKNOWN
SASKATCHEWAN ARCHIVES BOARD R–B 1494/2

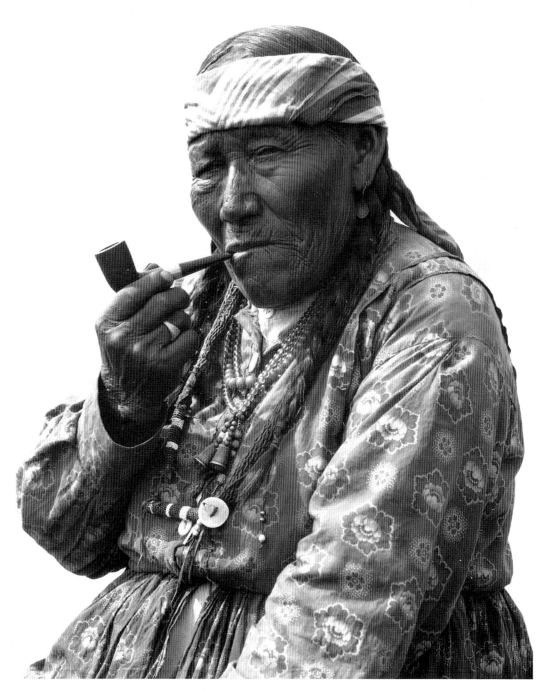

Betty Hunter–Stoney
SOUTHWEST ALBERTA / 1910
PHOTOGRAPHER UNKNOWN
PROVINCIAL ARCHIVES OF ALBERTA P.27

Transition

Following the North-West Rebellion of 1885, in which some Indians had played a supporting role to Louis Riel and the Métis, white society was confirmed in its view that the Indian was like a child who could be led by either good or evil influences. A concerted effort was thus begun to assimilate the Native people into the mainstream by engaging in cultural remodeling.

In particular, they were convinced to sign treaties, were shunted onto reserves and, to prevent any further "conspiracies," the federal government instituted the infamous pass system whereby Indians were not allowed off the reserve without permission from the local agent.

The government also placed heavy pressure on First Nations people to relinquish their nomadic lifestyle in favor of farming and stock raising. They supplied farm instructors, implements, and seed, although the quantity and quality of each, at times, were questionable. Other occupations, including haying, ranching, rock picking, and the harvesting of seneca root, were also encouraged.

In political terms, the finely tuned Indian process of consensus for the making of band policy was looked upon with suspicion by the Department of Indian Affairs. A democratic election process was therefore forced on the various nations in 1880, when the federal government refused to deal with the traditional chiefs and councils.

In addition, the Native people were forced to deal with various other unfamiliar scientific and technological trends in society. The proliferation of the railway network, the coming of the automobile after the turn of the century, the introduction of mass-produced clothing and food, and the invention of the radio in the 1920s, all contributed to the rapid and relentless alteration of Indian needs, desires, and priorities.

Colonial society has always been concerned about documenting the progress of its trappings and ideas, especially when they are used to "civilize" another culture. Archives throughout the world, for example, contain photographs of Zulus in frocks and top hats, of Australian aborigines using guns, and of east Indians drinking tea. Western Canada was certainly not exempt from this practice. White society demanded photographs of Indians on plows, dressed in European clothes, operating machinery, playing European musical instruments, engaging in white sports such as football or hockey, and attending white religious ceremonies.

The most influential institutions for "civilizing" the First Nations were possibly the residential or boarding schools established by the Roman Catholic, Anglican, Presbyterian, and Methodist churches.* Starting in 1882, with operational grants from the Canadian government, the aim of these schools was to impart an academic, agricultural, and domestic education to Indian youth. To do so, administrators felt they had to remove the children from their families and previous lifestyles.

There were also a number of industrial schools that trained Native children in practical occupations. The boys were taught carpentry, printing, shoemaking, painting, bricklaying, blacksmithing, tinsmithing, and engine repair. The girls were taught sewing, baking, butter and cream making, cooking, laundering, and care of cows and poultry.

* For detailed information about the residential and industrial schools and their locations, please see Supplementary Information, p. 100.

While these schools did indeed inculcate a "white" education, their legacy has many negative aspects. They almost extinguished the various Indian languages and cultures, they separated and in many cases alienated generations of Native people from their parents and grandparents, and the harsh discipline (corporal punishment was used extensively) frequently gave way to emotional, physical, and even sexual abuse.

The residential and industrial schools were ultimately unsuccessful from almost every point of view and were closed down by the end of the 1960s.

Supplementary Information
Residential and Industrial Schools

In Saskatchewan there were eleven major residential schools—Ah-tah-kah-Koop (Methodist); Crowstand on the Cote Reserve (Presbyterian); Cowessess at Crooked Lake (Roman Catholic); File Hills at Balcarres (Presbyterian); Gordon near Kutawa; Moscowequan in the Touchwood Hills (Roman Catholic); Onion Lake on the Seekaskootch Reserve (Roman Catholic); Onion Lake on the Makaoo Reserve (Anglican); St. Michael's at Duck Lake (Roman Catholic); Round Lake near Whitewood (Presbyterian); and St. Henry's adjacent to the Thunderchild Reserve (Roman Catholic). There were also three industrial schools—Qu'Appelle at Lebret (Roman Catholic); Battleford on the south bank of the Battle River in the former residence of Lt.-Gov. David Laird (Anglican); and the Regina School on the Wascana River in the east end of the city (Presbyterian). Finally, at Prince Albert, there was the school and orphanage (Roman Catholic) and Emmanuel College (Anglican), Saskatchewan's first university.

In Alberta, there were nineteen major boarding schools—Sacred Heart at Brocket (Roman Catholic); Piegan at Pincher Creek (Anglican); St. Mary's at Cardston (Roman Catholic); St. Paul's at Fort Macleod (Anglican); Crowfoot at Cluny (Roman Catholic); the McDougall Orphanage and Boarding School at Morley (Methodist); St. John's—actually two schools—Old Sun and White Eagle at Gleichen (Roman Catholic); Sarcee near Calgary; Blood School on the reserve (Anglican); Ermineskin at Hobbema (Roman Catholic); Lac La Biche (Roman Catholic); LeGoff (Roman Catholic); Blue Quills at St. Paul (Roman Catholic); Trochu (Roman Catholic); St. Albert (Roman Catholic); Holy Angels at Fort Chipewyan (Roman Catholic); St. Peter's Mission at Lesser Slave Lake (Anglican); and St. Bernard's at Grouard (Roman Catholic).

In addition there were three industrial schools: St. Joseph's (a k a Dunbow or High River, started by Father Albert Lacombe OMI) near DeWinton (Roman Catholic), Red Deer (nondenominational), and St. Dunstan's in Calgary.

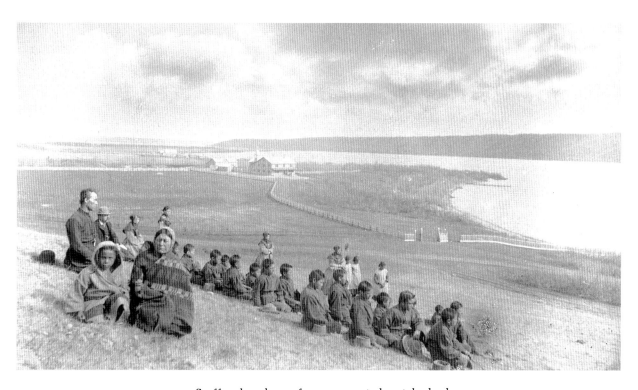

Staff and students of government industrial school
FORT QU'APPELLE, SK / MAY 1885
OTTO B. BUELL
NATIONAL ARCHIVES OF CANADA PA118765

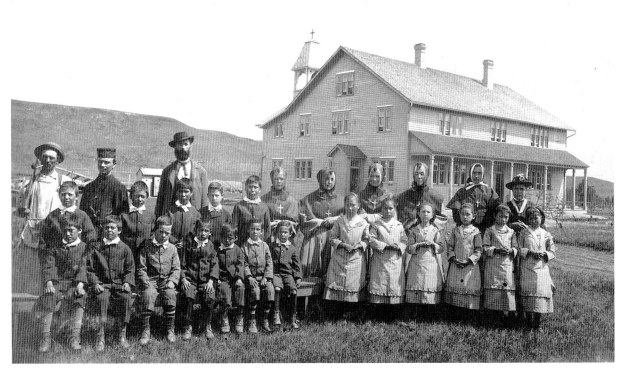

Staff and Students of Dunbow School
Dunbow, also known as St. Joseph's, was one of the first boarding schools for Indian children.
Built in 1884 on the High River near DeWinton, its first principal was Father Albert Lacombe OMI.
Because it was somewhat isolated from the southern Alberta reserves it was to service,
there were few students. It closed in 1922.

1888
PHOTOGRAPHER UNKNOWN
PROVINCIAL ARCHIVES OF ALBERTA OB.540

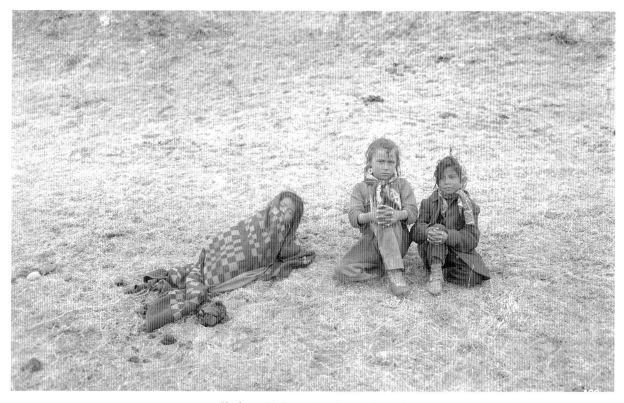

"Indian Children, Southern Alberta"
This is a refreshingly candid photograph, taken probably near Fort Macleod, Alberta.
1890S
FREDERICK STEELE
SASKATCHEWAN ARCHIVES BOARD R-B 1384

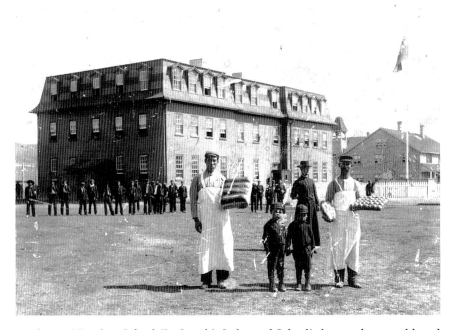

Students of Dunbow School (St. Joseph's Industrial School) showing buns and bread

NEAR DEWINTON, AB / 1890S

PHOTOGRAPHER UNKNOWN

PROVINCIAL ARCHIVES OF ALBERTA A.4703

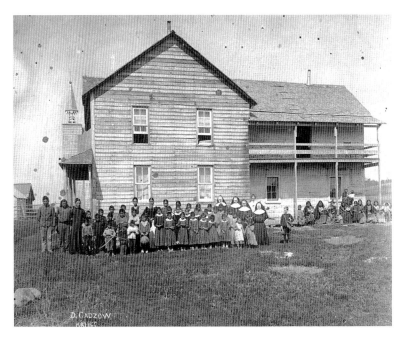

Staff and Students of Onion Lake School

WEST CENTRAL SASKATCHEWAN / 1893

D. CADZOW

PROVINCIAL ARCHIVES OF ALBERTA OB.1471

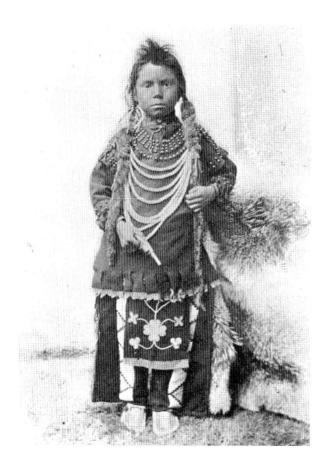

A dramatic example of before-and-after portraits, the photographs on this page show how the appearance of young Thomas Moore was altered radically after being admitted to the Regina Industrial School in 1896. Such a complete transformation was thrilling to the administrators of the Department of Indian Affairs, who included reproductions of the prints in the Canada Sessional Papers for 1897 (Vol.XXXI, No.11).

SOUTHERN SASKATCHEWAN

PHOTOGRAPHER UNKNOWN

SASKATCHEWAN ARCHIVES BOARD R–A 8223-1

Thomas Moore, posing in the regulation suit worn by young boys at the Regina Industrial School

SOUTHERN SASKATCHEWAN / 1896

PHOTOGRAPHER UNKNOWN

SASKATCHEWAN ARCHIVES BOARD R–A 8223-2

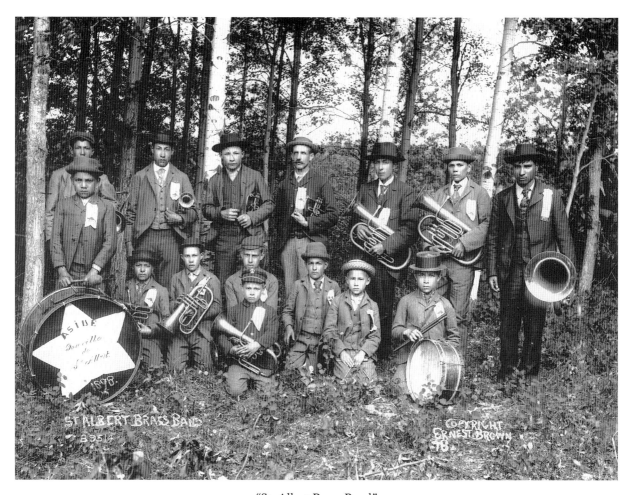

"St. Albert Brass Band"
CENTRAL ALBERTA / 1898
CHARLES W. MATHERS
PROVINCIAL ARCHIVES OF ALBERTA B.9514

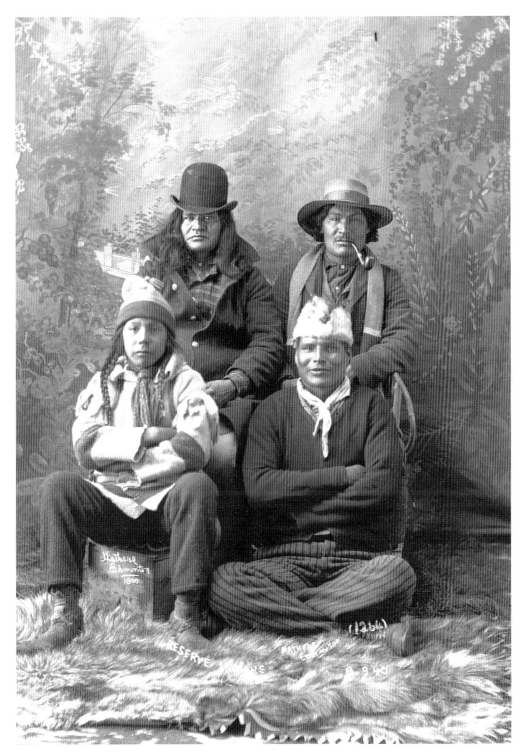

"Reserve Indians"
EDMONTON, AB / CA. 1898
CHARLES W. MATHERS
PROVINCIAL ARCHIVES OF ALBERTA B.940

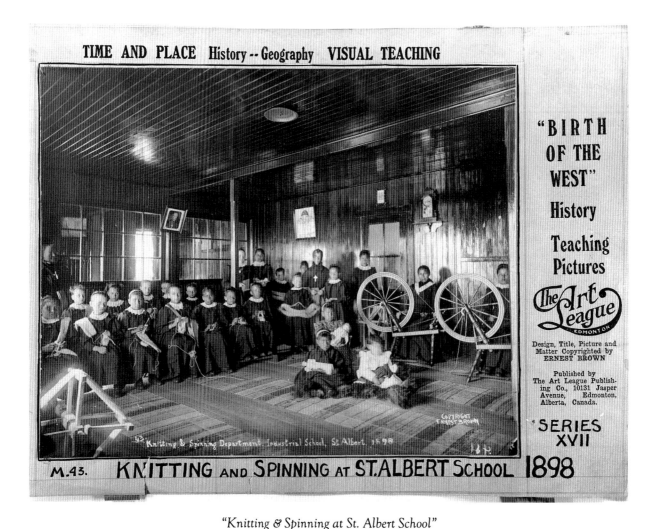

"Knitting & Spinning at St. Albert School"

CENTRAL ALBERTA

ORIGINAL IMAGE, 1898, BY CHARLES W. MATHERS

MOCKUP, 1920S, BY ERNEST BROWN FOR "BIRTH OF THE WEST" TEACHING SERIES

PROVINCIAL ARCHIVES OF ALBERTA B.10593

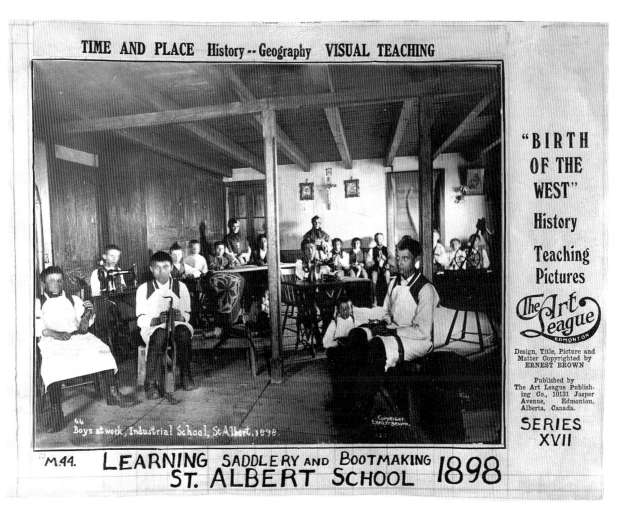

"Learning Saddlery and Bootmaking, St. Albert School, 1898"

CENTRAL ALBERTA

ORIGINAL IMAGE, 1898, BY CHARLES W. MATHERS

MOCKUP, 1920s, BY ERNEST BROWN FOR "BIRTH OF THE WEST" TEACHING SERIES

PROVINCIAL ARCHIVES OF ALBERTA B.10592

*"Piegan Indian Children and Teachers of Victoria Jubilee Home,
Pincher Creek, Alta., Canada, 3rd July, 1899"*
FREDERICK STEELE
SASKATCHEWAN ARCHIVES BOARD R-B1542

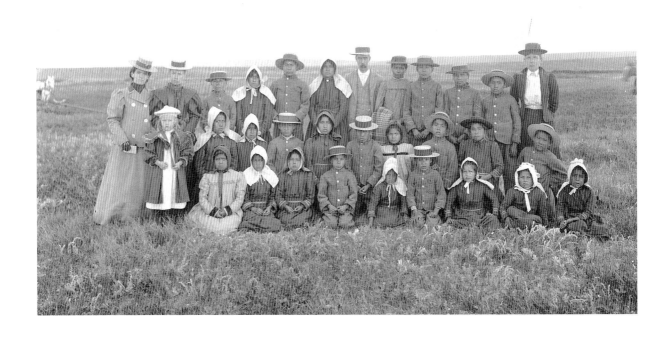

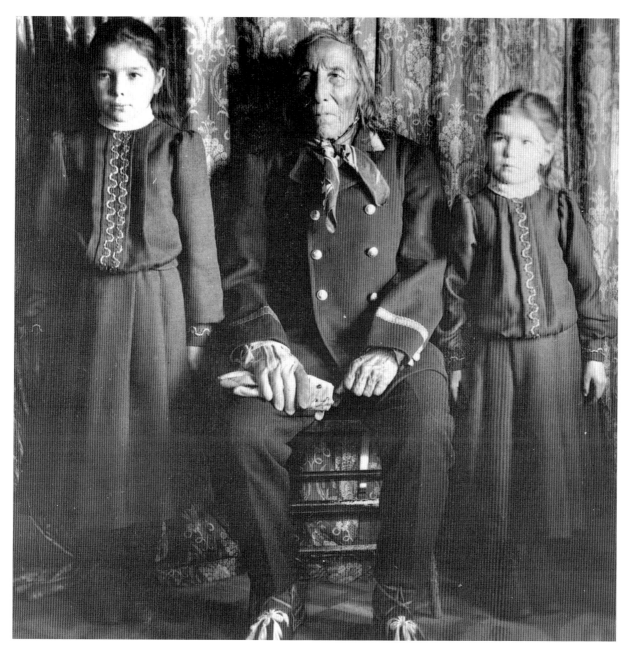

Chief Ermineskin and grand-daughters
CREE RESERVE, HOBBEMA, AB / N.D.
PHOTOGRAPHER UNKNOWN
PROVINCIAL ARCHIVES OF ALBERTA OB.8617

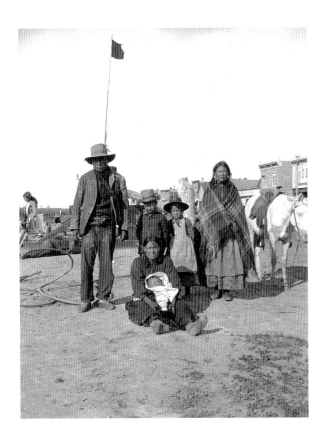

Unidentified family (Cree)
RIVER STREET, PRINCE ALBERT, SK / CA. 1900
WILLIAM J. JAMES
SASKATCHEWAN ARCHIVES BOARD R-A 1688

Members of the Battleford and North Battleford baseball teams
CENTRAL SASKATCHEWAN / CA. 1900
PHOTOGRAPHER UNKNOWN
SASKATCHEWAN ARCHIVES BOARD R-A 8693

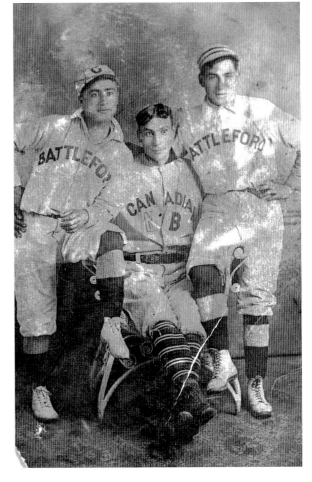

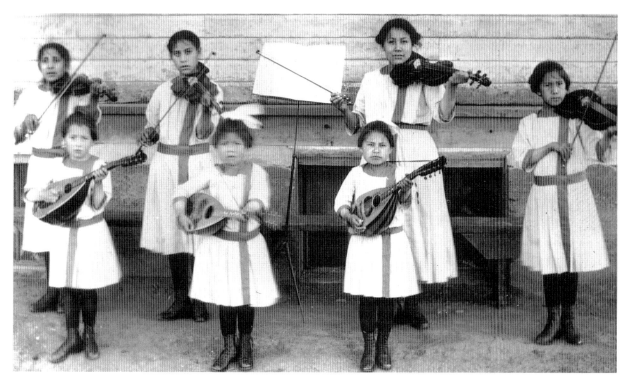

School band
ERMINESKIN RESERVE, HOBBEMA, AB / CA. 1900
PHOTOGRAPHER UNKNOWN
PROVINCIAL ARCHIVES OF ALBERTA OB.8624

"'Chakicum'–A Relic of the 'Reil [sic] Rebellion'"
SASKATOON, SK / 1908
CITY STUDIO
SASKATOON PUBLIC LIBRARY, LOCAL HISTORY DEPARTMENT #1859

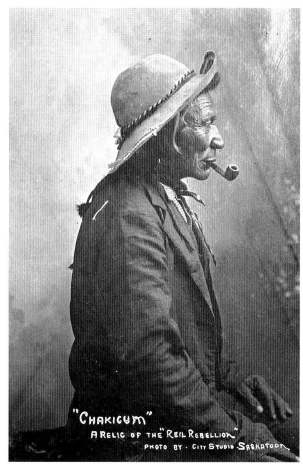

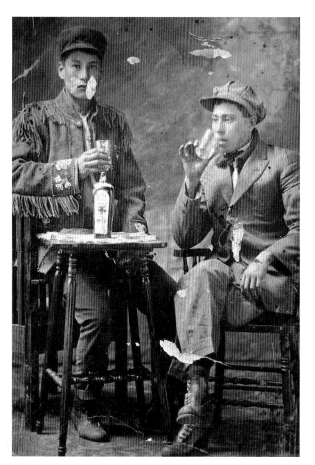

Leo Gardiner and friend share a drink
LOCATION UNKNOWN / 1920s
PHOTOGRAPHER UNKNOWN
SASKATCHEWAN ARCHIVES BOARD R-A 8687

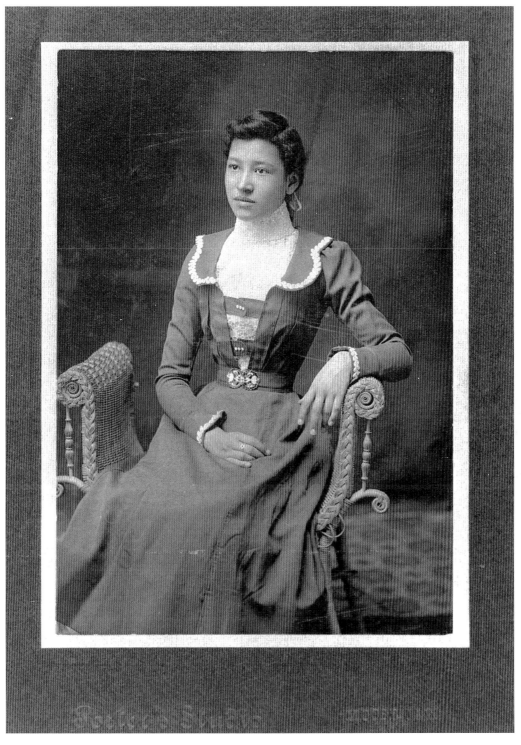

"Wanda Gilmour–Indian Girl Adopted and Educated by Rev. Neil Gilmour"
MOOSE JAW, SK / CA. 1905
NATHANIEL PORTER
SASKATCHEWAN ARCHIVES BOARD R–B 1465

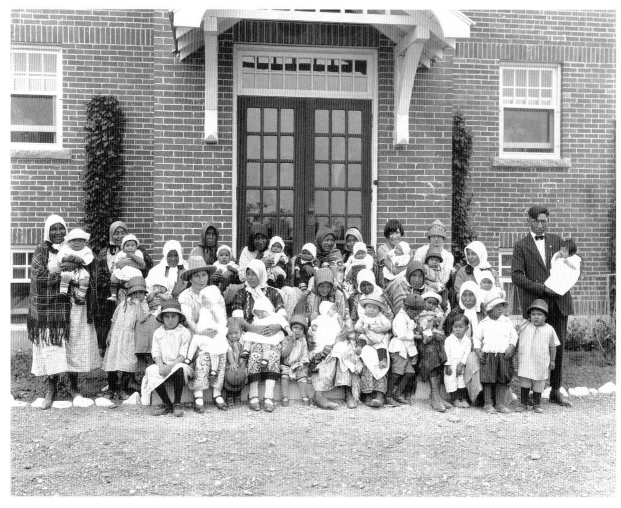

Baby contest at reserve hospital (front row, from left) Mrs. Charles Royal, first prize;
Mrs. Harry Red Gun, second prize; and Mrs. A. Young Man, third prize

BLACKFOOT RESERVE, SOUTHERN ALBERTA / 1926

HARRY POLLARD

PROVINCIAL ARCHIVES OF ALBERTA P.140

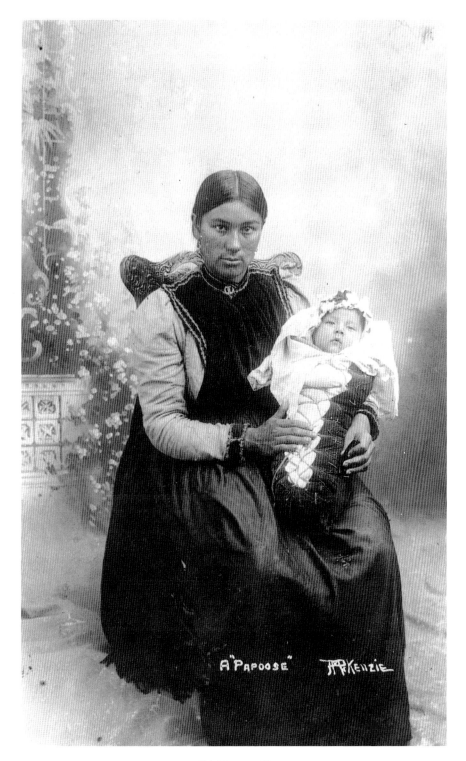

"A 'Papoose'"
SASKATOON, SK / 1907-08
PETER MCKENZIE
SASKATOON PUBLIC LIBRARY, LOCAL HISTORY DEPARTMENT I.H. 246

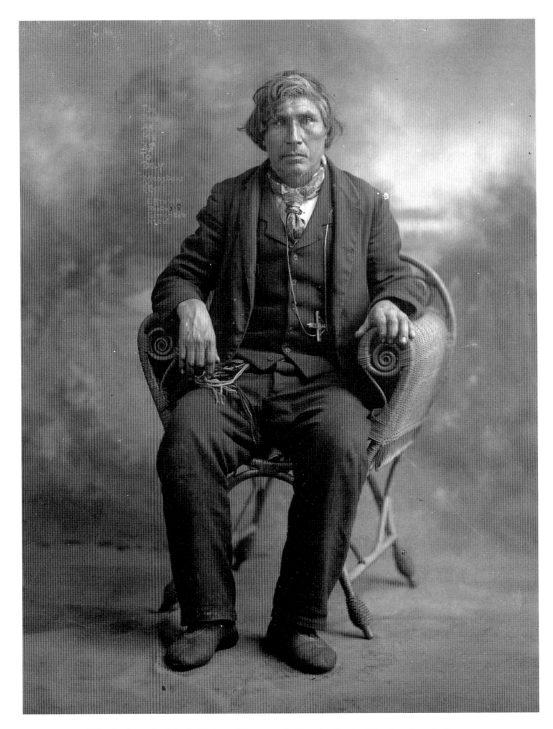

"The Indian As He Is Today–Moostoos" (Cree), chief of Sucker Creek Reserve
This is another portrait intended to show the progress of assimilation.
Note the three-piece suit and the crucifix tucked into a vest pocket.

EDMONTON, AB / CA. 1911

ERNEST BROWN

PROVINCIAL ARCHIVES OF ALBERTA B.790

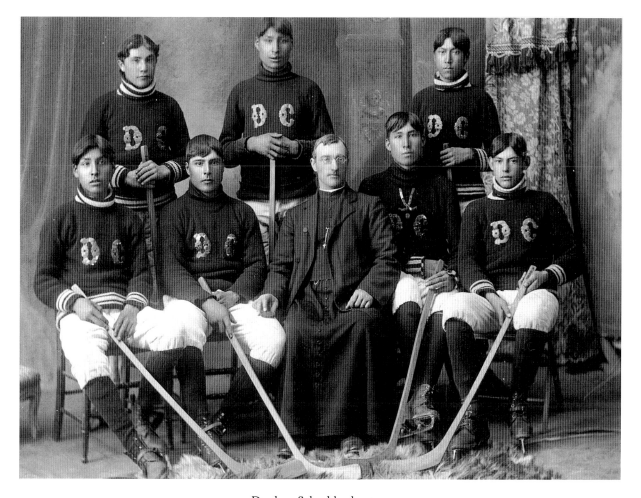

Dunbow School hockey team
This group portrait was taken in the Edmonton studio of Charles Mathers.
Although none of the boys is identified, the coach is Father Albert Naessens (OMI),
the principal of the school.

EDMONTON, AB / 1902–03

CHARLES W. MATHERS

PROVINCIAL ARCHIVES OF ALBERTA OB.8791

"Boys of the Indian Reserve, Saskatoon"
Contrary to popular belief, Native people were not always hostile to new technology.
Here, in August 1910, members of the White Cap Reserve at Moose Woods, Saskatchewan,
cheerfully examine one of the first automobiles to visit their community.
Charlie Eagle works the crank.
WILLIAM P. BATE
SASKATOON PUBLIC LIBRARY, LOCAL HISTORY DEPARTMENT, LH.4070

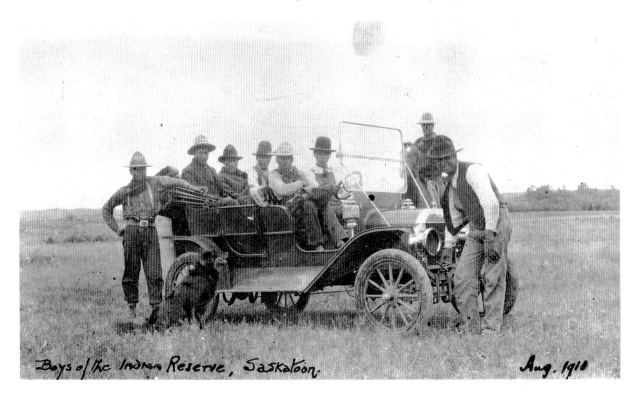

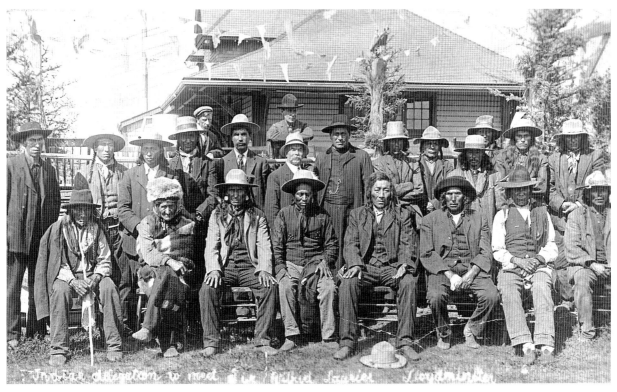

"*Indian Delegation to Meet Sir Wilfrid Laurier, Lloydminster*"
The image includes (*sitting in front, from left*) Fox (Makesis), Mr. Quinney Sr. (Manito-nikik),
John Calling Bull, Napeview, Feather Trousers (Opiway-tas), Horse (Kamistatim),
Ugly Fingers (Myitchetchiy), and Carpenter (Mistchi-Konapew); (*standing behind front row, from left*)
Angus Quinney, Benjamin Quinney, Jean Baptiste Opissinow, Young Chief (Wemistiko-siawasis),
Joe Taylor, William Sibbald (Indian agent), Father Cunningham, Mikweyapiy, Flying About (Waskahat),
Three Legs (Nistokotchis, or Mr. Cook), Antoine Muskego (Kekekwayan), Misihew (also called Chief),
and Silly Man (Motchyinis); (*standing in back*) unknown and Percy Gilbert.

LLOYDMINSTER, SK / 1910

PHOTOGRAPHER UNKNOWN

GLENBOW ARCHIVES NA-1036-9

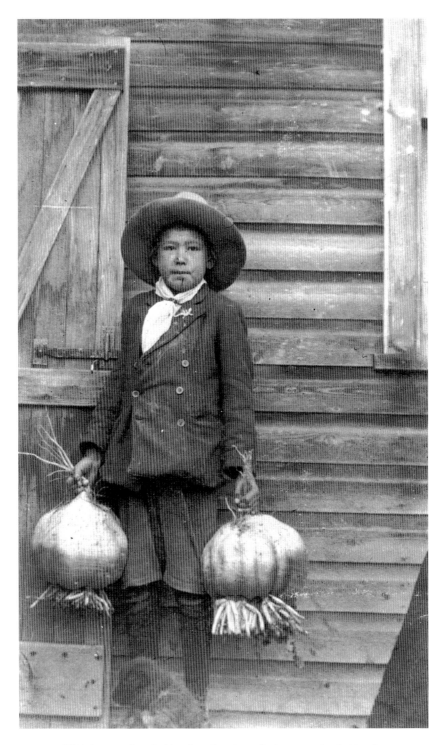

This image of an Indian boy showing off giant turnips belies the
commonly held assumption that Native people were not good at horticulture.
MIDNAPORE, AB / CA. 1912
PHOTOGRAPHER UNKNOWN
PROVINCIAL ARCHIVES OF ALBERTA OB.11235

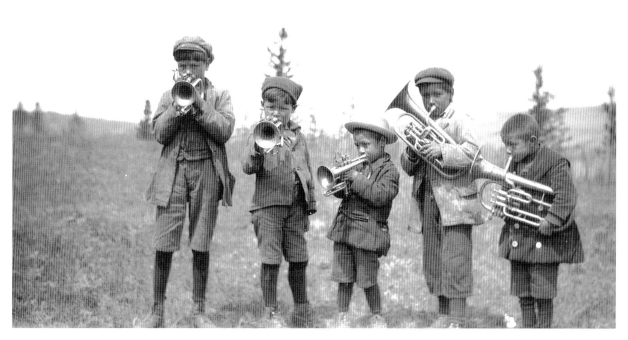

On the presumption that "music soothes the savage breast," the instructors at
Dunbow Boarding School, near DeWinton, Alberta, started these children
on musical instruments at a young age.

CA. 1912

PHOTOGRAPHER UNKNOWN

PROVINCIAL ARCHIVES OF ALBERTA OB.8787

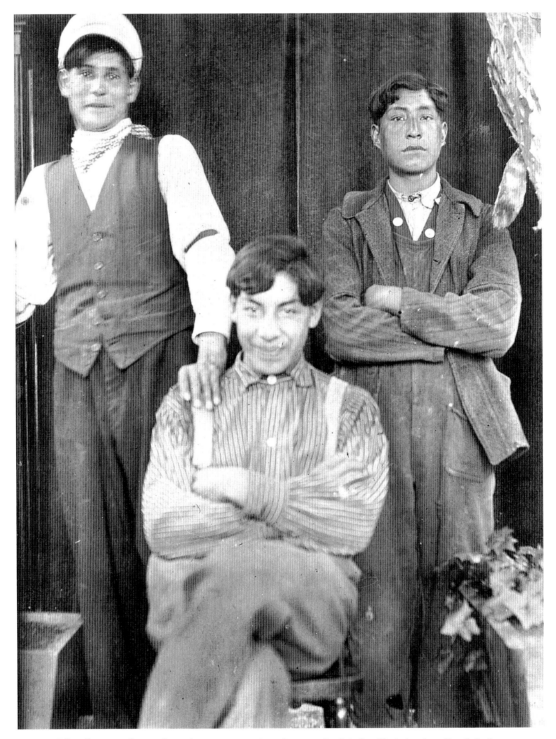

The photographs on these facing pages of students at St. Michael's School in Duck Lake, Saskatchewan, show that life in the residential school was not without its happy moments.

JUNE 1914

JOSEPH TESSIER OMI

PROVINCIAL ARCHIVES OF ALBERTA OB.8215

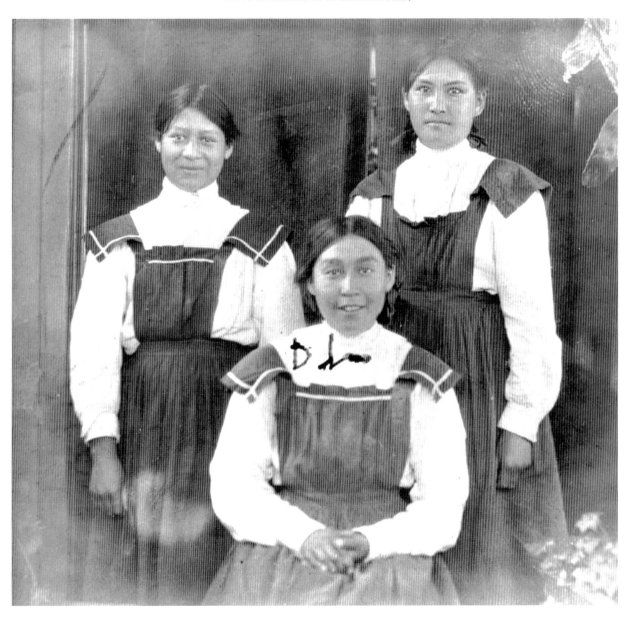

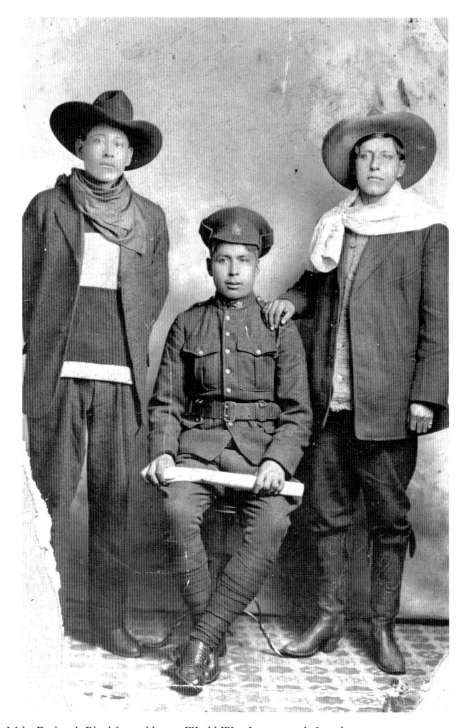

Mike Foxhead, Blackfoot soldier in World War I, poses with friends prior to going overseas. Foxhead served with the 191st Overseas Battalion, Canadian Expeditionary Force, and lost his life in the trenches.

LOCATION UNKNOWN / CA. 1916

PHOTOGRAPHER UNKNOWN

GLENBOW ARCHIVES NA-5-16

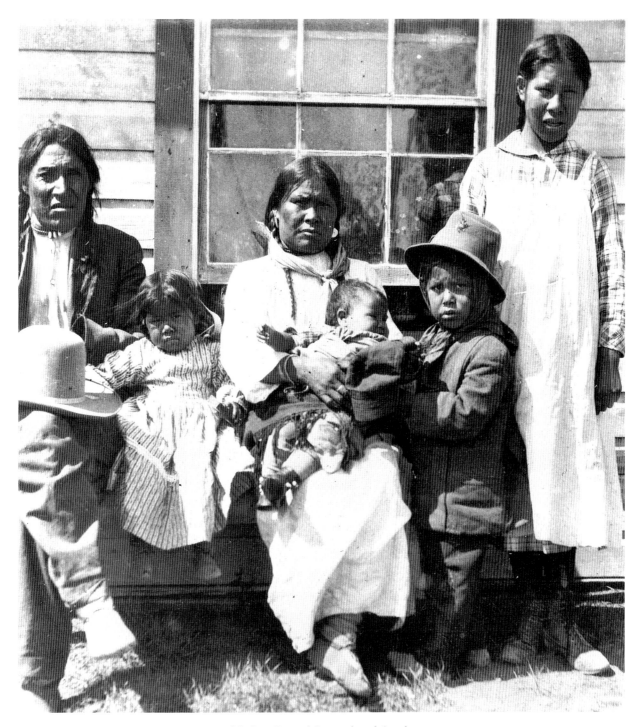

Norbert Striped Squirrel and family
PIEGAN RESERVE, SOUTHERN ALBERTA / 1921
PHOTOGRAPHER UNKNOWN
PROVINCIAL ARCHIVES OF ALBERTA OB.8866

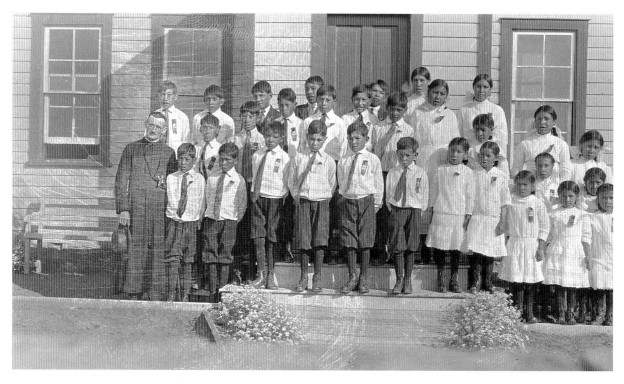

Father Levern OMI and students of residential school
PIEGAN RESERVE, BROCKET, AB / 28 JULY 1920
PHOTOGRAPHER UNKNOWN
PROVINCIAL ARCHIVES OF ALBERTA OB.157

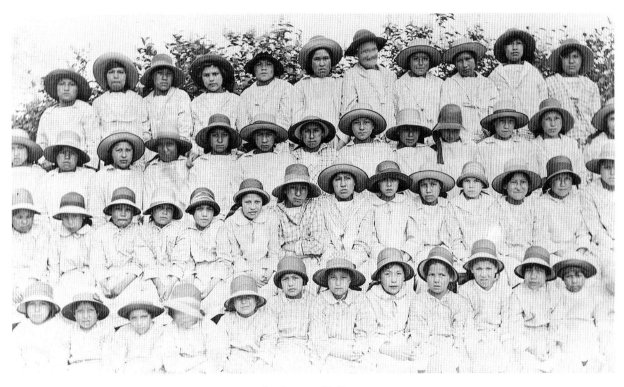

Students at Hobbema
ERMINESKIN RESERVE, HOBBEMA, AB / 1920S
PHOTOGRAPHER UNKNOWN
PROVINCIAL ARCHIVES OF ALBERTA OB.8612

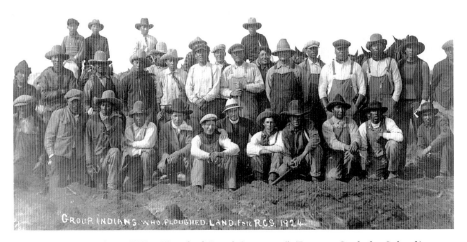

"Group Indians Who Ploughed Land for R.C.S." (Roman Catholic School)
BLOOD RESERVE, CARDSTON, AB / 1924
JOHN F. ATTERTON
PROVINCIAL ARCHIVES OF ALBERTA OB.8833

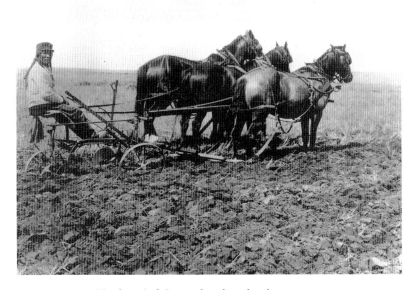

Unidentified farmer breaking land on reserve
LOCATION UNKNOWN / N.D.
PHOTOGRAPHER UNKNOWN
NATIONAL ARCHIVES OF CANADA PA48475

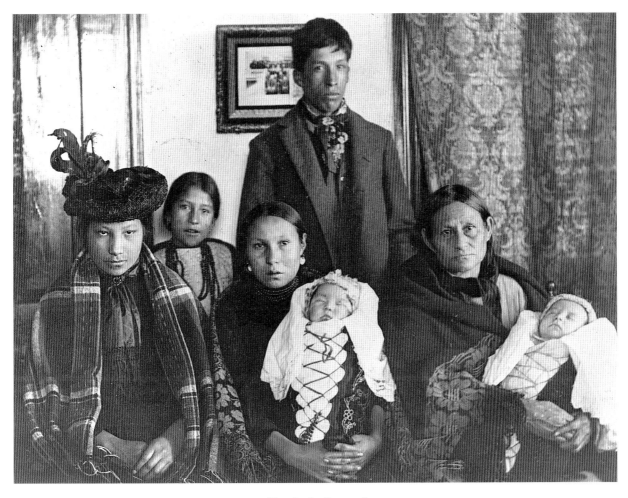

"Inside the Rectory"
Seated, from left, are Miss Goodeye, Marie Louise Little Child, Marguerite Kanowalch-Biché, and Eugenie Cardinal; standing is Johnny Little Child.

CREE RESERVE, HOBBEMA, AB / 1920S

PHOTOGRAPHER UNKNOWN

PROVINCIAL ARCHIVES OF ALBERTA OB.8611

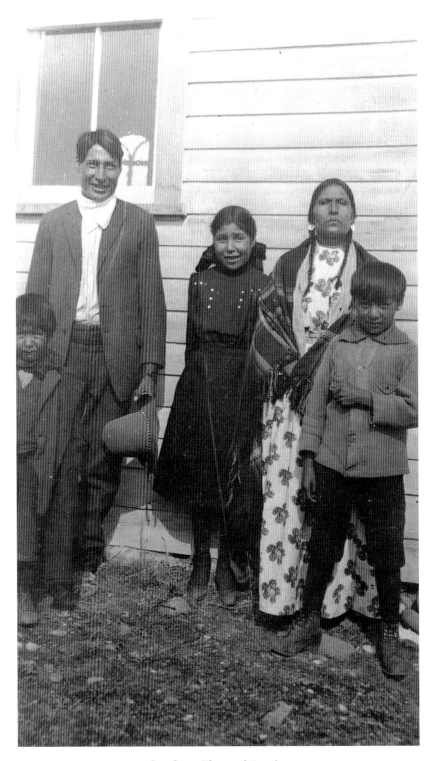

Jim Crow Flag and family
PIEGAN RESERVE, BROCKET, AB / 1920S
PHOTOGRAPHER UNKNOWN
PROVINCIAL ARCHIVES OF ALBERTA OB.8852

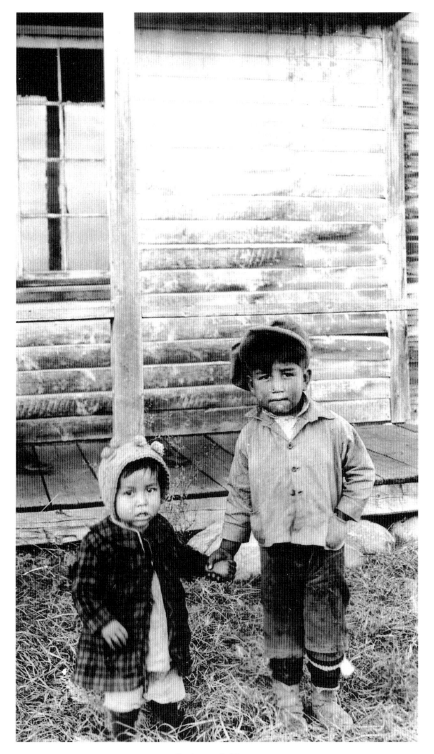

Indian children
COLD LAKE RESERVE, LEGOFF, AB / 1920s
PHOTOGRAPHER UNKNOWN
PROVINCIAL ARCHIVES OF ALBERTA OB.8583

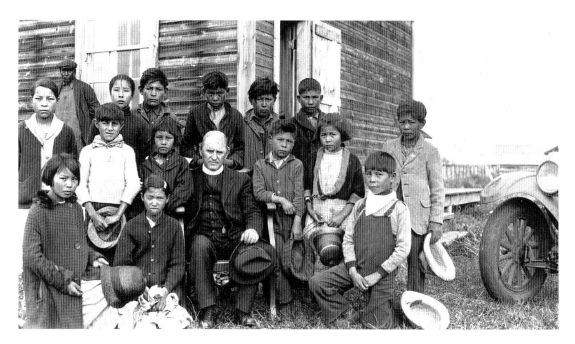

Montagnais Children with Father Ernest Lacombe

COLD LAKE RESERVE, LEGOFF, AB / 1929

PHOTOGRAPHER UNKNOWN

PROVINCIAL ARCHIVES OF ALBERTA OB.8593

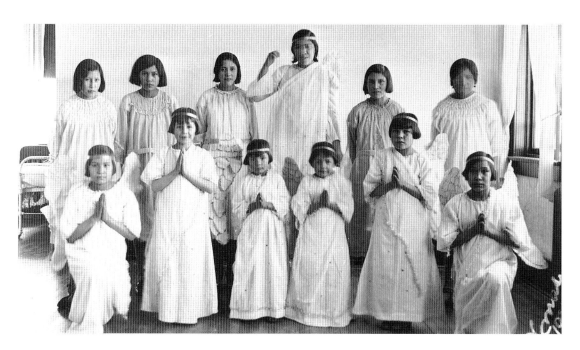

Christmas concert at St. Mary's School

BLOOD RESERVE, CARDSTON, AB / DECEMBER 1933

PHOTOGRAPHER UNKNOWN

PROVINCIAL ARCHIVES OF ALBERTA OB.10571

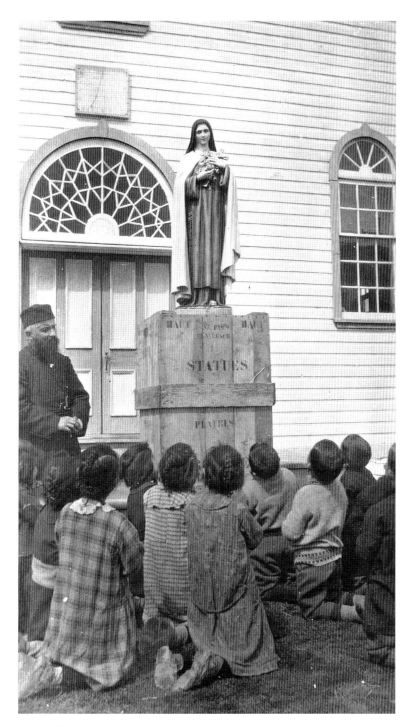

Native children praying to statue of the Blessed Virgin newly arrived from France
One of the dubious advantages of a residential school education was
learning to worship a plaster statue rather than the sun.

HOLY ANGELS BOARDING SCHOOL, FORT CHIPEWYAN, AB / JUNE 1931

PHOTOGRAPHER UNKNOWN

PROVINCIAL ARCHIVES OF ALBERTA OB.735

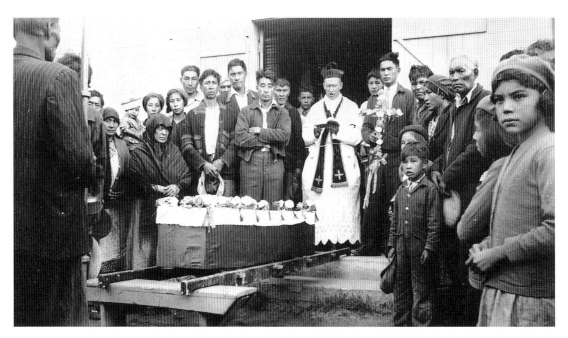

Indian funeral (Father Lavallée officiating)
COLD LAKE RESERVE, LEGOFF, AB / 1939
PHOTOGRAPHER UNKNOWN
PROVINCIAL ARCHIVES OF ALBERTA OB.1171

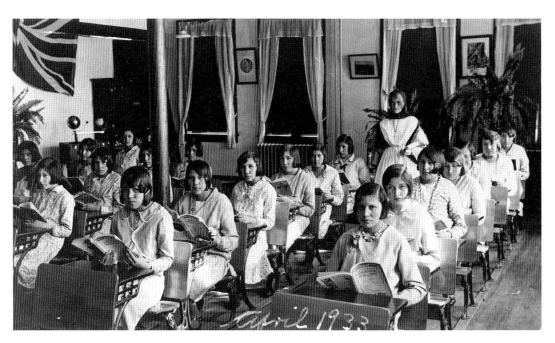

Classroom, St. Mary's School
BLOOD RESERVE, CARDSTON, AB / APRIL 1933
PHOTOGRAPHER UNKNOWN
PROVINCIAL ARCHIVES OF ALBERTA OB.10558

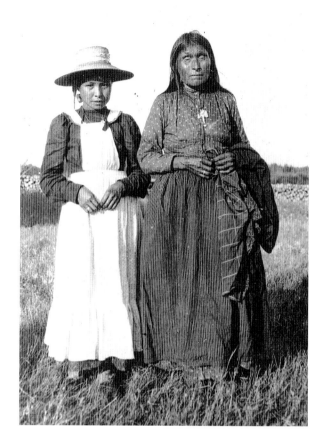

LOCATION UNKNOWN / 1910s
PHOTOGRAPHER UNKNOWN
B. SILVERSIDES COLLECTION

*Little is known about these images except that
they clearly demonstrate a generation gap in age,
clothing, and attitude.*

LOCATION UNKNOWN / 1930s
PHOTOGRAPHER UNKNOWN
PROVINCIAL ARCHIVES OF ALBERTA OB.9249

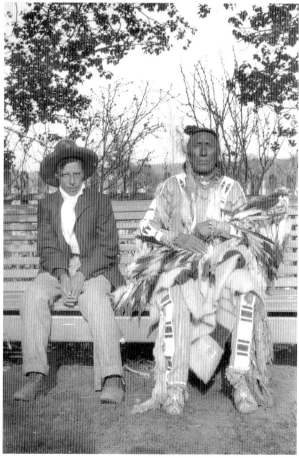

Boys playing hockey at Cluny on the Blackfoot Reserve
SOUTHERN ALBERTA / 1939
JEAN LESSARD OMI
PROVINCIAL ARCHIVES OF ALBERTA OB.10534

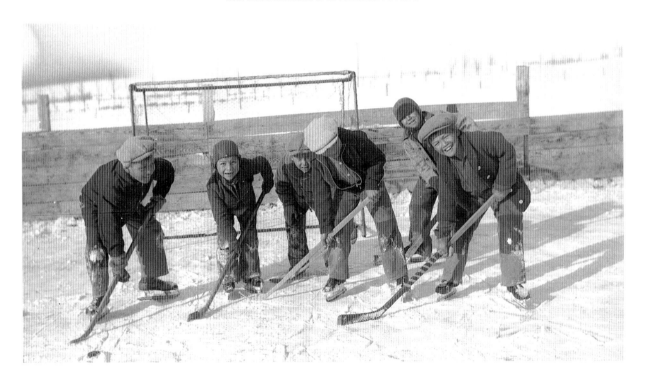

Potato roast
BLACKFOOT RESERVE, CLUNY, AB / CA. 1939
JEAN LESSARD OMI
PROVINCIAL ARCHIVES OF ALBERTA OB.10535

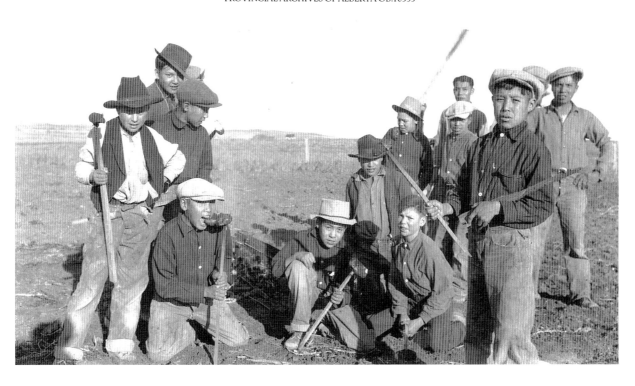

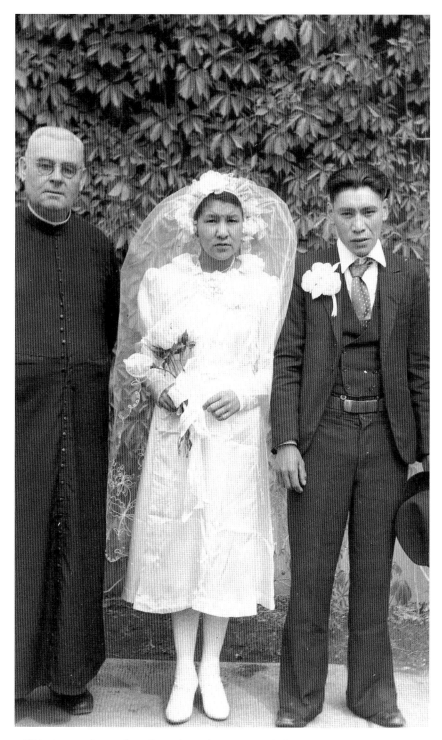

This image of a newlywed couple and priest reveals how some Indians adapted,
however uncomfortably, to white clothing and religious ceremonies.

BEARDY RESERVE, DUCK LAKE, SK / 1930S

PHOTOGRAPHER UNKNOWN

PROVINCIAL ARCHIVES OF ALBERTA OB.515

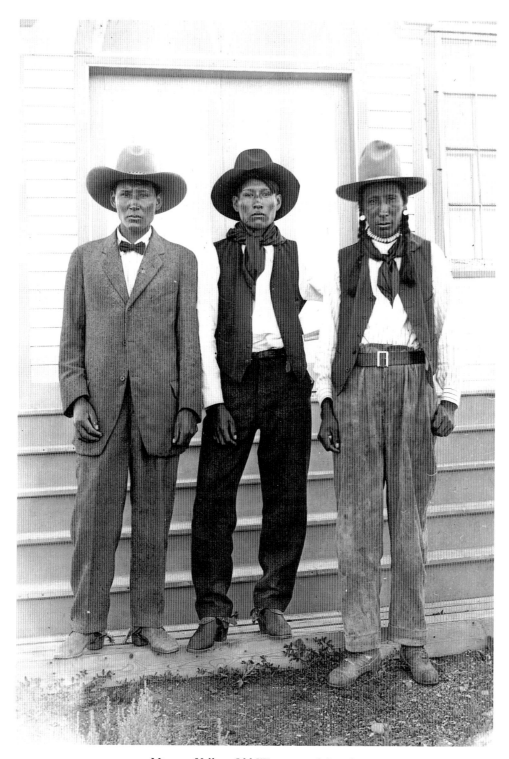

Vincent Yellow Old Woman and friends
BLACKFOOT RESERVE, CLUNY, AB / 1936-40
ATTRIBUTED TO JEAN LESSARD OMI
PROVINCIAL ARCHIVES OF ALBERTA OB.7318

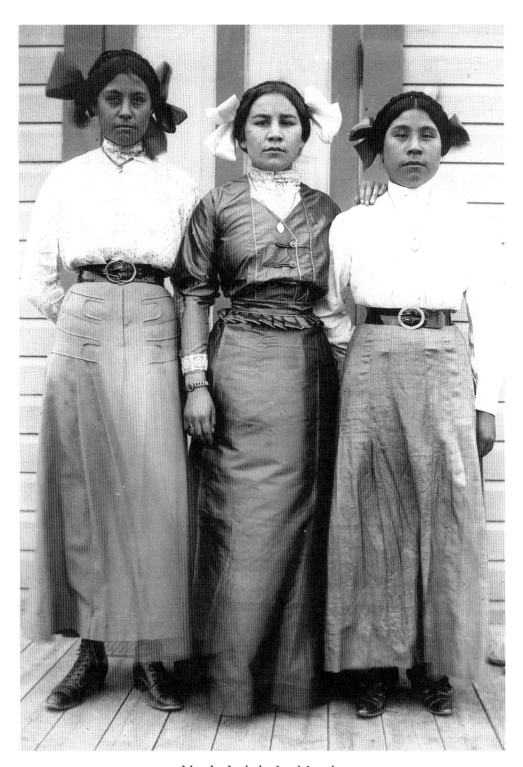

Mrs. Joe Littlechief and friends
BLACKFOOT RESERVE, CLUNY, AB / 1936–40
ATTRIBUTED TO JEAN LESSARD OMI
PROVINCIAL ARCHIVES OF ALBERTA OB.7320

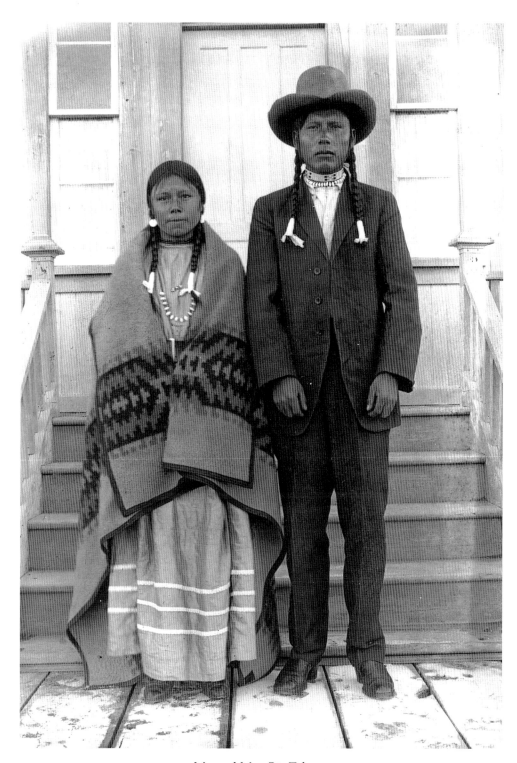

Mr. and Mrs. Big Tobacco
BLACKFOOT RESERVE, CLUNY, AB / 1936-40
ATTRIBUTED TO JEAN LESSARD OMI
PROVINCIAL ARCHIVES OF ALBERTA OB.7319

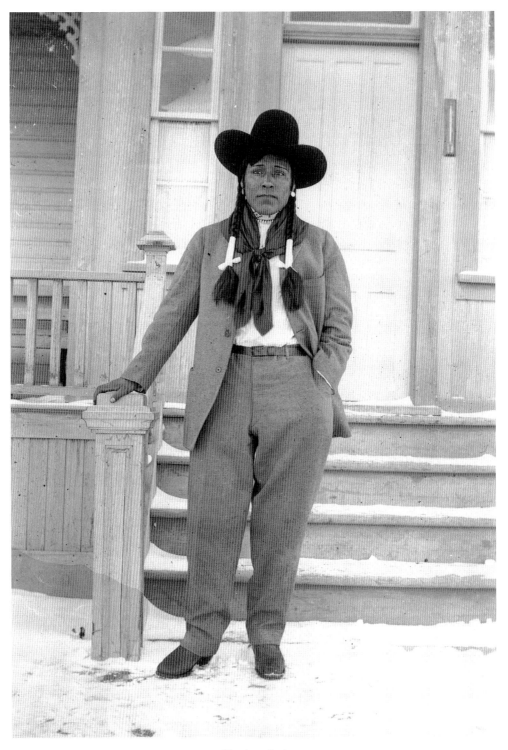

Unidentified
BLACKFOOT RESERVE, CLUNY, AB / 1936-40
ATTRIBUTED TO JEAN LESSARD OMI
PROVINCIAL ARCHIVES OF ALBERTA OB.7316

Inventing the Legend

Sometime after the turn of the century the image of the Indian started to lose its appeal for white society. Through no fault of their own, and indeed at the urging of the larger society that surrounded them, Native people had become less glamorous. Most now lived on reserves, eking out a living well below the standard of white Canadians. They had adopted European clothing and their children were being educated in "white" schools.

The First Nations no longer roamed the plains for the now all-but-extinct buffalo—no longer had need of tepees and travois. They had been "tamed"; in other words, they were no longer a menace. The "noble savage" had disappeared, but white society still had a certain fondness for this make-believe character.

Edward Roper, a tourist on the CPR in 1891 (who later published a book on his excursion entitled *By Track and Trail: A Journey Through Canada*), expressed his displeasure at Native people wearing "white" clothes during a stop at Maple Creek: "Many of them were partly civilized in dress, though ragged and dirty, and there was very little of the picturesque about them. Some few had good faces, but the ideal Red Man was not there." (p. 118)

If this was not what customers wanted to see, then photographers would produce what they did want to see.

Thus the Indian had to be resurrected, if only in image, and the image had to be safe, yet still incorporate symbols of a previously "heathen" life. Most important, it had to be exotic again—buckskins, headbands, headdresses, moccasins—things that were no longer a common sight on the streets. Photographers' customers wanted not only "Indian costumes" but also "Indian activities"—sitting around a campfire, stretching and scraping hides—and contrived "Indian poses"—pointing into the distance, hand over eyebrows as if in salute, and arms crossed over chest.

The strong appeal of the "legendary" Indian inspired several non-Indians to undertake complex, and for a time successful, impersonations of Native people. Two of the most well known were Chief Buffalo Child Long Lance (1890-1932) and the caretaker of animals at Prince Albert National Park, Grey Owl (1888-1938), who gained international recognition for his wildlife preservation campaign in the 1930s.

The "Indian costumes" usually appeared in connection with public functions entirely unrelated to Native life, such as civic ceremonies, visits of dignitaries, or parades. Committees or managers of summer fairs like the Saskatoon Agricultural Exhibition, Banff's Indian Days, and especially the Calgary Stampede, decided that Indians (and only in full regalia) would add to the drawing power of the event. Accordingly, little Indian "villages"—half circles of tepees—were set aside where fairgoers could gawk at Indians sitting around a fire or engaging in "Indian" activities.

Native people thus became safe and decorative, but the image was one of little substance and almost no relevance to the original lifestyle before white settlement.

While images of the "legendary" Indian had been produced from about 1890 onward, they did not reach the level of respectability until the American photographer Edward S. Curtis started his project to record the North American Indian in 1900. Although at the time he was considered a documentary photographer of the first order, it would appear in retrospect that he fixed his photographs—convincing his subjects to don headdresses and loin cloths, which he

carried around with him, so as to appeal to his audience.

Curtis's photographs were published in several volumes, as well as in portfolios, and appear to have influenced many western Canadian and American photographers. Those who had formerly been straightforward in their presentation of First Nations people started to compose their photographs in romantic or allegorical settings and poses. Combined with an upsurge in camera clubs and the pictorialist movement in photography, these Indian images were considered to be art.

In fact, these images were the still equivalent of the grade B Hollywood feature film—a fictional treatment based on a slim margin of historical veracity and a great deal of wishful thinking. Unfortunately, the "Legendary Indian" continued to be produced well into the 1960s on postcards and placemats.

That these nostalgic images were made at all underlines the fact that while white photographers may have learned much about the Plains Indian, they never understood the culture.

This is not to say that the photographs are not attractive; indeed, many of the portraits are aesthetically extremely pleasing. They simply do not possess integrity of purpose.

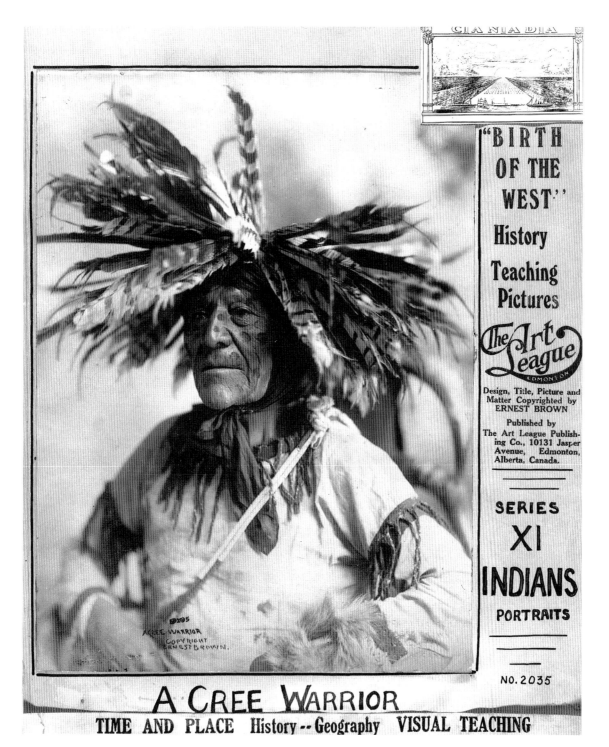

"BIRTH OF THE WEST" History Teaching Pictures

The Art League EDMONTON

Design, Title, Picture and Matter Copyrighted by ERNEST BROWN

Published by The Art League Publishing Co., 10131 Jasper Avenue, Edmonton, Alberta, Canada.

SERIES XI INDIANS PORTRAITS

NO. 2035

A CREE WARRIOR

TIME AND PLACE History -- Geography VISUAL TEACHING

"A Cree Warrior"
EDMONTON, AB
ORIGINAL IMAGE, CA. 1905, BY ERNEST BROWN
MOCKUP, 1920S, FOR "BIRTH OF THE WEST" TEACHING SERIES
PROVINCIAL ARCHIVES OF ALBERTA B.10597

"A Mystery to Solve"–(from left) Constable Banks, Corporal Harper, Many Shots, and Black Kettle

SOUTHERN ALBERTA / CA. 1910

HARRY POLLARD

PROVINCIAL ARCHIVES OF ALBERTA P.205

"A Mystery to Solve"–(from left) Corporal Harper, Constable Banks, Black Kettle, and Many Shots

SOUTHERN ALBERTA / CA. 1910

HARRY POLLARD

PROVINCIAL ARCHIVES OF ALBERTA P.204

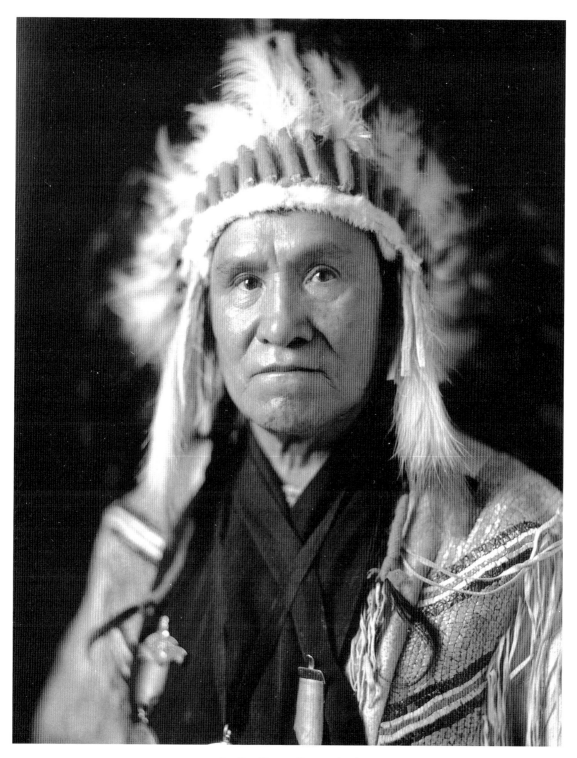

Joe Big Plume, Sarcee chief
CALGARY, AB / CA. 1910
HARRY POLLARD
PROVINCIAL ARCHIVES OF ALBERTA P.21

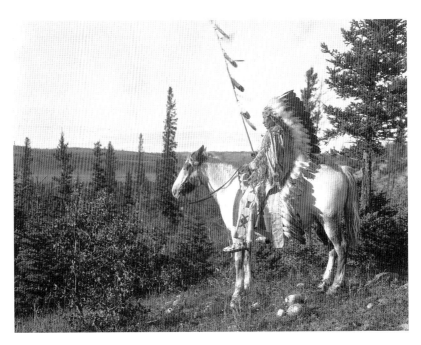

Walking Buffalo (Assiniboine)
NEAR CALGARY, AB / CA. 1910
HARRY POLLARD
PROVINCIAL ARCHIVES OF ALBERTA P.2

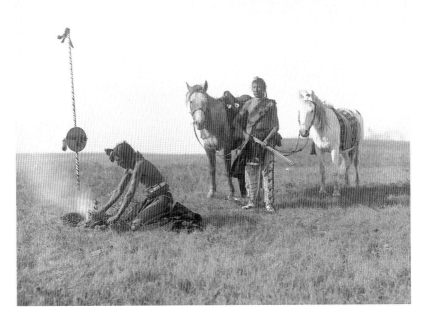

Many Shots and White Headed Chief simulate the starting of
a prairie fire to protect an encampment from raiding tribes.
BLACKFOOT RESERVE, SOUTHERN ALBERTA / CA. 1910
HARRY POLLARD
PROVINCIAL ARCHIVES OF ALBERTA P.468

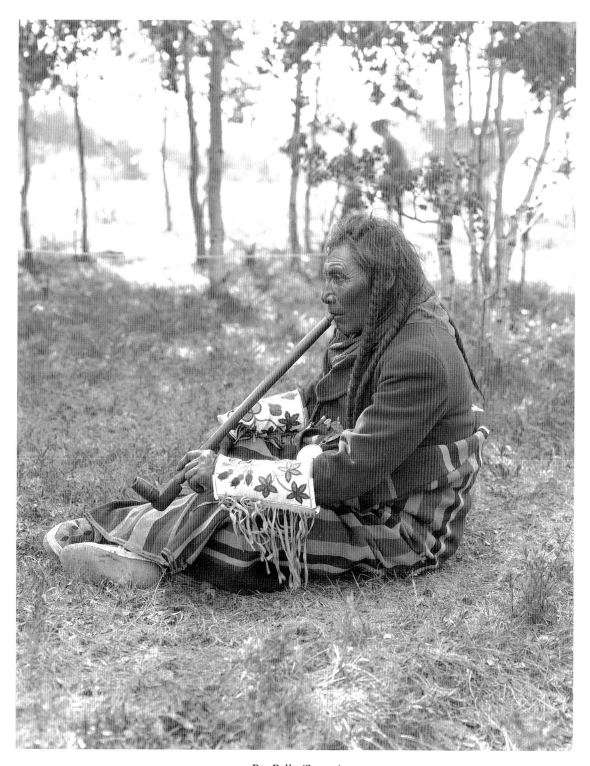

Big Belly (Sarcee)
NEAR CALGARY, AB / CA. 1910
HARRY POLLARD
PROVINCIAL ARCHIVES OF ALBERTA P.24

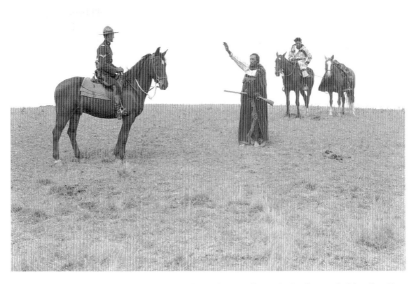

(From left) Corporal Johnston and Indian "scouts" Little Light and Charlie Cutter
SOUTHERN ALBERTA / CA. 1910
HARRY POLLARD
PROVINCIAL ARCHIVES OF ALBERTA P.207

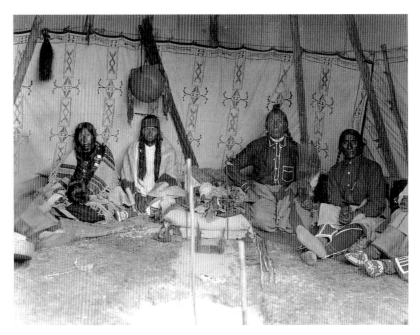

Inside Medicine Lodge (Blackfoot), medicine pipe bundle in center,
medicine pipe bowl hanging on wall
SOUTHERN ALBERTA / CA. 1910
HARRY POLLARD
PROVINCIAL ARCHIVES OF ALBERTA P.52

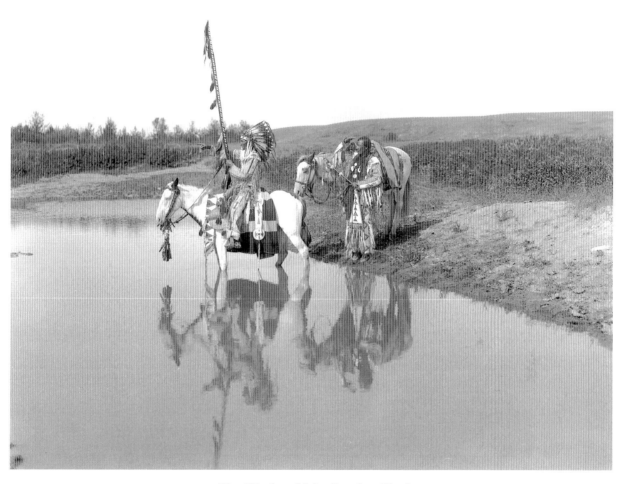

Chief Duck and John Drunken Chief
BLACKFOOT RESERVE, SOUTHERN ALBERTA / CA. 1912
HARRY POLLARD
PROVINCIAL ARCHIVES OF ALBERTA P.102

Parade of Indians on Stephen Avenue (for Calgary Stampede)
CALGARY, AB / 1914
HARRY POLLARD
PROVINCIAL ARCHIVES OF ALBERTA P.6792

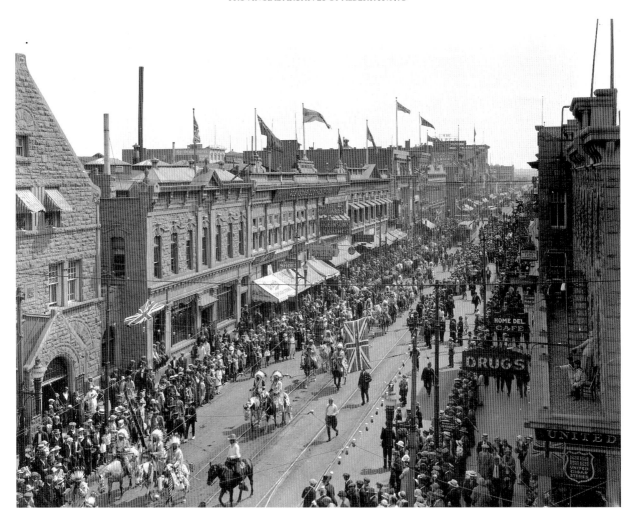

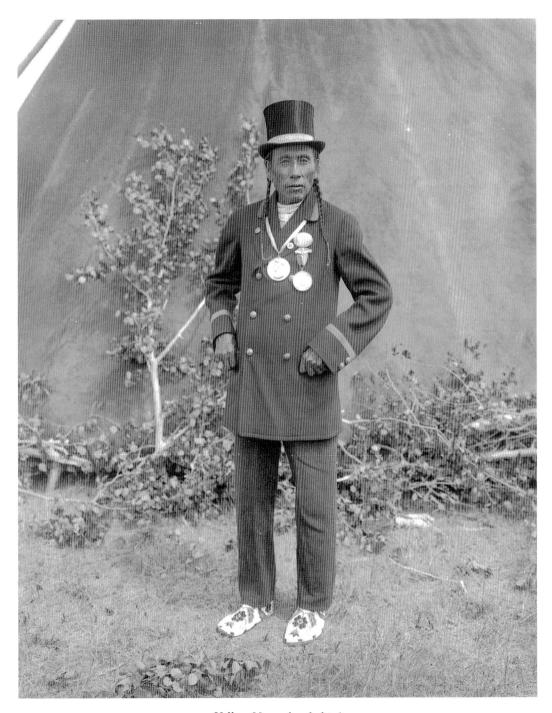

Yellow Horse, head chief
According to photographer Harry Pollard's original cataloguing notes, two graves were dug
when Yellow Horse died—one for him and one for his horse.
The horse was shot and buried with its saddle and bridle.

BLACKFOOT RESERVE, SOUTHERN ALBERTA / CA. 1910

HARRY POLLARD

PROVINCIAL ARCHIVES OF ALBERTA P.113

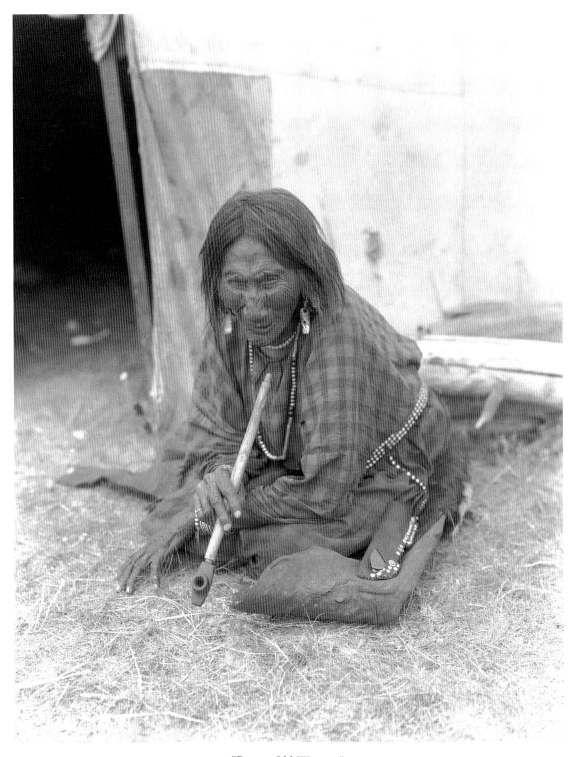

"Beaver Old Woman"
BLACKFOOT RESERVE, SOUTHERN ALBERTA / CA. 1919
HARRY POLLARD
PROVINCIAL ARCHIVES OF ALBERTA P.42

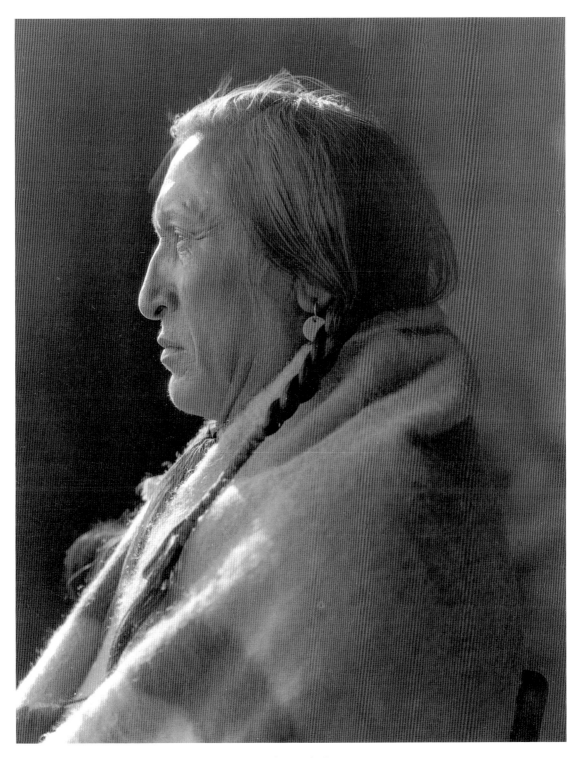

Spring Chief (Blackfoot)
SOUTHERN ALBERTA / CA. 1910
HARRY POLLARD
PROVINCIAL ARCHIVES OF ALBERTA P.148

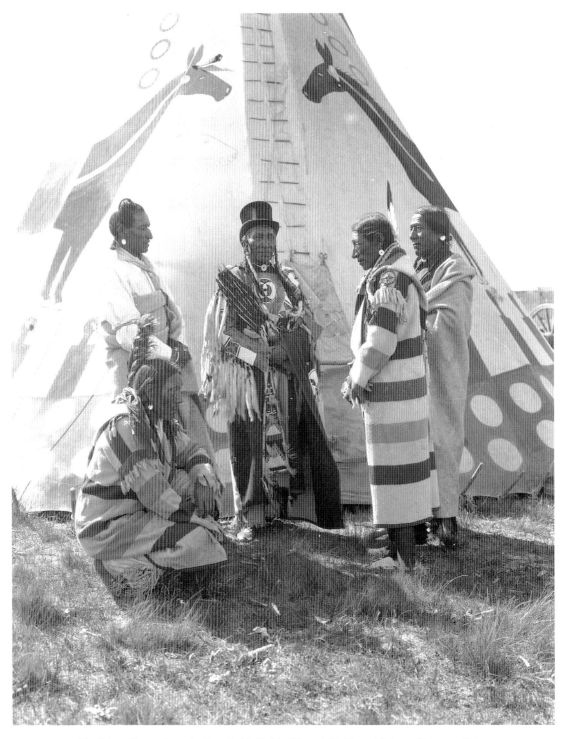

*Blackfoot Council, including Calf Child, Weasel Calf, and Many Turning Robes
(second from right), a portrait of whom is on the facing page*

SOUTHERN ALBERTA / CA. 1920

HARRY POLLARD

PROVINCIAL ARCHIVES OF ALBERTA P.25

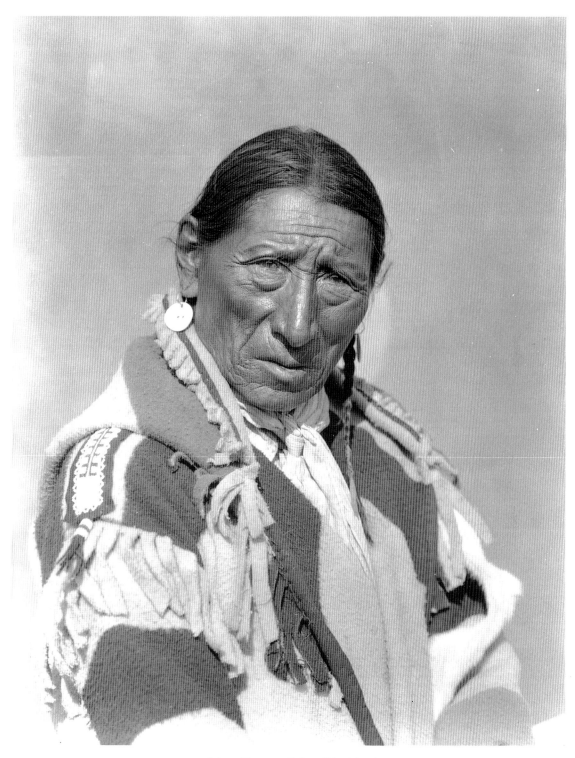

Many Turning Robes (Blackfoot)
SOUTHERN ALBERTA / CA. 1920
HARRY POLLARD
PROVINCIAL ARCHIVES OF ALBERTA P.156

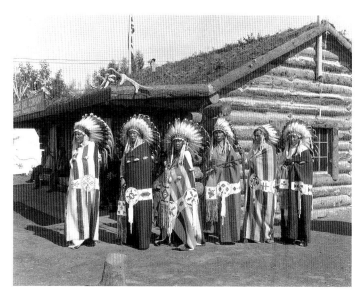

Indians at Calgary Stampede, including (from left) Dick Bad Boy, Harry Red Gum, Joe Good Eagle,
Manny Fire, Sam Red Old Man, and Willie White Pup
1920S
HARRY POLLARD
PROVINCIAL ARCHIVES OF ALBERTA P.61

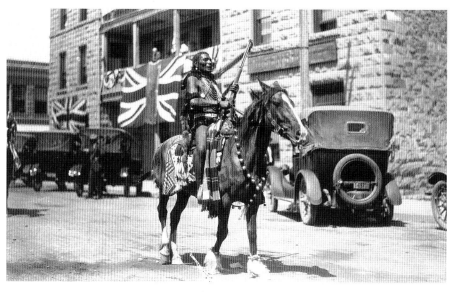

Blackfoot brave, Macleod Jubilee Parade
Fort Macleod celebrated the fiftieth anniversary of its founding, and the arrival of
the North-West Mounted Police, on 1 July 1924. This young man is one of the many Native people
who participated in the Grand Parade, which consisted of 5 miles (8.3 km) of floats, bands,
and community groups. The *Macleod Times* of 10 July 1924 notes that "the Indians in their paint and feathers
were one of the big features of the parade. They were magnificent . . . "
H.V. CLARKE
PROVINCIAL ARCHIVES OF ALBERTA A.20683

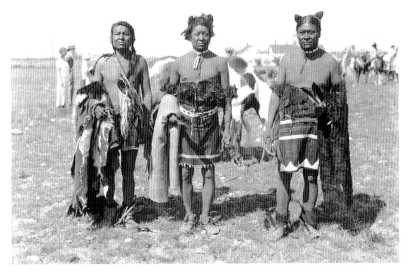

Pigeon Society, including (from left) Rough Hair, Tom Four Horn, and Jim Rabbit
(Blood), a portrait of whom is on page 164
MACLEOD, AB / 1 JULY 1924
HARRY POLLARD
PROVINCIAL ARCHIVES OF ALBERTA P.51

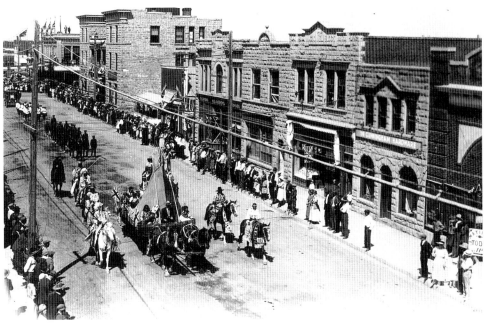

Tepee float, Macleod Jubilee Parade
SOUTHERN ALBERTA / 1 JULY 1924
H.V. CLARKE
PROVINCIAL ARCHIVES OF ALBERTA A.20682

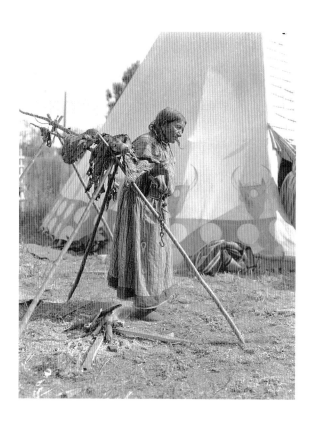

Unidentified
LOCATION UNKNOWN / CA. 1920
HARRY POLLARD
PROVINCIAL ARCHIVES OF ALBERTA P.40

Chief Ben Pasqua
REGINA, SK / CA. 1924
EDGAR C. ROSSIE
SASKATCHEWAN ARCHIVES BOARD R-B 3840(2)

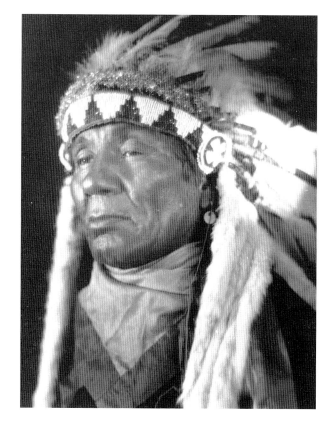

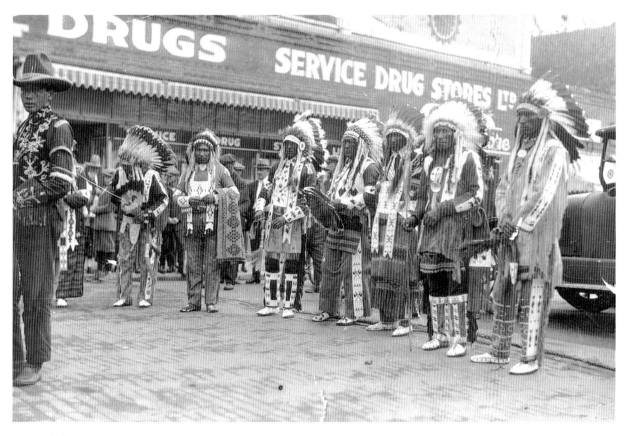

Indians on Jasper Avenue, Edmonton, Alberta, probably participating in the Edmonton Exhibition Parade
1920S
PHOTOGRAPHER UNKNOWN
PROVINCIAL ARCHIVES OF ALBERTA A.18990

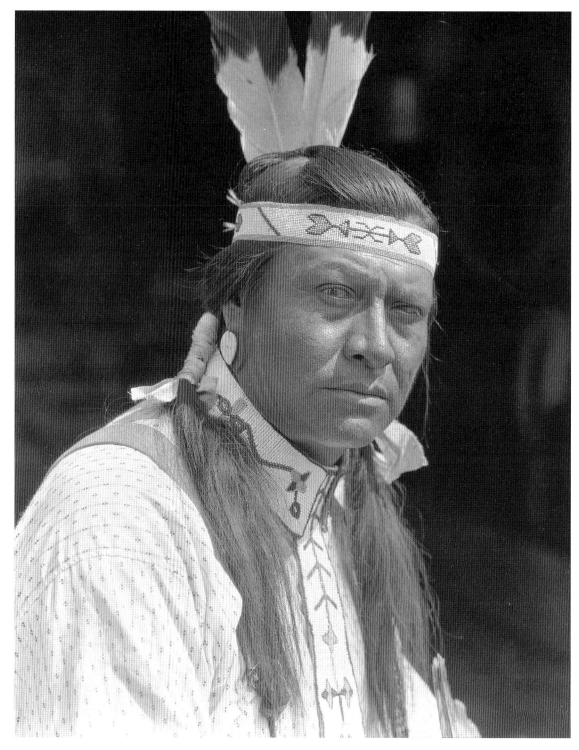

Jim Rabbit (Blood)
MACLEOD, AB / 1 JULY 1924
HARRY POLLARD
PROVINCIAL ARCHIVES OF ALBERTA P.35

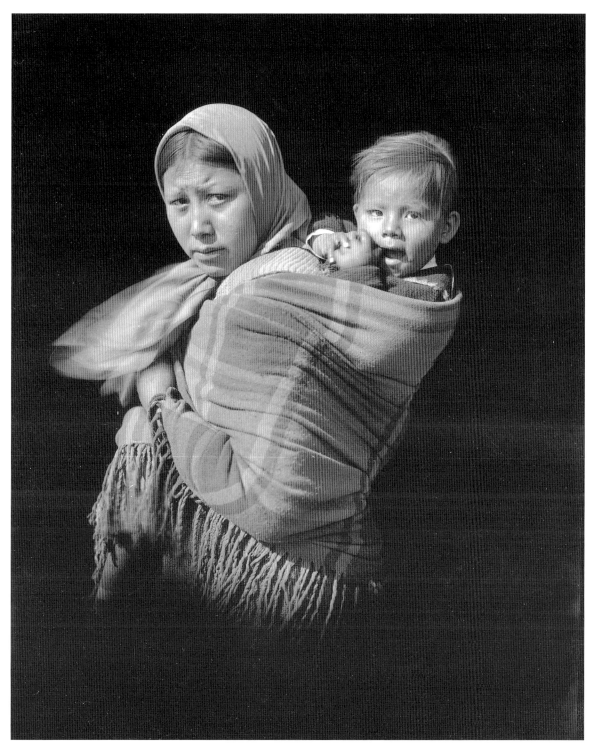

Three Suns, wife of Dick Bad Boy, who appears in the photograph on page 160
BLACKFOOT RESERVE, SOUTHERN ALBERTA / 1920s
HARRY POLLARD
PROVINCIAL ARCHIVES OF ALBERTA P.149

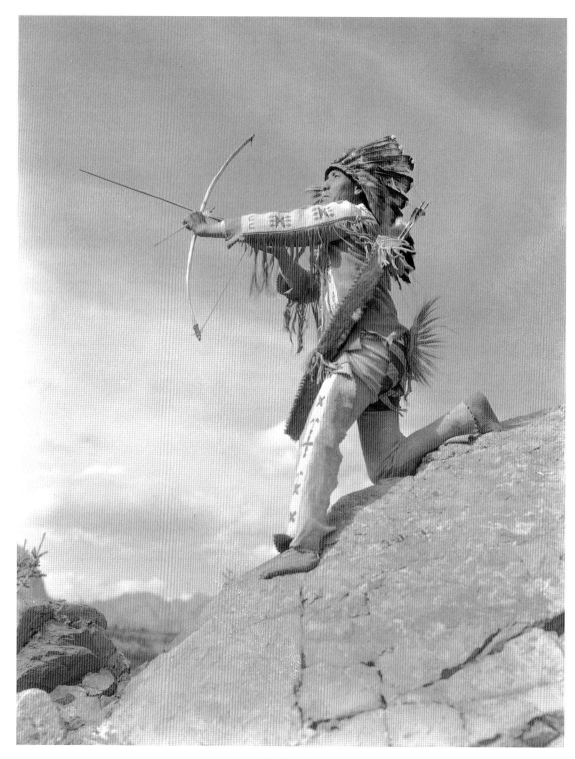

Lone Walker (Stoney)
LOCATION UNKNOWN / 1920s
HARRY POLLARD
PROVINCIAL ARCHIVES OF ALBERTA P.34

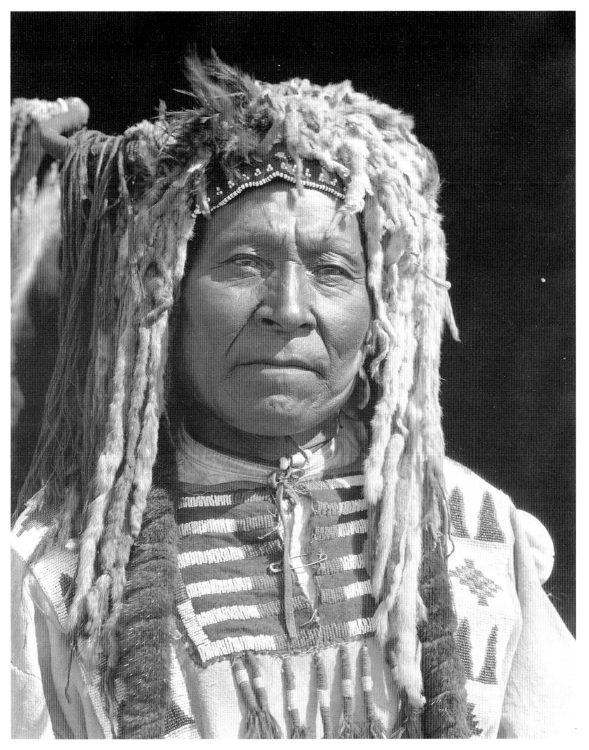

Big Face Chief
PIEGAN RESERVE, SOUTHERN ALBERTA / CA. 1920
HARRY POLLARD
PROVINCIAL ARCHIVES OF ALBERTA P.43

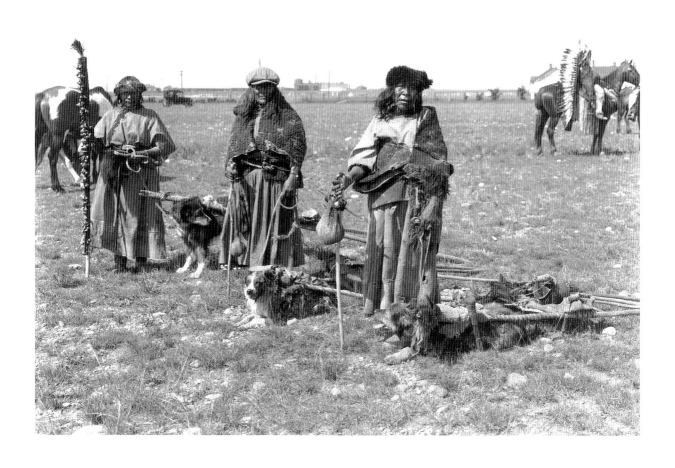

(From left) Peter Year, John Hunter, and Dan Wild Man
STONEY RESERVE, MORLEY, AB / 1920S
PHOTOGRAPHER UNKNOWN
PROVINCIAL ARCHIVES OF ALBERTA P.56

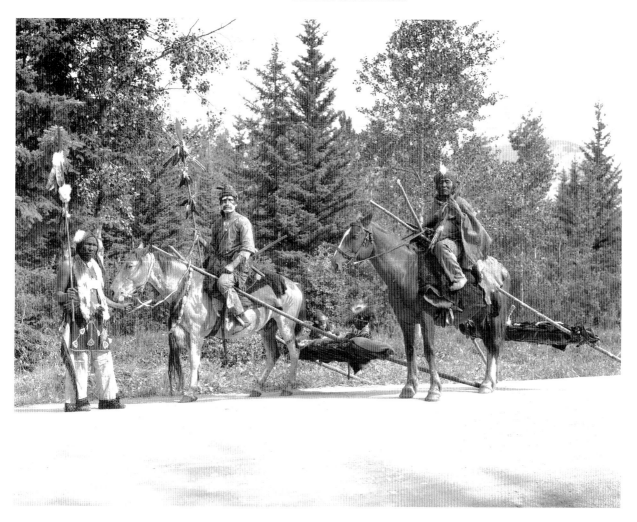

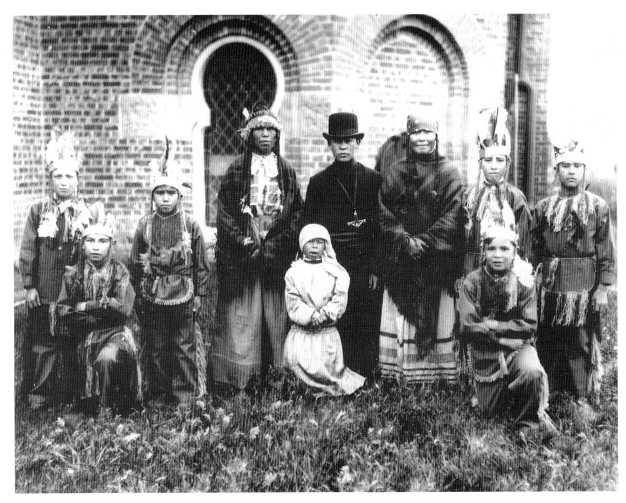

A group shot of a slightly absurd situation—Native people dressed up as Indians to play their roles in a skit commemorating the centenary of Father Albert Lacombe OMI in 1927.

LOCATION UNKNOWN

PHOTOGRAPHER UNKNOWN

PROVINCIAL ARCHIVES OF ALBERTA OB.8524

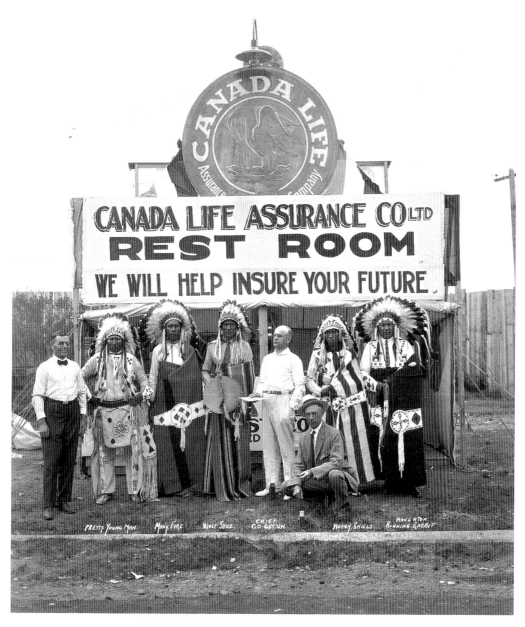

This apparently deliberate but oddly chosen backdrop for a group photo, in front of a rest room
set up by the Canada Life Assurance Company at the Calgary Stampede, includes (from left)
Pretty Young Man, Many Fire, Wolf Shoe, Chief Go Getun, Heavy Shield, and Haughton Running Rabbit.
The white man at left and the one squatting in front are unidentified, nor is there an explanation
for the white man, centre, labelled Chief Go Getun.

1920s

HARRY POLLARD

PROVINCIAL ARCHIVES OF ALBERTA P.4227

The Vic Robertson Tire Service truck shown here illustrates the use of the "legendary" Indian
for advertising purposes–in this case Pathfinder tires, a tenuous link at best with
the exceptional tracking skills of Native people. Images of Indians were also used for promoting
Red Indian Motor Oil, Prince Albert tobacco, and Seneca cameras.
This photograph was taken in Saskatoon by John W. Gibson.
1930
GLENBOW ARCHIVES ND-13-33

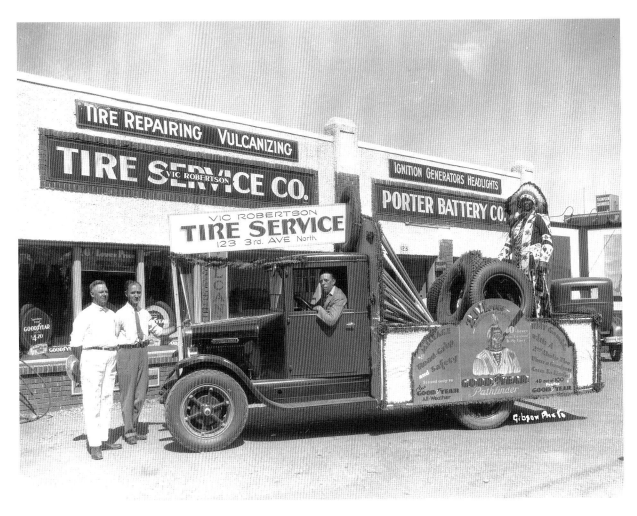

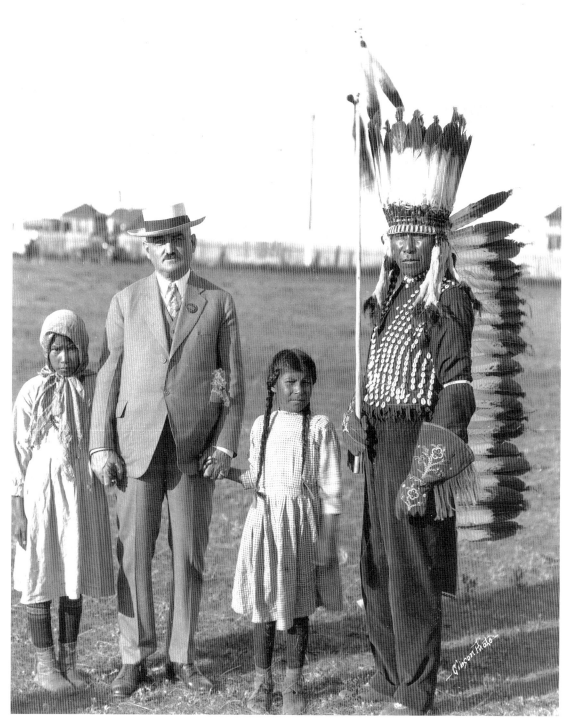

Indian family posing with a white fairgoer at the Saskatoon Industrial Exhibition
1930
JOHN W. GIBSON
GLENBOW ARCHIVES ND-13-104

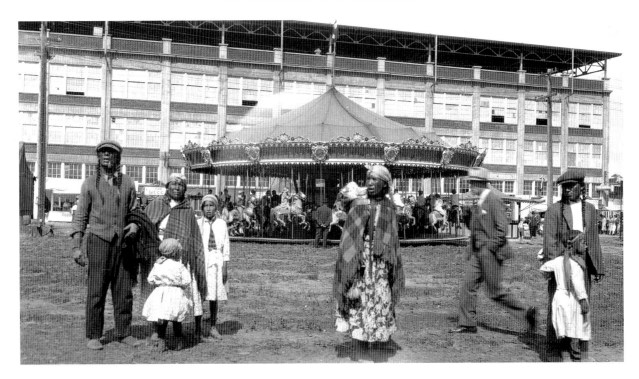

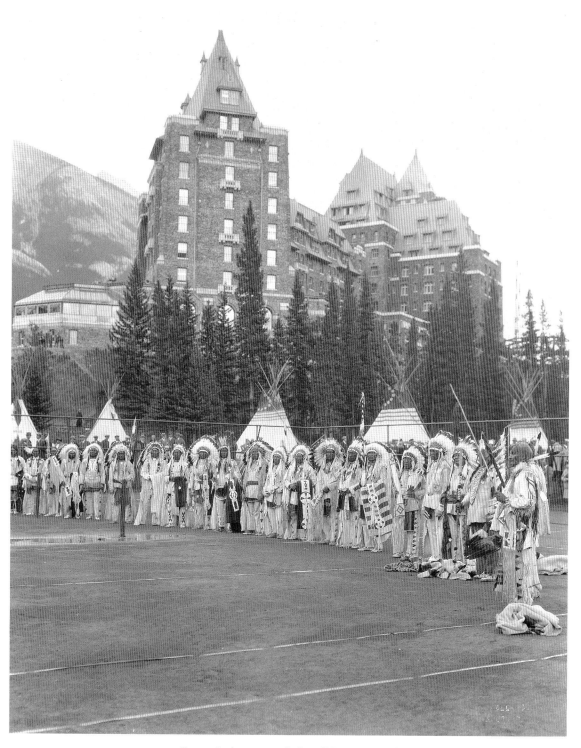

Stoney Indians outside Banff Springs Hotel
BANFF, AB / 1922
HARRY POLLARD
PROVINCIAL ARCHIVES OF ALBERTA P.81

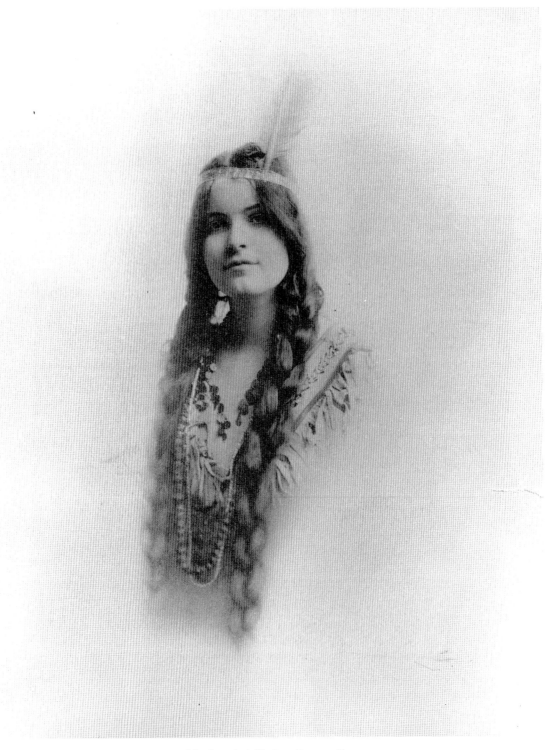

Unidentified "Indian Princess"
LOCATION UNKNOWN / N.D.
PHOTOGRAPHER UNKNOWN
SASKATOON PUBLIC LIBRARY, LOCAL HISTORY DEPARTMENT LH.9827

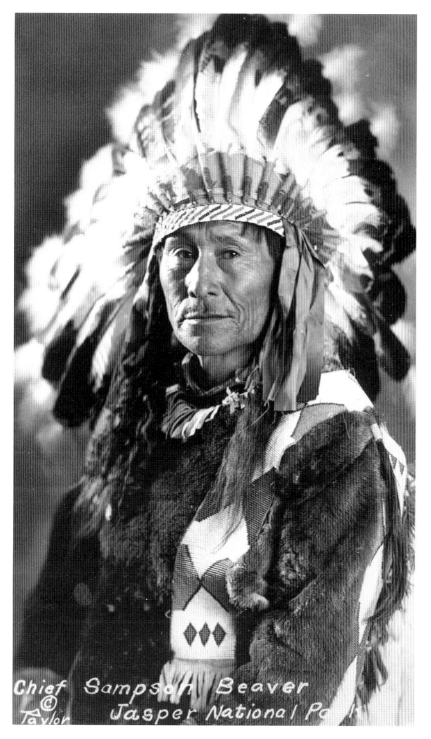

"Chief Sampson Beaver (Stoney) Jasper National Park"
A photograph of the young Sampson Beaver and his family appears on page 95.
WESTCENTRAL ALBERTA / 1930S
G. MORRIS TAYLOR
B. SILVERSIDES COLLECTION

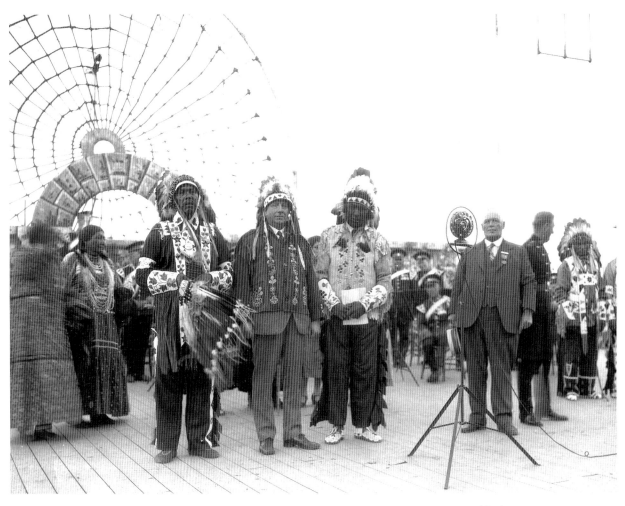

Opening ceremonies of the Saskatoon Industrial Exhibition of 1930. Organizers felt the presence
of traditionally clad Native people would add a touch of the exotic to the event.
Residents of the nearby Moose Woods (Whitecap) Reserve obliged,
bringing extra jackets and headdresses for dignitaries.

JOHN W. GIBSON

GLENBOW ARCHIVES ND-13-103

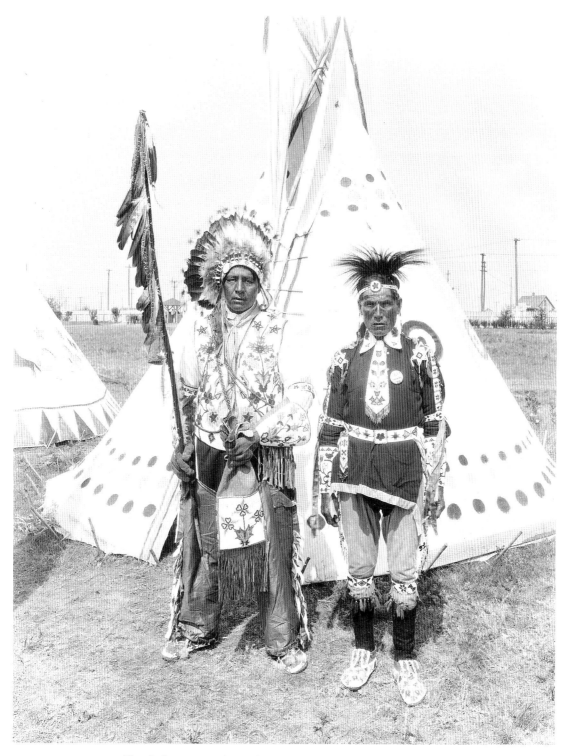

Two Indians in traditional costume at the Saskatoon Exhibition
1930s
LEN HILLYARD
SASKATOON PUBLIC LIBRARY, LOCAL HISTORY DEPARTMENT A.1786

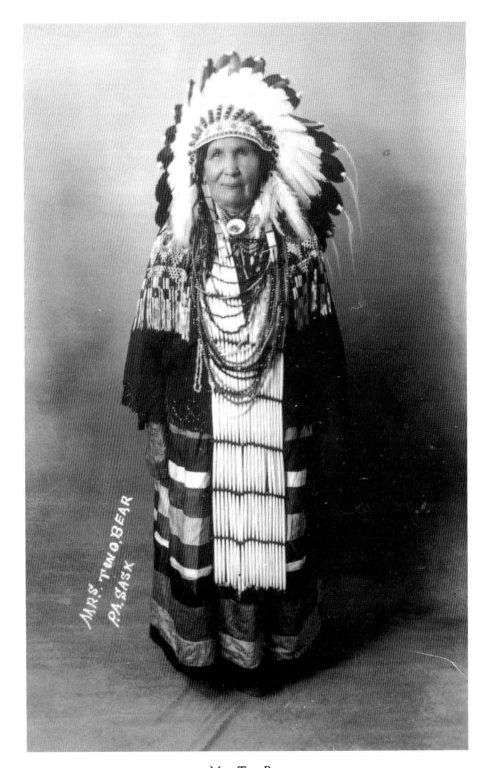

Mrs. Two Bear
PRINCE ALBERT, SK / 1930S
WILLIAM J. JAMES
SASKATCHEWAN ARCHIVES BOARD R–A 1649–2

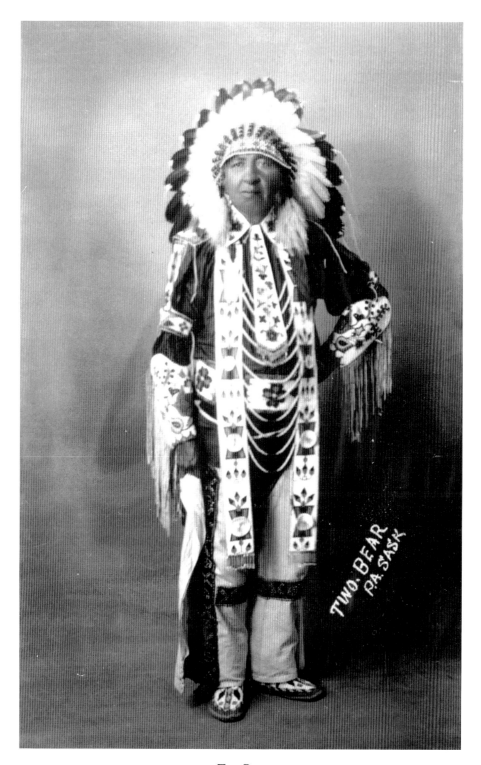

Two Bear
PRINCE ALBERT, SK / 1930S
WILLIAM J. JAMES
SASKATCHEWAN ARCHIVES BOARD R–A 1649-1

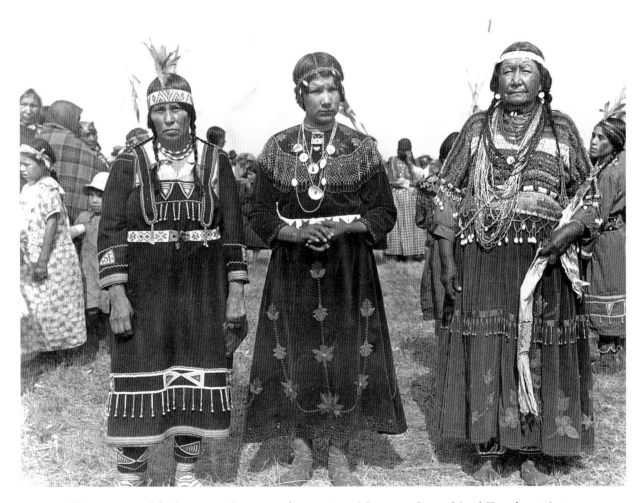

Three women of the Sweetgrass Reserve on the occasion of Governor General Lord Tweedsmuir's visit
NEAR BATTLEFORD, SK / 1936
KEN W. F. COOPER
SASKATCHEWAN ARCHIVES BOARD R-B 693

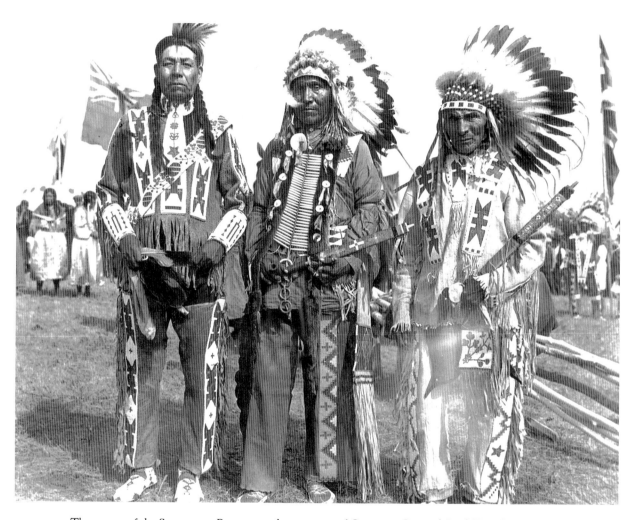

Three men of the Sweetgrass Reserve on the occasion of Governor General Lord Tweedsmuir's visit
NEAR BATTLEFORD, SK / 1936
KEN W. F. COOPER
SASKATCHEWAN ARCHIVES BOARD R–B 696

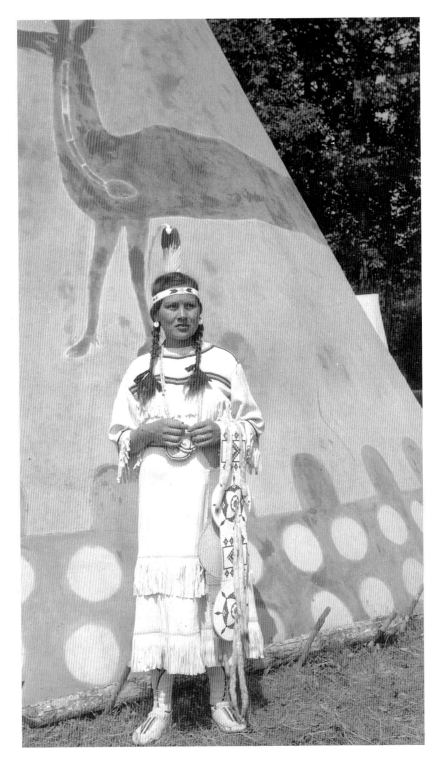

Annie Royal

BANFF, AB / 1939

J. LESSARD

PROVINCIAL ARCHIVES OF ALBERTA OB.10518